MICHAEL HONE

SEBASTIAN
HOMOEROTIC ICON

Renaissance Italy

© 2014

OTHER BOOKS BY MICHAEL HONE

HOMOSEXUALITY in FOUR VOLUMES
VOLUME ONE – ANCIENT GREECE
VOLUME TWO – THE ANCIENT ROMANS
VOLUME THREE – RENAISANCE ITALY
VOLUME FOUR – MODERN TIMES

ADRIAN AND ANTINOUS

SEXUALITY AND LOVE IN ANCIENT GREECE AND ROME

ASTORRE MANFREDI

LOVE AND SEX – ANCIENT GREECE – ANCIENT ROME – RENAISSANCE ITALY

TROY

ALCIBIADES

PORT BEAUSOLEIL

SUPER PARADIS (in French)

AN AMERICAN IN PARIS

UN AMÉRICAIN À PARIS (in French)

CELLINI
His Life and Times

I KNOW THAT THIS BOOK AND I ARE UNWORTHY OF THIS DEDICATION, BUT I DO, HUMBLY, TEARFULLY, DEDICATE *SEBASTIAN* TO THE 8,000 BOYS AND MEN WHO LOST THEIR PRECIOUS LIVES AT SREBRENICA IN 1995

INTRODUCTION
Page 8

COSIMO – FRANCESCO SFORZE – FRA' FILIPPO LIPPI – LORENZO *IL MAGNIFICO* – FEDERICO DA MONTEFELTRO – THE BORGIA – THE SFORZA – CATERINA RIARIO SFORZA DE' MEDICI– ASTORRE MANFREDI
1413 – 1513
page 15

DONATELLO
1408 – 1466
page 58

ANTONELLO DA MESSINA
1430 – 1479
page 59

MANTEGNA
1431 – 1506
page 60

CARLO CRIVELLI
1435 – 1495
page 63

VINCENZO FOPPA
1430 – 1515
page 63

JULIUS II
1443-1513
page 64

BOTTICELLI
1445-1510
page 67

PIETRO PERUGINO
1446 – 1523
page 69

DA VINCI
1452-1519
page 70

MARCO BASAITI
1470 – 1530
page 81

ALVISE VIVARINI
CA. 1442 – CA. 1505
Page 81

ALONSO BERRUGUETTE
1488 – 1561
page 82

MICHELANGELO
1475 - 1564
page 82

SODOMA
1477 – 1549
page 102

HENRY VII – PERKIN – JAMES IV – MAXIMILIAN
AROUND 1490
Page 104

RAPHAEL
1483 - 1520
page 114

THE WEST: ENGLISH AND SCOTTISH KINGS
1500 – 1600
page 117

THE CONTINENT: CHARLES V AND PROGENY
''I speak Spanish to God, Italian to women, French to men and German to my horse.''
1500 - 1558

page 122

TITIAN
1488 – 1576
page 127

CORREGGIO
1489 – 1534
page 129

THE EAST: 1500 – 1600
Page 131

DOSSO DOSSI
1490 – 1542
page 137

THE RENAISSANCE WARS
1494 – 1559
page 138

TINTORETTO
1518 – 1594
page 147

GIROLAMO SICIOLANTE DA SERMONETA
1521 – 1580
page 148

CARAVAGGIO
1571 – 1610
page 149

GUIDO RENI
1575 – 1642
page 167

**THE CARRACCI: UNCLE LUDOVICO, COUSINS ANNIBALE
AND AGOSTINI**
ca. 1585 – ca. 1618
page 171

RIBERA

1591 – 1652
page 173

BERNINI
1598 – 1680
page 174

BATTISTELLO CARACCIOLO
1578 - 1635
page 177

CESARE FRACANZANO
1605 – 1651
page 178

FRANCESCO CAIRO
1607 - 1665
page 179

DOMENICO PASSIGNANO (BORN CRESTI OR CRISPI)
1569 – 1638
page 180

NICOLAS RÉGNIER (RENIERI)
1588 – 1667
page 181

PIETRO RICCHI
1606 – 1675
page 182

SOURCES
Page 183

INTRODUCTION

The Golden Age of homoeroticism came to a screeching halt with the Golden Age of Pericles and the Roman conquest. Night descended over hallowed Greece where the Thebans had passed a law proclaiming "that it is illegal for anyone to maintain that sex between men is *not* beautiful." Romans were no strangers to the unique bond formed between males but somewhere a wrench was thrown into the works, so that even the greatest of them all, Caesar, had to refute his having been bedded by King Nicomedes, even when his infatuation with the virile all-powerful monarch had been witnessed by a Roman embassy at the king's court, during a series of dinners and festivals. The beauty of Caesar as a boy, coupled with his willingness to be "a man to all women, a woman to all men," plus the opulence of Nicomedes' palace and life style, made the two inseparable. Later, as a general, Caesar had to grit his teeth while outside his tent his men, his soldiers, each of whom truly loved the man Caesar had become, ribbed him mercilessly in a variant of rustic Latin that could express filth as in no other tongue.

Only Trajan and Hadrian, unique in having perhaps both died virgins (in today's heterosexual sense of the word) managed to impose boy-love over an empire at times so reserved that a senator, caught kissing his wife in public, was discharged. Of course, there were the excesses of Caligula, Nero and Elagabalus, for which they paid with their lives.

During the Middle Ages the English king Henry II, no tyro when it came to boy buttocks, nonetheless just tolerated his son Richard Coeur de Lion's love for the young French dauphin Philippe II, Philippe who threw himself into the grave of Richard's brother Geoffrey, a boy as handsome as the Renaissance Astorre Manfredi (3). Geoffrey was worshipped by Philippe and died in a joust in Paris, in front of his beloved's eyes.

With the advent of the Renaissance the penalty for love among males was death, but because everyone was doing it--especially as girls, valuable wares in marriages as long as untouched by male members--the penalties hardly amounted to more than a slap on the wrist. Lorenzo *Il Magnifico* had his palaces, his villas, his stables and his stable boys, da Vinci had his Salaì and Melzi, Michelangelo his Urbino and Cellini his Cecco. Pope Alexander VI was sexually active and his son Cesare threw the most beautiful boy in Italy, Astorre Manfredi and his 15-year-old brother, into the Tiber, after the historian Burchard's assurance that both Alexander and Cesare had used the boys in an all-night orgy. But with the Counter-Reformation burning at the stake became the real penalty for sodomy.

In modern times prewar Berlin had thousands of rent-boys, and in beauty and sexual prowess German lads are right up there with their French and Italian counterparts. Hitler gassed them all, and the fatherless sons of soldiers that grew up at war's end, in the ruins, were the continent's Hershey Bar whores, even more available than before the conflagration.

Homophobic harassment followed in even the most civilized countries, in Central Park, for example, until Stonewall '69, and here where I live, in France, until just this year, and the legal right to now marry the boy of my choice. But there were manifestations here too, against the law, and even in the wondrous freedom of the States a guy would need undaunted courage to announce, to his locker-room buddies, his preference for them over the chirping maidens in the showers just next door.

So when a lad, in our times, looks on a painting of the nearly totally nude Sebastian, his tear-filled eyes turned up to the heavens, the arrows piercing white skin trickling with blood from open wounds, his natural desire is to stem his suffering, suffering familiar to gays since the day they realized their difference, and the difference of their inadmissible desires. Mocked, gassed, burned at the stake, humiliated in the gym, beaten up in parks, how would it be possible *not* to identify with the beautiful, youthful, suffering Sebastian?

The hagiography of Sebastian falls invitingly into the story of Renaissance painters and sculptors as his burial place, San Sebastiano fuori le mura, was rebuilt by Scipione Borghese around 1610, at the time of the death of Caravaggio. The importance of Scipione Borghese to us is the combination of several factors: Born Scipione Caffarelli he was turned over to Camillo Borghese, the future Pope Paul V, because his father, fallen on hard times, didn't have the funds to educated and bring him up in a noble manner. Paul V changed the boy's name to Borghese and made him a cardinal and his secretary. Scipione guarded the door to the pope, thanks to which he amassed an immense fortune, making him perhaps the wealthiest man in Rome. (His ''salary'' alone, for 1612, was 140,000 scudi, while François I offered Cellini a yearly stipend of 300 scudi, which gives one an idea of what Scipione was worth.) To these factors were added his gift of extreme intelligence and passion for art and the collection of art, turning the Palazzo Borghese into an incomparable museum, while assuring the material comfort of Caravaggio and Bernini, among others.

Against Paul V's wishes, Scipione brought his lover Stephen Pignatelli to Rome and together they filled the palazzo Borghese with homoerotic art. Pignatelli was said to have loved Scipione to the point of insanity. Both men shared the services of other boys, one of whom, age 18, they were thought to have ordered murdered, just outside their bedroom, perhaps because the boy had sought bribes to keep Scipione's tendencies from his uncle the pope. Pignatelli was requested to leave Rome but was brought back when

Scipione became deathly ill, and only his lover's presence could heal him. Scipione immediately recovered and was awarded a cardinal's hat.

Scipione Borghese ordered the restoration of San Sebastiano, founded in 312, and possessing the greatest collection of artifacts known at the time. San Sebastiano had had three names: San Sebastiano ad Catacumbas (at the Catacombs), Basilica Apostolorum (Basilica of the Apostles) because it had once held the remains of Peter and Paul, and now San Sebastiano fuori le mura (outside the walls). As relics it has one of the arrows that struck Sebastian and part of the column to which he was tied during his martyrdom.

Amusingly, Scipione commissioned Bernini to sculpt a Hermaphrodite, a reclining figure with an ample appendage, found today in the Louvre, the backside to the public. In order to view the statue's singularity, one has to squeeze between the pedestal (and wonderfully sculpted mattress over which the Hermaphrodite reclines) and a wall, which only people who know what to look for do (at least that was the logistics a number of years ago when I viewed it).

Paul awarded Scipione 105 paintings confiscated from the artist Cavaliere d'Arpino to cover unpaid taxes, among which were the *Sick Bacchus* and *A Boy with a Basket* by Caravaggio. Caravaggio had worked for Cavaliere d'Arpino as an apprentice, churning out paintings of fruit and flowers.

The pope also stole Raphael's *The Deposition* from the Baglioni Chapel in Perugia, gave it to Scipione, and then legalized the theft with something called the *motu proprio* which somehow made what a pope did lawful. (It reminds me of the law here in French which protects the president of France against any and all legal actions, except treason, until he is no longer president; that the Americans can try an American president at any time seems baffling to the French.)

Later Bernini did *Apollo and Daphne* for Scipione, a miracle of beauty although, as you will find in my book *HOMOSEXUALITY – The True Lives of the Fabulous Men who preferred men – Volume One – Ancient Greece*, Apollo lusted far more for boys. Scipione also acquired Caravaggio's horrifyingly real *David with the Head of Goliath*.

Sebastian had been born in today's France at Narbonne. He was taken into the Praetorian Guard of Diocletian who was aware of his being a Christian but was forced to take action against the young man when he became too adept at making converts. It's true that the promise of eternal life is an enticement, as money, position and power today are excitants that assure bedmates for even the most hideous of personages. Soldiers fled the field for more pastoral concerns, amusing when one learns that today Sebastian is the patron saint of soldiers. Prisons were emptied by jailors turned converts, and, due to the Christian God, the altars of Jupiter lacked

for sacrifices. Diocletian therefore had the boy taken to a field for merited punishment. He was bound to a tree for archery practice. The archers hadn't the least commiseration for him as individualism and individual pain came to light only with the Renaissance and the development of humanism. The Romans never questioned either the existence of God nor an order from a superior. Some believe that Diocletian had been in love with Sebastian and his advances refused.

This was Sebastian's first martyrdom, for he was succored and healed by a woman known as Irene of Rome. Later he found himself in the path of Diocletian's litter as he traversed the Forum. Sebastian harangued him, the immediate result of which was his being clubbed to death. His crushed remains were ordered thrown into the sewers. His location was reveled to Christians who fished out his body, miraculously immaculate.

Sebastian's influence grew during the plague when an altar dedicated to him put an immediate end to the conflagration. The news spread and other altars attained the same results. No one attributed this to the mysterious periods when the plague vanished and when it returned, as in the 1350s, annihilating at least half of Europe's population. Whenever prayers to St. Sebastian failed to halt the plague, worshippers assumed that men's sins had simply overpowered even Sebastian's ability to sway the wrath of God.

Mythology may have also influenced Sebastian being associated with the plague: Apollo brought plague during the Trojan War by shooting his opponents with arrows.(4) Sebastian may have died much older than depicted in art, but it was a Greek tradition to portray old men on steles as they had been at age 16, considered the most desirable time in a lad's sexuality, and this tradition trickled down to the Renaissance.

Roman priests and even the Oracle of Delphi had informed Diocletian that they could no longer predict the future due to the static emanating from Rome and the provinces, the origin of which was Christianity, now around 300 years in age. At first Diocletian took a soft approach--against the wishes of his advisors who demanded total extinction--by ordering churches destroyed, religious texts burned and the wealth of the believers expropriated. When a fire destroyed part of his palace, Diocletian, like Nero, blamed the Christians. Those close at hand were whipped, salt and vinegar were poured on their wounds, and they were put in water brought from cold to boiling. A lucky few were decapitated. As related, Sebastian was dispatched, first with arrows, then bludgeoned to death. A score of years later Christianity became an established religion when Emperor Constantine converted. And Diocletian? He became ill and abdicated, the first emperor to ever do so. He passed away in bed and his Empire … but that's a story for another day.

The Renaissance was the rebirth of Greek political, philosophical and sexual ideals. We'll see the vital role of Cosimo de' Medici later on, but for the moment suffice it to say that the rebirth of Greek ideals led artists, painters and sculptures to relive the mythological past through art, and as the ancients were devoted to male-male relations--Patroclus and Achilles, Hephaestion and Alexander, Harmodius and Aristogeiton, Orestes and Pylades--this provided a permission of sorts for artists to give free rein to their attraction to apprentices, models and workshop assistants. The painting and sculpting of naked boys, the prevalence of Greek pederasty-- the very foundation of Greek legends and sculptures--left them free to practice unbridled sex, daily within the workshop, and nightly in the adjoining sleeping quarters. The beauty of Italian boys, the languorous warm climate that encouraged disrobing to one's loincloth, all the while sculpting the naked bodies of, say, Laocoön and his nude sons, led to instant, rapid and highly-charged sex. A young body could function in this way multiple times during a day and night, and did.

From the art of the ancients the erotic spillover found an outcome in the religious. Paintings were needed by the church to instruct the illiterate-- the majority of churchgoers--in the lives of the saints. How much more pleasant to portray Sebastian as a beautiful lad than as an old man. As the model stripped for the painting, his skin already glistening with sweat in Rome's and Florence's implacable heat, the silky hairs of the underarms and those descending from the navel to the loincloth, filled the air with an eroticism that made one grateful to be alive and sensually fully awake. The sculptures and paintings in turn aroused the faithful who viewed them. This much was admitted by Vasari, the very important art historian, who deplored the paintings' effect on women, failing to mention that he himself was so stirred as to ask his friend Cellini to lend him the models for nights of love. Cellini later complained that Vasari never paid the boys and in at least one case injured one of them by severely scratching his back while in the throes of orgasm.

The paintings and sculptures therefore educated the masses, emotionally gratified them, impacting their existence in ways so strong as to never be forgotten throughout their entire--often otherwise listless--lives. Soon writers and philosophers took the cue, and homoeroticism found its way into their writings and teaching, by way of the likes of Aretino, Pico della Mirandola and Poliziano who taught Lorenzo *Il Magnifico*'s sons.

All the great artists turned to portraying Saint Sebastian: Reni, Ribera, Caravaggio, Mantegna, Carracci, Bernini and Il Sodoma, the only one who admitted taking pederastic pleasure while doing so.

The eroticism was often subliminal. Men and boys already bathed naked together in rivers such as the Tiber and the Arno, and as girls were out of reach before marriage, and as half of all Florentine men escaped the

marriage trap altogether, they were naturally drawn to each other, especially as even their saints--John the Baptist and the lithe Sebastian--shared their nudity with believers who passed through any cathedral doors. Religious art did indeed educate them.

Sebastian also played a prophylactic role. As he was known to ward off the plague, his portrait was in every household. Those eventually afflicted could find solace in Sebastian, himself pierced by arrows, who looked heavenward for succor and consolation.

Naturally the arrows represent phallic penetration, but this may easily be a modern reading, and there is no evidence of any sort that indicates that Renaissance man saw or painted him in this light. One can always believe they did so subconsciously, but I'm personally among the doubters. Renaissance artists were having enough real action in their workshops, in the private rooms of taverns and in back alleys, to be drawn into the psychological nonsense that reigns supreme today. (One modernist draws our attention to a painting where Sebastian, with his free hand, sensually caresses an arrowhead stuck in the trunk of a tree.)

That so little has come down to us concerning the lives of these artists is a tragedy. They perhaps didn't create masterpieces that were so wonderful they ''shamed nature,'' as one said of Michelangelo and his *David*. They were not, perhaps, intellectuals and awesome inventors like da Vinci, nor sculptors that could only have been God-inspired, like Bernini. They didn't leave behind, perhaps, the ultimate in homoerotic sublimity as personified by the *Perseus* of Cellini. Perhaps they didn't even make us dream of Florence and Florence's River Arno and the Arno's naked bathers as did Passignano. But they all, each of everyone, recognized the beauty of a boy's body, of the virility of a boy become a man, as witnessed in their St. Sebastians. Vasari did his best to reveal the lives of artists before his own death at age 63--far too young for what he had to offer. Bellori, Mancini and Baglione helped us some with their lives of Caravaggio, even if the works of all three put together amount to about six single-spaced A4 pages. An apothecary, Luca Landucci, left a few notes concerning what was going on during his time. From Aretino we've received a great deal of gossip about Raphael, Titian, and others who so feared his viper tongue that even kings like François I and Charles V paid him to keep quiet. Just scraps here and there. Even da Vince, in the hundreds of pages of his notebooks, says nearly nothing about himself, although his self-portrait as John the Baptist gives us a sublimity that would have shamed Antinous.

They worked, they struggled, they left behind traces of themselves in their oeuvres. But even these traces are vanishing. Half of Caravaggio's paintings have been lost. The Elgin Marbles are but the remnants of the Parthenon. Quakes have destroyed hundreds of masterpieces; revolts, wars and revolutions have destroyed others. Church art has been broken into

pieces and sold separately, and then lost or damaged. Throughout my research I continually come across: "some fragments remain"; "some of which have been preserved"; "was lost along with so many other major works by Venetian artists by the great fire of 1577"; "the flood destroyed all the old pictures in the great chambers"; "was plundered by thieves during the epidemic"; "lost in the 1944 allied bombings of Padua"; "although the pictures have perished"; and on ad nausium.

In addition to the absence of detail concerning the lives of these giants, is my own personal decision to *not* describe the paintings found in this book--or, at least, to do so very sparingly. The reason is that they should be seen and admired by the reader in situ in the museums, a wonderful occasion to make acquaintances, as I well know because it was in the Louvre, as a young man, that I met my very first lover, an encounter related in my book *HOMOSEXUALITY, Volume Four, Modern Times*.

For me the Renaissance ended in 1492, not with the discovery of America, but with the death of Lorenzo *Il Magnifico*. But in order to include Caravaggio in this study of Renaissance Sebastians, let's say that in 1492 commenced the death throes of the Renaissance, the Renaissance which ended with the silly exaggeration of mannerism and the baroque. Let's then add on a few years more, a baker's dozen, so as to include Bernini and his wonderful statue of our homoerotic arrow-pieced lad.

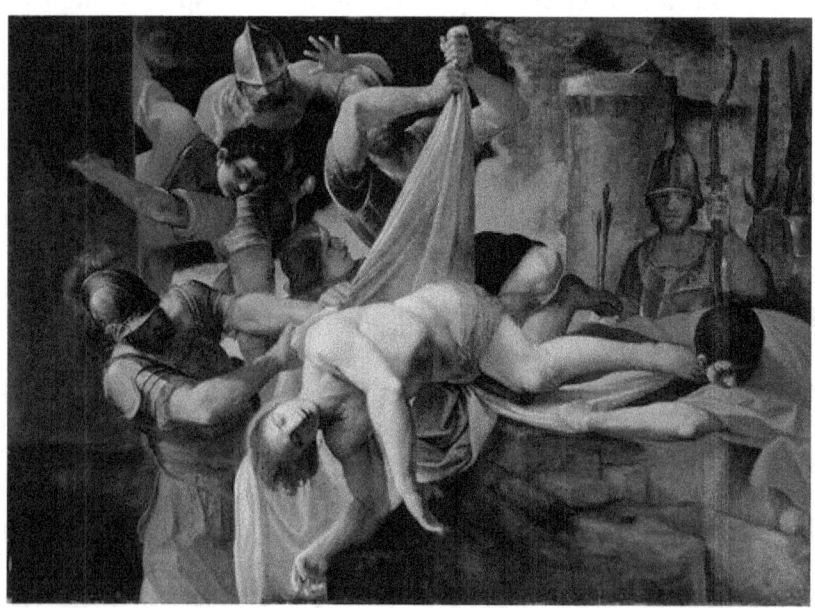

Sebastian removed from the sewers of Rome--Lodovico Carracci

COSIMO – FRANCESCO SFORZE – FRA' FILIPPO LIPPI – LORENZO *IL MAGNIFICO* – FEDERICO DA MONTEFELTRO – THE BORGIA – THE SFORZA – CATERINA RIARIO SFORZA DE' MEDICI– ASTORRE MANFREDI
1413 - 1513

Man is stirred physically, mentally and, of course, sexually. Whether we like it or not, sex is the motor that rules the world, now as then. Cesare Borgia wanted armed power and sexual conquest, an easy equation for him as he possessed military genius and physical beauty; another condottiere whom we'll soon meet, Federico da Montefeltro, had lost an eye in battle and compensated by having his nose surgically hollowed out so he could see in all directions with but one eye. His might and wealth assured him a warming presence for his bed.

Sexual satisfaction was by far the norm in the man's world of the Renaissance, but not exclusively. Caterina Sforza, of Imola and Forlì, used her position as regent to put her stable boy into her bed, an extraordinarily handsome lad murdered by her subjects who found him wanting in class, only to be replaced by another even more handsome suitor. But as might made right then as today, she was conquered by Cesare Borgia who wanted her lands. He raped her multiple times before turning her over to his tavern companions. Lucrezia Borgia was another free spirit who would know more love and the loss of love, debauchery and suffering, than mere mortals like myself would know in several lifetimes.

Throughout the book I'll approach Renaissance sexuality more completely, but for now I'll limit myself to the intellectual and militaristic impulses of the times, and what better place to begin than with one of the bright lights of the period, the Florentine Cosimo de' Medici, father of the future Lorenzo *Il Magnifico,* the star of the Renaissance.

The story of Cosimo begins to the north of Florence, in the city-state of Milan, ruled by Duke Filippo Maria Visconti, a hugely ugly and hugely fat recluse who kept to his fortress away from the sight of those--ambassadors, kings, emperors and the like--who might judge his physical hideousness. He had a dream, that of becoming lord over as much of the land surrounding Milan as militarily possible, a dream that led him to attack the Romagne, home of tiny fiefdoms such as Forlì, Imola and Faenza. He also attacked the Florence of Cosimo de' Medici. But before the attack, let's picture this incredible excuse for a human being. He was paranoiac to the extreme, switching bedrooms as many as three times a night to avoid assassination. He murdered his older brother Gian Maria, a ruler of incredible cruelty who dressed his dogs to devour whomever he sicced them on. During one of the wars Gian Maria waged, the people of Milan, starving to death, pleaded with him to decree peace. In response he had his soldiers massacre 200 of

them. From then on he forbade the word "peace" in Milan, under pain of death. When Filippo Maria Visconti found his wife lacking in enthusiasm to be covered by his walruse-like blubber, he accused her of having an affair with a young page and had her beheaded. He then married a girl whom he expulsed from the palace when, on the wedding night, the superstitious duke heard a dog barking--naturally, an evil omen. Before taking any decision he had his astrologers indicate the place and time for each of his actions. But he did have time to father an illegitimate daughter, Bianca.

The attack of Duke Filippo on Florence pushed Cosimo to hire a mercenary, the extraordinary Francesco Sforza. Cosimo wanted Francesco to destroy the power of Milan but Francesco Sforza hesitated before entering the city-state as he had plans to marry Bianca and take over Milan without having to wage war. His plan worked, he married the beauty, but as Duke Philippo had not formally named him as his successor, Milan declared itself a republic on Duke Philippo's death, a mere hiccup for Sforza who garrisoned the town and had himself declared duke. But Sforza's contacts with Cosimo had been so humane and intellectually stimulating that Milan and Florence became friends. Cosimo backed Sforza financially to such an extent that Cosimo's palace became, literally, the Bank of Milan.

Venice, ever afraid of the hegemony of Milan, decided to send troops against both Florence and Milan. Florence appealed to Charles VII of France, a super power that made Venice withdraw simply by threatening to intervene. To thank Charles, Florence acknowledged France's age-old claim to Naples. Furious, Naples decided to go to war with Florence and sent troops to capture the city. Venice too decided to intervene again. Cosimo became literally sick due to the new circumstances and took to his bed. Then two miracles occurred. Naples had to withdraw its troops from the outskirts of Florence when France sent troops to make good its claim on Naples, and Venice had to withdraw its troops when Constantinople fell to the Turks, the greatest threat ever to Venetian trade. For added safety, Venice united with Florence and Milan and an era of peace descended over the former belligerents. To make doubly certain that peace would last, Cosimo sent the most precious of his possessions, a manuscript by Livy, to Ferrante, King of Naples--itself now safe thanks to the timely death of Charles VII. Ferrante was a humanist who loved ancient learning, as did Cosimo himself. Overjoyed, Ferrante promised eternal peace between Naples and Florence.

So here we have the powers that will concern this story as it unfolds: Milan, Florence, France and Naples--we can't count Venice because the Serenissima was too busy making money to really care what was going on outside its waters. Papal authority will remain inefficacious until the advent of Alexander VI, followed by Jules II. Then all hell will break out.

I began by referring to war and carnage. But Italy was far from the only country where we find the inhumanity of men. At the exact same moment, to the East, another despot reigned. Vlad the Impaler was known by his father's name, Dracul, meaning son of the dragon. His father ruled Wallachia. He was a warrior who dedicated himself to the protection of Christians against the hoards of Ottomans of whom he is credited with impaling tens of thousands. As a boy he spoke Romanian and learned Greek, German and Latin, combat skills as well as geography, mathematics and science. Vlad and a younger brother, Radu the Handsome, were sent by their father to the Ottomans as hostages and there Radu converted to Islam. The Ottomans taught the boys warfare and horsemanship. Vlad's father was overthrown and Vlad's older brother, who should have succeeded his father, was blinded and buried alive. When Vlad eventually came to power in Wallachia he strove to increase both the defenses of the country and his own political power. He had the nobles he held responsible for his father and brother's murders impaled. When Turks arrived to reclaim tribute from Wallachia he requested that they remove their turbans in respect for his person. When they refused, he had the turbans nailed to their heads, killing them all. The Turks sent an army that Vlad defeated; the soldiers were impaled with the highest stake reserved for their general. The pope and the Venetians--whose trade had been disrupted by the Turks--were wild with joy at the news. But Vlad's little brother who had converted to Islam, Radu the Handsome, came at the head of Janissary battalions to destroy his Christian brother. In addition, he promised that the nobles in Wallachia who had lost their positions because of Vlad would recuperate their entire wealth. Vlad was thereafter assassinated under unclear conditions and beheaded. His reputation for evil spread through Germany and Russia. How much is true will never be known. He was said to have children roasted and then fed to their mothers, and to have the breasts of women cut off and forcibly fed to their husbands, before impaling them all. It is also reported that the Ottoman army turned back from the Danube, in horror, when they came across thousands of rotting corpses, all impaled.

After the fall of Rome the lights went out over Europe. New Christians like Charlemagne were proud of their ignorance, declaring that they were above grammar. Charlemagne gave a choice to conquered peoples, either they convert or they would fall to the sword. During just one morning 4,500 were beheaded when they hesitated. In Constantinople the first emperor to convert, Constantine, watched helpless while 3,000 Christians died under the sword of other Christians over the interpretation of the new faith, and during the Fourth Crusade the city itself was sacked and the inhabitants massacred when the crusaders failed to receive the monies the new emperor promised them. Saint Augustine, after a youth of depravity, declared that a

child was already polluted in the womb, as he had been conceived through lust. People converted easily thanks to the promise of the afterlife, but went on with everyday violence in which thousands died in drinking brawls, sexual disputes and sports such as tournaments. Fear of disease and plague, invasion and famine, lightening and floods, dark forests of boars, bears and wolves, all combined to unite families in backward villages, where incest and a limited gene pool assured mental deficiency. Hunched over, afraid of every storm, medieval men lived out their existence is pure anonymity. There were no clocks, not even calendars among them, and even the century in which they lived was both unknown and of no importance. The Great Schism--a pope in Rome and one in Avignon--was unknown to the peasants who passed their days in perpetual toil, seeking out the church at the time of baptisms, marriages and deaths, alongside priests as ignorant as they. Illiterate, pockmarked, gullible, superstitious, for them there were no changes anywhere simply because they were unaware of all. They didn't even have surnames, because none were needed. Only later, when the ancient world was rediscovered, did the individual begin to emerge from the formless masses. Then they would take names in order to distinguish one from the other--the smithy became Smith, the tailor Taylor. Anonymity: nothing is known of the twenty-three generations it took to build the cathedral of Canterbury. But finally names emerged from the mist, those of da Vinci, Michelangelo, Botticelli, all thanks to the rediscovery of the ancient texts, a rediscovery and a rebirth: a Renaissance

The serpentine road from the Middle Ages through the Renaissance and on to Modern Times took centuries to unfold. It was this reemergence of the past, it was the heritage of a very distant Rome and Greece. It was the freedom of the human mind, a mind that turned to individual thought and rationalism over crass religious doctrine and its foundation--faith. Humanism is thought to be anti-religion, but at the time the humanists were believers in religion who simply wanted to reform certain religious practices. Those who no longer believed in religions, and there were certainly few, were heretics and candidates for the stake--a real-life burning bush, a strong incentive not to wander too far from the beaten track. The belief in the separation of the church and state, and the right not to believe in certain dogmas at all, would come--albeit only partially--near the 1700s, with Voltaire.

Petrarch is not only the founder of humanism, but also the very inventor of the term Middle Ages. His endeavor was to free Middle-Ages man by bringing back such thinkers as the Roman Cicero (slaughtered at the hands of Marc Antony who wished to still Cicero's truths). Along with the great Boccaccio (immensely readable to this very day), he also freed access to ancient works by reproducing them in the vernacular, Italian.

The Florence of Lorenzo *Il Magnifico*'s grandfather, Cosimo de' Medici, helped found humanism with his friend Niccolò Niccoli. A banker, Cosimo offered Niccoli the funds necessary to send him far and wide, even to the Holy Land, in search of the ancient manuscripts that would bring the words of the likes of Plato into the very living rooms and libraries of the Medici, hundreds and hundreds of volumes. Each discovery that Cosimo made, each old text he unearthed, was like Howard Carter peering into the tomb of Tutankhamen. Cosimo employed forty-five copyists to spread the liberating concepts of the ancients, assisted by Niccoli who wore a Roman toga to the embarrassment of his entourage. Greek studies became a part of Florentine university instruction and artists like Donatello and Brunelleschi built their art along classical lines. The distinction between Platonic truth and beauty and Plato's ideal republic diverged sharply with Cosimo's continued religious beliefs, among them that he was committing a mortal sin by applying, as a banker, usury to his loans. And then, each time civilization advances a step, it seemed (and seems) that something came (comes) along to set it back, forcing men on their knees before some god or other, because of man's lack of faith in himself: wars, disease, the horrors of the Black Death, civil strife, illness, sent (sends) men back in time to the first of the species who feared fire and lightening.

The Renaissance was Florence, and Florence was the Renaissance. Why this should be so is unknown; perhaps the other great sites of the times, Naples and Milan, were too despotic, perhaps Venice too stable; Rome was out of the running because, until the intervention of Jules II, it was Hicksville, dirty, smelly and soiled by papal hangers-on and other such bovines. Traditionally, Florentine merchants vied with each other in their support of the arts. Ghiberti was commissioned to build the doors of the Baptistery of San Giovanni, a task that took twenty years. Brunelleschi somehow capped the Cathedral of Santa Maria del Fiore with a towering roof--the enigma being how the walls of the cathedral can bear the tons of weight--that is still the city's major landmark.

Today we make an industry of searching each other out; huge amounts of time and energy are dedicated to the enterprise. In Italy sex between males was but a strand of the social tissue. Men worked, studied and played together; they engaged in games and sports and cultural pursuits; they associated professionally or labored side by side. And when the mood and/or occasion was right, they shared a joint orgasm, a way of relief as was playing ball or swimming or horseracing, fencing or tournaments. It was natural in the way that sex should be. It was not the concentrated effort to rack up the greatest number of experiences or glee over the abundance of boys/girls one inseminated. Naturally, sex could become serious; the quest for the girl or boy that one fell head over hills in love with was time consuming and stressful. But the occasional release alongside the buddy

who was at hand (literally) was the norm, in the same way that they ate and drank together.

It took the Dark Ages to make sodomy a crime. In ancient Rome male-to-male sex was simply an alternative means to pleasure. Amusingly, the exception to the prohibition of same-sex sex didn't apply to *boys* in Italy, boys could literally do anything they wanted with a male friend. It all fell under the category of 'kids will be kids". For their parents, sex during adolescence was simply the discovery of one's body: what brought it pleasure, what brought it pain; what worked and what didn't; which zones were erogenous and which weren't. It was discovery--to the adolescent boy far more important than Columbus' fumbling onto the Americas. It was sexuality; it was in no way *homo*sexuality.

It was known that Cosimo's grandson, the great *Il Magnifico* himself, had a marked preference for boy buttocks. The preference was illegal but so prevalent that it was rarely prosecuted. But *rarely* prosecuted still meant that there were thousands of cases brought before the courts, which shows the prevalence of the phenomena. A man could be castrated for having sex with a boy (the ultimate cure!); boys 14 to 18 had to pay a fine of 100 lire; boys under 14 paid 50 lire. Foreigners could be legally beaten by whoever caught them *in flagrante delicto*, and if found guilty by a tribunal they could be burned at the stake. In reality no one was much bothered unless he raped a young boy or had sex with children. Consensual sex was more or less admitted; it was the coercive variety that was prosecuted.

Every boy wanted to marry a virgin. So boys who tried to seduce girls could find themselves in mortal danger as families were set on protecting their capital, their virgin girls, girls who served to form the alliances so necessary during the Renaissance. A girl deflowered was no longer an asset. To the contrary, she exposed her family to the open ridicule of the nobility. On the other hand it was accepted that boys needed physical release. The least harmful means of such release was between themselves, a measure that was silently but totally acknowledged.

Naturally, boys could pay for sex in whorehouses or on the street, especially around the old market called the Mercato Vecchio. Alleys at night often saw prostitutes lined up against walls while the boys humped them through the drop fronts of their skin-tight trousers, drop fronts attached by ribbons that could be rapidly untied.

As a banker Cosimo needed papal business due to the prestige that affiliation with the church represented to the world. He therefore cultivated certain men whom he felt might become pope (in the same way he had cultivated the Condottiere Francesco Sforza who eventually became duke of Milan and an enormously important ally). One such man was Parentucelli, a bookworm about whom it was said that anything he did not know was beyond human understanding. Cosimo lent him vast sums of money to buy

manuscripts. When Parentucelli became Pope Nicholas V Cosimo helped him found the Vatican Library modeled after Cosimo's own. After Pope Nicholas came Pope Pius II, said to have been the Vatican's first humanist. He nonetheless loved wine, women and honors, all of which Cosimo provided him when he came to Florence. Pius tried to suppress a book he had written as a youth, *The Tale of Two Lovers*, supposedly full of erotic imagery, but through my twenty-first century eyes I see nothing sensual enough to offer the reader. The suppression of the book failed and it was a Renaissance best seller.

Another artist in Cosimo's service was Fra' Filippo Lippi. Headstrong and uncontrollable, his aunt placed him in a monastery when he was fifteen, where he later took his vows. When he discovered that he had a natural gift for drawing, he made his way to Padua to study art. A womanizer who fathered at least one known son, he was forced to flee to Ancona where, out sailing, he was captured by Moors and sold into slavery in Africa. Although human portraits were forbidden by Muslims, he drew the local caliph who was nonetheless so impressed that he freed him. Through the vagaries of life Lippi found himself in Florence working for Cosimo, but his taste for drink, women and bar fighting kept him from his art. In response, Cosimo had him locked in his studio where he ate and slept. He escaped and was found weeks later drunk and whoring. Cosimo tried a different tactic. He sent him into the country where, even so, Lippi met a nun he made pregnant. Cosimo arranged things through Pius II, the pope known for his erotic literature, who allowed the nun and the artist to marry. But before the marriage took place the nun's family poisoned him, although other sources believe he was poisoned by another mistress because of his continued interest in the nun. In any case, he *was* poisoned and Cosimo's grandson Lorenzo had a monument raised to him, built by Lippi's son who had, by then, become an artist just like his dad, Filippino Lippi.

Cosimo the great humanist died, but not before fathering Piero who in turn fathered the great Lorenzo *Il Magnifico*. The image of Cosimo that I love best is reported by an ambassador who, when he visited him, found him in bed between his two sons, Piero and Giovanni, one old man and two others middle-aged, all three suffering from gout.

Cosimo was succeeded by his son Piero called the Gouty, a disease that attacked the wealthy who could afford meat and rich sauces and who disdained vegetables considered peasant food or animal fodder. The result was the retention of uric acid which crystallized in the joints causing incredible pain. Piero married Lucrezia Tornabuoni, a chance for his son Lorenza, the future *Il Magnifico*, because of her forceful nature and intelligence.

Piero was no banker compared to his father Cosimo. He rarely foreclosed debts and loaned funds to the likes of Edward IV of England who battled for years with Henry VI to see which of them would finally become king, running up horrendous bills and then, following victory, Edward died too young to repay them. Cosimo's squishy-squashy approach made enemies of every class from merchants to the nobility.

Piero attempted to shore up his relations with King Ferrante of Naples by sending Lorenza, superb from the heights of his seventeen years. Lorenzo did more than anticipated, charming the king out of his boots with his youthful candor, intelligence, sparkle and spunk.

In Milan Francesco Sforza died and was replaced by his son Galeazzo Maria Sforza, age twenty-two. Galeazzo had been trained in combat by his father and was therefore feared. When the Duke of Ferrara decided, along with Venice, to take advantage of Piero's weakness as a leader by invading Florentine territory, Galeazzo sent 1,500 troops to Florence's aid. The Duke of Ferrara discovered that, although the citizens of Florence were unsatisfied with Piero, they would not rise up against him as the duke had been led to believe. So he retraced his steps and returned to Ferrara. The Doge of Venice continued on, however, forcing Piero to seek help from not only Naples and Milan, but also from a very feared condottiere, Federico da Montefeltro of Urbino, a city-state on the edge of the Romagna.

Federico da Montefeltro had been trained by Francesco Sforza. A condottiere sent by Venice, the equally feared (but aging) Colleoni, had also proved himself under the direction of Francesco Sforza. Colleoni had, in addition, married Francesco's daughter Battista. Along with Naples, Milan and Urbino, the Florentines themselves rounded up 3,000 soldiers that assembled in the main square of Florence, the Piazza della Signoria, under the direction of the very young Lorenza in full splendid armor. Galeazzo withdrew his forces for reasons he never explained and so it was that the troops of Federico da Montefeltro and the Venetian troops of Bartolommeo Colleoni met in battle, one that ended indecisively even though both sides claimed victory.

Much has been said about Lorenzo's ugliness, a nose so flattened it deformed his voice and destroyed his sense of smell. His hair was straight, his chin jutting, his eyes intelligent and piercing, dark and gentle. It is known that he attracted women who seem to have their own agenda in life's choices. Piero sent his wife Lucrezia to Rome to find a wife for their son. The choice fell on Clarice Orsini, beautiful but scoffed at by Lorenzo's friends behind his back as she was not known for her intelligence. The match was a step up for Lorenzo because the Orsini were nobles well entrenched in the church, many of whom had been cardinals and there had even been one Orsini pope.

Piero, too ill to do so himself, had Lorenzo organize a tournament in celebration of his betrothal, a contest between combatants on horses, armed with lances, aimed at unseating each other. It was said to have cost 8,000 florins while Clarice's dowry had been a modest 2,000 in comparison. There were banners and pennants and Lorenzo himself wore a cloak of white silk lined with scarlet. He rode a white charger given him by Ferrante King of Naples which made--given the back-stabbing tendencies of Italian politics--Galeazzo Maria Sforza green with envy. The wedding banquet lasted three days, with minstrels, tables laden with roast pig and 300 barrels of the best wine. Although Clarice and Lorenzo may never have been intellectually attuned, they were physically, as she gave him ten children. There is little doubt that more went on in Lorenzo's palaces and stables than girl-boy activities, and it is a fact that the laws against male-to-male encounters were relaxed to the point of near nonexistence while Lorenzo controlled Florence. The artists surrounding him--Donatello, da Vinci, Michelangelo--as well as teachers like the Greek and Latin scholar Poliziano, were homosexuals, as were a number of Lorenzo's closest companions.

Italy throughout the ages, as much today as then, is known for its *jeunesse dorée.* Lorenzo had the best education possible, thanks to his grandfather Cosimo who allowed him to participate in the meetings of the Platonic Academy he had founded. His mother was versed in the arts and Lorenzo spent his life collecting the finest manuscripts, paintings, sculptures, coins and jewels--although, again, far less than Cosimo. He loved riding and hunting with falcons, giving full voice to dirty songs that amused his comrades as much as himself. He was not drawn to banking but he had the gift of appointing the right man to do the job in his place. He could be a brilliant conversationalist, an ardent churchgoer, and still slum the nights away in taverns and bordellos, ending the evening in the early hours by serenading the virgin sweetheart of one of his friends--after they had all fulfilled the lustful yearnings of their young flesh. He wrote poems, one of which warned of the ephemeral nature of youth, exhorting himself to make the most of what he had--and he had plenty. Again, then as today: the Italians have always been among the most sensual people on earth, and who could represent the beauty of the era better than the painter Botticelli whose *Primavera* is among the most gorgeous works of the human hand.

Lorenzo was a golden boy, yes, but one who was soon to know adversities that would have brought a lesser man to his knees.

A discussion of the church is necessary to the understanding of the geneses of Alexander VI. For a time the popes reigned in Avignon, a small pleasant town of beautiful fortifications and two beautiful rivers. They moved back to Rome in order not to lose the Papal States, land held from roughly 500 to 1870 when under Victor Emmanuel II Rome was captured

as part of the final unification of Italy. At the time of Alexander VI the papacy held sway over a huge portion of Italy. The territory was expanded under two popes. The first pope was Alexander VI, whose reign saw the sudden rise of the ultimate warlord, his own son Cesare. The second was Julius II, during whose reign Cesare met his equally sudden end. The popes had only partial control over the Papal States, their influence varying according to the strength of the lord or count or prince who held this or that papal property.

Depending on the era and the pope, Rome was a dirty town with few inhabitants when compared to ancient times. Much of it was in ruins, the haunt of thieves and murderers, and pastureland filled with goats and sheep. Bands of youths owned the streets, parading where they would, daggers and swords at the ready, beasts with ever-hungry bellies and ever-lustful loins. Cholera and dysentery left corpses where they expired, and the body parts of quartered victims, the remnants of executions, were hammered to doors or, in the case of heads, brandished on pikes. Smelly swamps and piles of refuse polluted the air, a far cry from sweet Avignon.

Pope Calixtus III was a Spaniard who had been in the service of King Alfonso V of Aragon (who also wore a second hat as Alfonso I of Naples). For vice-chancellor he chose his nephew, Rodrigo Borgia, a cardinal at age twenty-five, a Catalan like Calixtus, and the future Alexander VI.

At the death of Calixtus Rodrigo helped to elected the next pope, Pius II, after the usual conclave during which promises of wealth or important positions, such as vice-chancellor, were bantered about in the conclave latrines, the only private area for secret negotiations. In thanks, Pius kept Rodrigo on as vice-chancellor, the most substantive function after the pope, one in which a man could gain unheard-of wealth by accepting bribes that covered literally every aspect of human congress, especially sexual, from divorce to incest. Pius tried to limit what the historian Johannes Burchard called his "endless virility." Burchard was responsible for the organization of ceremonies under Pope Pius, and thusly in an excellent possession to claim that Rodrigo organized frequent orgies, one of which, known as the Banquet of the Chestnuts, rewarded those men who had the most frequent orgasms or could ejaculate the farthest, with rich gifts.

The next pope was Eugenius IV, quickly followed by Sixtus IV who kept Rodrigo on as vice-chancellor, again thanks to his work in assuring the pope's election. Rodrigo extended his palace and enriched its furnishings and his clothes. Sixtus awarded him with bishoprics and abbeys, sources of more wealth still. During this period Rodrigo returned to Spain for an extended visit. On his way back his ship was wrecked off the coast of Tuscany and he was taken to Pisa to recover from his close call with death. There, at a banquet in his honor, he met Vannozza de' Catanei, the mother of his future children. In very quick succession she gave him Cesare, Juan,

Lucrezia, Jofrè and Otaviano. In return, Rodrigo gave Vannozza a series of complaisant husbands and great wealth. These six were, however, only part of the brood he fathered with other acquaintances.

When Cesare was eight, Rodrigo moved all of his children to the home of his Spanish cousin Adriana da Mila, more qualified to raise them as she was of noble birth and would instruct them in the ways of the aristocracy. Adriana's son married a beautiful girl known as La Bella whom Rodrigo immediately took as his mistress.

The next pope, Innocent VIII, was known as the Rabbit for his lack of authority. Bands of youths, armed with daggers and swords, ruled the streets of Rome, stealing, raping and murdering to such an extent that the cardinals were forced to place guards with crossbows and artillery at their windows and on the roofs of their palaces. The new pope soon fell ill and died, but not before making Lorenzo *Il Magnifico*'s son Giovanni, age thirteen, a cardinal, a cardinal who would one day become Pope Leo X. The cardinals who came to the Vatican to replace Innocent VII met in conclave, now decided to elect a strong pope who would bring order to Rome.

Following the usual bargaining, during which wagonloads of gold, silver, jewels and precious furnishings and tissues were loaded at the Borgia palace and unloaded at the residences of nearly all of the cardinals (a few were said to have refused the bribes), Rodrigo Borgia became Pope Alexander VI. The truth of the bribes will never be known, and anyway, those who ran against him for pope were at least equally wealthy and equally inclined to bribe whomever they could.

He *was* virile, producing many legitimatized children (as well as being the first pope to ever recognize his bastards) on his main mistress, Vannozza de' Catanei, of whom two were to become world famous, a daughter, Lucrezia, *un véritable four à bites*, as the French say, and a son, Cesare, a veritable--although extremely evil--warrior. He had at least four others he did not recognize officially, but all his offspring and mistresses were abundantly cared for. Alexander was sensual, fun loving, certainly good to his children, a sugar-daddy papa, extremely tolerant, ruthless, courageous, and an administrator of genius.

He and his children spoke Spanish when together, but they all knew Italian, French and Latin. Cesare was destined for the orders, a destiny he hated as he hated his brother Juan who was marked for a military career, one Juan loved but was not good at--or at least not as good as Cesare would show himself to be. Juan was clearly Alexander's favorite, another supposed reason for Cesare's hatred. As virile as his father, slim waisted and certain of his sex appeal, Juan swaggered through the streets of Rome in what can only be described as gorgeous attire, a cloak of gold brocade, jewel-encrusted waistcoats and silk shirts, skin-tight trousers with drop fronts--cloth attached by ribbons that would free a man's loins when he

wished to piss. This beautiful, gorgeously clad body, with 30 golden ducats still in his belt purse, was fished up from the Tiber, to the grief-stricken horror of his father who locked himself away from public view for three days. The death freed the way for Cesare to renounce his vows, having been made cardinal at age 18. Alexander never confronted his son with the murder of his favorite boy, but that he was guilty was silently acknowledged by nearly all. On the morning of the murder, just before sunrise, men were seen leading a horse with a body strapped over its back to the river edge, untie and then caste it into the middle. They were accompanied by another man on a white charger, his gold spurs reflecting the moon's glow. The men, said the witness, spoke in very low voices ... in Spanish. So it was Cesare ... unless ... unless, thought some, it was his other brother, Jofrè.

It's not clear at exactly what age Jofrè married but he was thought to be 12 and his wife Sancia 16. As puberty was far later in the Renaissance than today (around ages 15 or 16 then) he was unwilling to consummate the union. His brothers took over the task for him, however, an experience that was not necessarily grueling for the young girl as she was rumored to have had many lovers before arriving in Rome. At any rate, some historians place their bet on Jofrè as his brother's assassin, out of jealously. Jofrè played only a minor role in the uncoiling events attached to the Borgias. At Alexander's death he was made Prince of Squillace, a vassal town of Naples where he lived until he died, having produced four children of his own.

Charles VIII entered Italy on his way to occupy Naples. His stopover in Rome was the first test of Alexander's exceptional intelligence. Alexander withdrew to Castel Sant'Angelo with all his possessions, including his bed. Romans fled to the countryside. Charles tried to calm the Romans by telling them that his men wouldn't take an egg without paying for it. So numerous were Charles' men that they took six hours to file through the gate of Santa Maria del Popolo. They may not have stolen a single egg, but they stole everything else that hadn't been battened down, reportedly cutting off finders when rings refused to budge. They raped any woman silly enough to have not already fled the city. They killed as well, especially the Jews. Alexander finally agreed to a meeting that took place in the papal palace. Charles is reported to have rushed to him and was prevented from a third genuflection by the pope who stopped him in mid-kneeling, giving him the kiss of peace on the lips. As Charles and his troops had brought syphilis, the kiss could not have been hygienic.

Syphilis may have been brought to Europe by Christopher Columbus but this seems questionable as Columbus discovered the Americas in 1492 and the first cases of the disease were recorded in 1494 in Naples during Charles' invasion. How it could have spread so rapidly is one question, another question is why it wasn't present before Charles entered Naples,

present in Paris for example. (At that time it was known, in French, as *le mal de Napoli*.) At any rate Charles had it and soon Cesare would be disfigured by its terrible scarification. Luckily for Charles, back in Paris he would knock his head against a doorframe and fall into a fatal coma two years later, at age 28--thus sparing him of the ravages of the disease. But for the moment he's kissing the pope. Charles, despite his extreme ugliness, had at least two different women a day, and in his baggage he carried a book of pornographic sketches and paintings of intercourse he had had with a few select beauties. Alexander successfully bypassed Charles' request that he recognize his claim to Naples, but the French king did insist on having Cesare as a traveling and hunting companion--a hostage to make certain that the pope kept his troops in their barracks. Alfonso II of Naples abdicated in favor of his son Ferrante II who fled Naples, leaving the city wide open for Charles. On the way there Cesare hung back on his horse and then took French leave, leaving the king beside himself with fury.

Alexander had given Lucrezia Giovanni Sforza for husband, but discovering that the boy was a spy for Milan, Alexander decided to annul the marriage in favor of Alfonso of Aragon who was a member of the royal family of Naples and also Sancia's brother. After the slaying of Juan, Giovanni feared that Cesare would kill him too in order to further the ties between the Borgia and Naples. So he easily gave in, especially when he was told that he didn't have to reimburse Lucrezia's dowry of 31,000 ducats. He nonetheless spread the rumor that Alexander wanted the annulment so he could have Lucrezia for himself, and he bruited that he knew for a fact that Cesare had enjoyed his sister on many occasions. When Alexander informed him that he would have to sign a statement saying that he was impotent, he answered that he had had Lucrezia a thousand times (about six month's work for a boy of Giovanni's stamina). As an additional proof of her innocence, Lucrezia was examined and found to be *vergo intacta*. In reality, she was six months pregnant and would give birth to a stillborn child, the first of many such disappointments to follow.

The boy responsible for her pregnancy was a handsome Spanish valet, Pedro Calderon. In a frenzy of rage Cesare chased him through the palace until the lad sought shelter within the robes of Alexander VI himself. The pope tried to protect him but Cesare slashed at the boy through the robes, literally cutting him to pieces. The body was caste into the Tiber.

Alfonso and Lucrezia married and the wedding was consummated.

After the death of Cosimo his son Piero oversaw affairs in Florence, thusly establishing the reality of Medici control over the Florentine city-state. But as he was weak in mind and body, that control nearly ended with him. The city-state of Ferrara, to the north of the Romagna, sent troops to take over Florentine territory, as did the Doge of Venice under the generalship of the condottiere Bartolommeo Colleoni. Florence requested

the help of the condottiere of Urbino Federico da Montefeltro. Once the Duke of Ferrara learned that the Florentines would not rise up against Piero as the duke had been assured, he withdrew to Ferrara. The battle between Venice and Urbino ended in a draw.

Galeazzo Maria Sforza was thought to be a psychopath who didn't hesitate to tear off a man's limbs with his own hands or rape a woman, noble or not. His sexual appetite was hard to appease but once his lust fulfilled, the woman was handed to his entourage for their needs. He detested poachers, strangling one to death on a rabbit pushed down his throat and another was nailed inside a coffin and then buried alive. A priest who predicted Galeazzo would have a short life was starved to death. Galeazzo was finally brought down by three conspirators, one of whom was a very young man named Girolamo Olgiati who, thanks to Galeazzo's library to which the duke gave him access, was able to read the lives of Brutus and Cassius and how they tried to bring republicanism back to Rome through the assassination of Caesar (a perfect example of how the ancient texts formed the Renaissance mind). That was his ideal for Milan. A second conspirator, known only as Lampugnano, had obscure motives concerning land deals. The third conspirator was Carlo Visconti whose sister had been dishonored by the duke, a motive of importance today but at the time everyone was throwing his daughter or wife at Galeazzo in hopes of gaining profit. They met in church. Who struck first is in question, but the version I prefer has Visconti (the boy whose sister was raped) on his knees as if requesting a favor as the duke walked down the nave. When Galeazzo paused to listen to him, Visconti plunged his dagger into the duke's genitals. The other men followed suit. Galeazzo, at age 32, was dead before he hit the ground. The three assassins, certain of public support, did not bother to hide. Instead of thanking them, the citizens of Milan killed Lampugnano instantly and then dragged his body through the streets; the other two were caught later by Galeazzo's guard and their genitals were cut off and stuffed into their mouths before they were disemboweled, quartered and decapitated. As he was dying one of the three is reported to have shouted out, "Death is perhaps terrible, but honor and glory are eternal!" Which may be true as I'm retelling the story *500 years* after the event.

Bartolommeo Colleoni, mentioned above, was a Renaissance exception to all of this violence. He was not known for treachery and he didn't rape, nor did he kill without reason. He tended to the vast lands the Venetians accorded him when not leading Venetian armies. He left his fortune to his army and funds to finance an equestrian statue in his honor.

By far the most impressive condottiere of the period was Federico da Montefeltro (already briefly mentioned). He was a Renaissance man, the possessor of a truly wonderful study done in *trompe-l'oeil*. He's thought to have killed his stepbrother Oddantonio, made easy by the population of

Urbino who were unhappy with his reign. Federico took his place as count. He inspired loyalty among his men, sharing his gains as condottiere with them. Because his fees were high, he was able to enrich Urbino. He had surgeons remove part of his nose so that he could see with the eye remaining him, the other having been lost in a tournament. He fought for Florence, for Milan, for Naples and then against Florence before the Treaty of Lodi brought peace to the three city-states. The Treaty ended quarrels concerning the boundaries between the belligerents and confirmed the position of each duke, prince, count, doge or what have you as the head of his particular city. It was not only signed by the three city-states, but also by Venice and the Papal States. The Treaty came to an end with the invasion of Charles VIII on France. After the death of Francesco Sforza, Montefeltro assisted Francesco's son Galeazzo Maria Sforza in governing Milan.

At the death of Piero, Lorenzo was asked by the city nobility to take his place, which he did at age twenty, bowing modestly before the aged men standing before him. His first guest to his palace was Galeazzo Maria Sforza, accompanied by his soon-to-be-famous daughter, Caterina. Unknown to the nobles who requested his leadership, Lorenzo, fearing that he would be brushed aside as being too young and inexperienced, had sent messages to Galeazzo requesting troops, should he be forced to take power through arms. Galeazzo answered by putting a thousand men on the road to Florence. To thank him, Lorenzo put at Galeazzo's disposal every culinary, artistic and erotic pleasure at his disposal. Galeazzo returned to Milan decided to rebuild the city and stock it with art along the lines of Florence. Italy being Italy, Ferrante, King of Naples, became jealous of Lorenzo's influence over Galeazzo. This was Caterina's first visit to Florence, the city in which she would turn to Christ when too old to receive lovers, the city in which she would die.

Lorenzo met with the new pope, Sixtus IV, and is said to have impressed the old man by his youthful vigor, although not enough so that Sixtus would give Lorenzo's brother Giuliano a cardinal's hat (Sixtus did, however, give six hats to his six nephews). Sixtus compensated by giving Lorenzo a splendid head of Augustus to the fury of Galeazzo he wanted it. Galeazzo was becoming less sane each day and, luckily for all, he was soon assassination.

Young Lorenzo's first military sortie was against nearby Volterra that was under Florentine influence, the cause of which was a dispute over trade dues owed Florence. Lorenzo chose the famous Federico da Montefeltro to take the city, which he did, losing, alas, control over his soldiers who sacked, raped and killed hundreds. Lorenzo went to the town to offer his excuses and make amends by handing out money. Lorenzo knew it was a

situation that his grandfather and father would have defused before an eventual massacre.

Sixtus IV, who had found Lorenzo to be a darling boy, asked him, as head of the Medici banking system, for a loan of 40,000 florins in order to buy Imola. Sixtus wanted Imola as a gift to his son Girolamo Riario, whom the pope passed off as one of his numberous nephews. Because the pope already owed 10,000 florins to the Medici bank, Lorenzo hesitated, a hesitation that would cost him plenty. The pope, apoplectic, turned to the Pazzi, bankers who immediately agreed. The Pazzi were an old family with money that went way back. The manager of the Rome branch of the Pazzi bank, Francesco de' Pazzi, hated Lorenzo whom he found arrogant and far too rich for a parvenu. He hatched a plan to assassinate both Lorenzo and his brother Giuliano. For this he turned to Girolamo Riario, now lord of Imola, and Francesco Salviati, an enemy of the Medici, whom Lorenzo had forbidden to cross Florentine territory. Salviati wanted to get to Pisa where Sixtus had named him archbishop and Lorenzo's refusal to let him pass deprived him of huge sums of money. The conspirators went to get Sixtus' permission "to take care of Lorenzo" which the pope gave, although piously adding that he wanted no bloodshed. The conspirators then went to see Jacopo de' Pazzi, the head of the clan, who refused his consent until he was told that the pope himself had blessed the endeavor.

On the day of the planned murders, Easter Sunday, Francesco de' Pazzi went to the Medici palace in search of Giuliano who said he wouldn't be going to church because he felt ill. Giuliano was an exception among the Medici for several reasons. Although older than Lorenzo, he was never offered a position of real power by his brother. He was far handsomer than the younger Lorenzo and liked to think of himself as a woman killer, which made his entourage laugh because he lacked his brother's charm, meaning that his bed was often empty whereas Lorenzo's never lacked for company. In addition, the youths laughed behind his back because when he did find someone, far from being the heartless enslaver of women's hearts he said he was, he would fall head over heels in love, love that invariably ended with *his* heart broken. Francesco de' Pazzi was accompanied to Lorenzo's palace to fetch Giuliano by Bernardo Baroncelli, a banker and friend of both Francesco and the Medici. They persuaded Giuliano to go to church, giving him a friendly manly hug when he consented--in order to find out if he were wearing armor under his cloak.

In the cathedral Giuliano was separated from Lorenzo by a few yards. Sometime during the High Mass, thanks to a predecided signal, Baroncelli struck Giuliano with his dagger that pierced his brain. Francesco followed with more blows, twenty all together. Giuliano was dead before he hit the marble floor. Nearby two priests attached Lorenzo, one of whom nicked his neck with a dagger, but Lorenzo whipped off his cloak and held it up as

protection, his sword already in his hand. As friends came to Lorenzo's aid, the attackers fled. One friend risked his life by sucking the blood oozing from Lorenzo's wound, afraid the dagger had been poisoned. Lorenzo ran to his palace, perhaps believing that his brother, whom he had not seen fall, had already returned there.

The second act of the drama took place at the Palazzo della Signoria, the Florentine Town Hall, a wonderful crenellated tower that overlooks the Piazza della Signoria and the God-inspired statue of Michelangelo's *David*. Here Salviati, the man Lorenzo had forbidden to cross Florentine land so that he could take up his position as archbishop of Pisa, led a pack of thirty mercenaries. Due to the archbishop's renown, he was allowed to enter the Palazzo della Signoria but due to his incredible nervousness the guards felt that something was terribly amiss. The archbishop was separated from his men who were invited into a nearby chamber that one the guards immediately locked. Government officials sounded the alarm, bells that tolled in emergencies, the ringing of which automatically set in motion the ringing of other bells in other churches surrounding Florence, until the entire countryside knew that something was wrong and, in response, sent armed men to the Piazza della Signoria. The moment the guards at the Palazzo found out what had happened, they killed the thirty followers of Salviati, throwing them from the windows of the crenellated tower. Francesco was found at his palace, badly wounded by a knife blow he had inflicted on himself while stabbing Giuliano. He was taken naked to the Palazzo and hung by the neck from an upper window. Archbishop Salviati himself was flung from the same window, in full vestments. Eerily, he sunk his teeth into Francesco, perhaps in revenge for getting him into such a mess, perhaps to ease the noose around his neck, perhaps due to an involuntary convulsion.

The fifty-seven-year-old Jacopo ran for his life into the country where he was recognized by peasants, arrested, sent to a dungeon and tortured. He was then taken to the Palazzo della Signoria from whose tower he too was hurtled, dressed only in his drawers. His body was cut down and pulled through the streets of Florence by boys beating it with sticks before being nailed to the door of his palace against which they banged his head, yelling out "Open up, the master is back!" Other deaths followed, more than a hundred in all as plotters and believed plotters were hounded down.

Sixtus, sick with rage that an archbishop had been hung by the neck in his ceremonial robes, excommunicated all of Florence when the citizens refused to turn over Lorenzo to a papal court. The pope declared war on the city-state and turned to Lorenzo's dear friend, King Ferrante of Naples, for troops which the king provided. The pope named Montefeltro, Duke of Urbino, to head the forces. Now old, the duke proved far less valorous than in times gone by. In the meantime, excommunication had put Florence in

the position of a leper, cold-shouldered by its neighbors. Bands of armed youths descended on the city, robbing and raping and depriving it of food. Last rites couldn't be given and the dead couldn't be buried. Lorenzo, seeing that something extraordinary had to be done, took a ship from Pisa to Naples to appeal directly to his former friend Ferrante, a courageous move as Ferrante was as liable to cut off his head as to kiss him. Before leaving Florence Lorenzo had mortgaged his castles and palaces to raise money, money he now spent like water on making gifts to the Neapolitans, on lavish festivals and on charities. It's said, though, that although he laughed at the side of Ferrante during the day, he was in despair at night. Finally Ferrante, faced again with French desires to take Naples on the one hand and, on the other hand, confronted with Turkish ships that were approaching, freed the young man. Also thanks to the Turks, Sextus decided that he needed Florence at his side in his attempt to mount a crusade against them. He lifted the excommunication.

Lorenzo allowed the dissident monk, Savonarola, to preach in Florence where he predicted the imminent death of three dictators, Innocent VIII, Ferrante of Naples and Lorenzo himself. Both Innocent and Lorenzo died in 1492 and Ferrante, at age seventy, in 1494. Lorenzo died relatively young from complications probably due to family gout. He turned over the reins to his son Piero who immediately tried to shore up relations with Ludovico Sforza of Milan who had succeeded Galeazzo Maria Sforza. Ludovico was known to be devious and unpredictable. He had taken a liking to Lorenzo but Piero lacked his father's charm. Ludovico was in fact a regent for Galeazzo's son Gian Galeazzo, but once he'd gained power Ludovico kept it, a fait accompli accepted by Gian Galeazzo who preferred hunting and was considered intellectually stunted. But Gian's wife was Isabella, granddaughter of King Ferrante of Naples. Ferrante sent troops to take over Milan, forcing Ludovico to request the intervention of Charles VIII of France who considered himself the rightful possessor of Naples.

Two years after Lorenzo's death Charles entered Italy at the head of 60,000 soldiers and camp followers, the greatest invasion since Hannibal. His troops, many of whom were mercenaries, were heat-tempered professions, armed with cannons and the morality of beasts. They plundered, raped and murdered their way south. Charles was quite naturally well received in Milan where, under his influence, Ludovico had Gian Galeazzo poisoned, although he spread the word that the young man had died from an excess of coitus. (Perhaps Ludovico had Charles in mind when he made the accusation against Gian Galeazzo for excessive screwing, as the French King had several women throughout the day, and never ever the same one twice, this despite the fact that he was deemed the ugliest man alive.) Alfonso II, who had replaced Ferrante in Naples, fled the city-state. In order to protect Florence from the surge of Charles' barbarians, Piero

decided to copy his father Lorenzo by going to meet Charles personally, as Lorenzo had gone to meet with Ferrante of Naples. Alas, Piero was no *Il Magnifico* and Charles, treating him with open disdain, sent him home like a boy. At home the Signoria blamed him for all of Florence's troubles and banished him and his family, bringing down the curtain on the Medici.

In response to the terrible ravages caused by the French, the Italians finally unified in an anti-French coalition sponsored by Pope Alexander VI, noted for his courage. Venetians and Ludovico of Milan took part. Charles was forced to retreat, although in various battles the anti-French coalition lost a reported 2,000 men to every 1,000 lost by Charles. The coalition hounded the retreating French army like wolves, attacking its baggage train until nothing remained to Charles of the tons of gold, jewels and other loot he had amassed. Just a little more than two years later Charles, on his way to a tennis match, struck his head on the lintel of a door and hemorrhaged to death. His successor, Louis XII, decided to follow up an ancient French claim to Milan by launching an attack on the city-state. Ludovico was captured by Louis and imprisoned in an underground dungeon until his death.

Savonarola had welcomed Charles with open arms to Florance, claiming that he had asked God to send the Frenchman as an arm to punish the evildoers in Italy in general, and Florence in particular. When Savonarola had first come to Florence he had gained a huge following because he had had the right answers to how Florentines could wage war against corruption, brigands and iniquity. He painted a clear picture of the depravity of the church, from the trade of indulgences to the selling of cardinal hats. He was the precursor of the coming Reformation, and because he was ahead of his time he was burned at the stake--the word of the true God gone up in flames.

That was not all that went up in flames. Ignorance and superstition took a huge hit when Ferdinand Magellan's crew circumnavigated the world, proving it was not flat. The forces that push some men to do what they do are truly mindboggling, and both Alexander VI and Magellan possessed those forces. In 1494 Alexander VI divided the world in two parts, West of a line that divided the Atlantic down the middle went to Spain, the East went to Portugal. Alexander got the king of Spain to agree to the division and, while he was at it, he gave King Ferdinand and Queen Isabella permission to initiate the Inquisition and rid Spain of Jews and Moors (it must be remembered that Alexander, a Borgia, was himself Spanish). Magellan was a totally fearless warrior, many times wounded in battles against the Arabs. Magellan set out from Seville to discover a route to the Spice Islands, the source of spices that, at the time, far outweighed gold in value. He was given five ships--all totally black due to the pitch that covered even the masts--and 260 sailors, for the most part illiterate scum

who thought only of their stomachs and scrotums. They sailed first to the Canary Islands and then to Brazil. During the trip a sailor was caught sodomizing a page. Pages, aged eight to fifteen, were shanghaied to do the menial jobs onboard. The general rule at sea was simply to look away when one was caught in a sex act, the norm being that sailors, in their teens and twenties, took care of each other's carnal needs. For some unknown reason Magellan took offense now, perhaps because the boy was very young. The sailor was garroted (a rope encircled his throat and a stick--called garrote in Spanish--was introduced between the neck and rope and turned until the man was strangled to death). What happened to the lad is unclear. Either he jumped overboard or was thrown; at any rate, he too died. On the coast of Brazil the sailors enjoyed accepted sex with native women, the price being a nail or any other metal object. The crewmembers were careful not to venture far from the ships, as they knew that the natives practiced cannibalism and human sacrifices. The men suffered terribly from heat in summer, as well as from rats and mice that left feces and urine in their food, and lice, bedbugs and cockroaches.

The Straits of Magellan were called, at the time, the Dragon's Tail due to their incredible complexity. To find the passage Magellan had to investigate countless dead ends. Then winter set in. At this latitude winters were terrible: blizzards, storms, howling winds and cold so intense it was a wonder any of them survived. Magellan put the crew on half rations and because no one really believed that a passage existed and because Magellan was inflexible and unfeeling, mutiny was in the air. The first mutiny was foiled because a few crew members, loyal to Magellan, managed to trick the mutiny leader into thinking they were on his side, giving them the opportunity to grab him by the beard and plunge a dagger into both his throat and head. A priest who had taken part in the revolt was abandoned, in the snow, on an island. Other traitors were mercilessly beaten but not killed as they were needed to run the ships. A few days later, under the cover of night, another ship mutinied by setting a course back to Spain. During my research I discovered an incredible quirk that existed at the time. Saints were listed as being veritable members of the crew! For example, Santo Antonio because he was known to rescue ships; Santa Barbara because she calmed storms. More incredible still, they received a percentage of the profits when the ships returned to port, profits that were turned over to the church.

When Magellan exited the straits he is said to have cried for joy. He was now in the Pacific, a stretch of water, in his mind, less in width than the Atlantic. He would discover that, in reality, it covered half the world, and he was already nearly out of food. Thanks to the Trade Winds, they made it to Guam three months later, although many men were dead from scurvy. They reached Cebu several months after that. Here Magellan became blood

brothers with the Prince, both of whom mingled their blood in a bowl mixed with wine that they drank. Ravishing young girls were offered, virgins who had their vaginas enlarged from birth in order to accommodate men who inserted gold bolts through their penises, just under the glans. The tube of the bolts had a hole through which urine passed. The bolted penises were difficult to insert and they didn't allow rapid movements, meaning that intercourse lasted a very long time, even an entire day, and the men could pull out only when soft. The women claimed the bolts gave them ultimate pleasure.

So friendly was Magellan with the Prince that he offered to wage the Prince's battles for him, certain of his superiority thanks to firearms. All the Prince had to do was convert to Christianity, which he did, along with 2,500 of his subjects. Magellan went after those who didn't, so numerous that their poisoned arrows and spears, aimed at the crew's unarmored legs, proved fatal to Magellan and many others.

One ship made it back to Spain, three years after having left, its sails and rigging rotting. Of the original 260 only 18 had survived, among them the ship's greatest treasure, Antonio Pigafetta, an historian who gave us such a detailed account of the voyage that books, based on his observations, have been published, from the time of his arrival to our own day.

Caterina Sforza now enters our story. That she was illegitimate was of no consequence in the Italy of the Renaissance. In that, Italy was totally exceptional. Not only was Caterina treated with the same love as her legitimate brothers and sister, she was offered the same education as the boys in the palace, unlike what girls were offered in most other parts of the country. In addition to a superb education, she learned to handle arms, to ride and to hunt. She was a Sforza, born into a family of warriors that dated back to Francisco Sforza, her grandfather. She was thusly the daughter of Francisco Sforza's son, Galeazzo Maria Sforza, whom she adored, and the mother she loved, Lucrezia Landriani. Caterina was destined to be married three times and through each of them she would proudly wear the Sforza name, Sforza meaning ''force'' in Italian. Her love for her father continued untainted even when, at age ten, she was betrothed to Girolamo Riario, count of Imola, who insisted on deflowering her despite the tradition that the girls should be at least fourteen. Girolamo had been offered another girl, age eleven, but her family backed out as soon as they learned of Girolamo's pedophilic tendencies. Girolamo was continuously described at depraved by contemporary historians without further details-- although the reason may simply be his taste for virgins and a huge capacity for women in general. Caterina's wedding night may have been rough (as her father certainly knew it would be), but thereafter she was known for her numerous sexual encounters and her attraction to especially handsome lads, one of whom, a stable boy, she raised to lord of Forlì after her

husband Girolamo's death. She would eventually present Girolamo with six sons and a daughter.

Girolamo was the son of a shoemaker whose good luck was to have Pope Sixtus, known for his nepotism, for uncle. Thanks to Sixtus IV Caterina became countess of Imola.

Girolamo Riario hated the Medici with every bone in his body because they had always been obstacles in every adventure initiated by the Riario. He therefore tried to assassinate Lorenzo *Il Magnifico* and his brother Giuliano, as we've seen. Girolamo would become known for his cowardliness in battle, and here too, in the attempt on Lorenzo's life, he was not to be found in the heat of things. Only the confessions of the perpetrators made it clear to all of Italy the essential role that was his in the plot. He fell into public disgrace, he infuriated his uncle Pope Sixtus, and he became the object of jokes concerning his bravery and competence. Caterina, at age sixteen, was thought to have lost trust in him.

In rapid succession she had two sons, Ottaviano, whose godfather was none other than Cardinal Roderigo Borgia, and Cesare, named after the great Roman, he who crossed the Ribicon, a river just a short distance from Forlì.

Between Imola and Forlì was the city-state of Faenza, home of the Manfredi and birthplace of Astorre Manfredi, said to be the most beautiful boy in Italy. Imola, Forlì and Faenza were part of the Papal States, territories under the sovereign rule of the pope, and represented his temporal power on earth. Popes had only partial control over the States, some of which were under the command of one prince or another. The hold over Faenza by the Manfredi was backed by the Este family of Ferrara, a country to the north of Faenza, too powerful for the current pope to bring into the Papal States. The power in Forlì, on the other hand, had gone from despot to pope and back again for centuries. At the moment it was in the hands of the Ordelaffi.

Antonio Ordelaffi had come to power in Forlì thanks to Venice. Forlì was a well-fortified city surrounded by walls and surmounted by the nearby fortress of Ravaldino that controlled passage between the north and south of Italy, as well as roads entering the Apennines. The city was passed on to Antonio's son Francesco who was murdered by his brother Pino. Pino failed to take Machiavelli's advice in such cases, he exiled Francesco's small sons instead of strangling them as did the Turks their brothers and brothers' sons. He then went on to poison his wife whom he suspected of infidelity. As she had been born in neighboring Faenza, he gained the enmity of the Manfredi. The next to be poisoned was his second wife and his second wife's mother, both from Imola, gaining him the hatred of the Imolesi. His third bride, Lucrezia Mirandola, was said to carefully watch what she ate. He had no children from any of his wives but did produce a

bastard whom he named to succeed him when he fell ill. So hated was he by even his own Forlivesi that he was pulled from his bed still breathing and dragged through the city streets, spat upon and kicked until he was unrecognizable.

His wife Lucrezia became regent for Pino's son but Francesco's boys, now youths, returned to take power. They easily took the city but not the adjoining fortress, Ravaldino, a fortress that would play an important part, later, in the story of Caterina Riario Sforza de' Medici herself. It was within Ravaldino that Lucrezia and her son took refuge. But the boy mysteriously died, giving Pope Sixtus IV the excuse he needed to send in Caterina's husband Girolamo. Girolamo's army chased the three youths from Forlì and now both Forlì and Imola belonged to him and Caterina, count and countess, but not the fortress of Ravaldino. Because it was unbreachable, Pope Sixus offered Lucrezia 139,000 ducats and a new castle if she would leave, which she gladly did.

Caterina and Girolamo visited their new acquisition, a backwater in comparison to Rome (which was, compared to Florence, a slum). The inhabitants were awed by the noble dress of the royal couple, their beautiful horses, the trumpets, flags, banners and pennants.

Now all the count needed was the city-state lying between Forlì and Imola: Faenza. Famous for its ceramics (faience, ergo the name Faenza) and bricks (from which Ravaldino was constructed), it was a land of vineyards and fertile valleys. At the moment Faenza was ruled by Galeotto Manfredi who had the support of his neighbor to the north, Ferrara, ruled by Ercole d'Este. Galeotto's wife was also the daughter of the lord of Bologna. Although Ferrara was powerful and Ercole a condottiere, the powers of the region were clearly Milan, Florence, Venice and Bologna. Ercole was hated by the pope and by Girolamo because of his support of Florence and Lorenzo *Il Magnifico*. As Lorenzo would have been glad to stick a dagger into Girolamo's throat because of his role in Lorenzo's brother's death, Galeotto Manfredi benefited from extremely serious assistance. Girolamo and his only support, Sixtus IV, had to renounce, for the time being, the seizure of Faenza.

To change air, Caterina decided to visit her mother, sister and relatives in Milan. There, to her stupefaction, she found a city in full bloom thanks to Ludovico Sforza who, against all preconceived notions, had opened Milan to engineers, architects and artists. In fact, the city was being rebuild from the foundations up. The most famous Sforza acquisition was the young Leonardo da Vince whom everyone found gorgeous--slim, strong, physically powerful and possessing cascades of hair flowing around his beautiful face. Caterina anticipated a close relationship by offering the boy a commission to do her portrait. Alas for her, this boy preferred other boys.

Back home in Forlì, Caterina became more and more aware of her husband's unpopularity. Then things boiled over, and what Caterina had expected finally happened. One of the noble clans, the Orsi, had had enough of Girolamo. As close friends of his, they were allowed to enter the palace early one afternoon while Girolamo was resting, and knifed him. Girolamo was able to raise himself and attempted to get to Caterina's rooms but the Orsi brothers kept slashing with daggers until he lay in a pool of his own blood. The body was thrown over the balcony into the piazza where Forlivesi examined the mangled remains and bloody face. At first fearful, they turned on it once they knew the tyrant was truly dead. He was kicked, spat upon and beaten. The Forlivesi then sacked the palace, taking away everything, down to the bedding. The Orsi ran to Caterina's apartments where she was entertaining her mother, sister and children. The children broke into terrified sobs, only Girolamo's bastard son, Scipione, age fourteen, faced the attackers with bravado. They were all locked in but luckily Caterina was able to get a message out to Naples and Bologna, as well as to the new pope, Innocent VIII in Rome. Bishop Savelli, who happened to be touring the region, entered Forlì the next day and immediately, on learning what was going on, went to make sure that nothing had happened to Caterina and her children. As the population knew that she could count on the huge armies of both Milan and Bologna, neither it nor the Orsi dared harm her. In addition, the mighty fortification of Ravaldino was in the hands of a man loyal to the countess.

Whether Bishop Savelli was in league with Caterina or not is unknown. What is known is that he accompanied her to the fortification of Ravaldino that she promised to hand over to the Orsi. The keeper, in league with her, said he would do so if she would pay his back wages and ensure his future employment there or elsewhere. When she agreed, he said she would have to enter the fortification and give him what he wanted in writing. The Orsi rejected the idea until Bishop Savelli vouched for her integrity. She entered Ravaldino, the door closed behind her, she mounted the steps to the top of the tower where she gave the Orsi--the finger.

The Orsi, outraged, went back to the palace where they fetched her son Ottaviano, age nine. He was brought back before the walls of Ravaldino and a dagger was placed against the lad's throat, the worst possible nightmare for a mother. The child was obliged to cry out for mercy, alerting Caterina to his presence. She returned to the top of the tower and stared down at the Orsi, their troops and the town people who had desecrated the body of her husband and ransacked her palace. She felt she had little to fear as they were all deathly afraid of the consequences of their acts. Spies had already returned to Forlì to inform them that troops from Bologna and Milan were on their way, and they all knew too that the new pope would never accept that even a hair of any of the children be harmed.

Accordingly, Caterina hollered out the words that have made her famous to this day. She told them all that they could do what they would with her children as she was pregnant again and with *this*, she added, pointing to her loins, she could produce many others.

Caterina's stance at Ravaldino had a highly unforeseeable consequence. Antonio Maria Ordelaffi, whose family Girolamo had chased from Forlì when he took power, had two messages sent to Caterina by arrows shot over the walls of Ravaldino, both suggesting that she and he marry. As the boy was young and handsome, he would soon gain access to her. But for the moment, 12,000 Milanese soldiers arrived to save Caterina. The troops were prepared for battle and for the inevitable sacking of Forlì, their reward. Seeing them, the Orsi brothers hurried to put their threat in action before being forced to flee: they went to kill the Girolamo children. Happily, the children had been hidden away by Bishop Savelli, whose presence had truly been a godsend. The Forlivesi had a sudden change of heart. They now cried out ''Ottaviano!,'' the name of Girolamo's heir, the boy who had nearly had his throat slit. The lad was brought to them, totally mystified by the events that he had in no way been responsible for, and was paraded around the main square of the city three times, symbolizing that he was now accepted as the new lord of Forlì.

When Caterina had regained control, she coolly dismissed the thousands of soldiers who had come to her recue and were waiting to enter and ransack the city. Soldiers always earned part of their pay thusly, an accepted practice recognized by everyone. But Caterina told them, with mind-boggling dispassion and courage, that as the Forlì had stolen everything she possessed, what the soldiers would take in sacking the city belonged, in reality, to her. More incredible still, the soldiers let her get away with it. As for the Orsi, they left Forlì in search of asylum elsewhere and historically simply vanished from the face of the earth. They left their father behind, however, who, at age eighty, was dragged from his bed cursing his sons *for not having succeeded*! His palace was torn down and the old man pulled through the streets tied upside down to the back of a horse, his head smashed to a pulp against the cobblestones.

In neighboring Faenza its ruler Galeotto was murdered by his wife. Just being married and having children was normally sufficient for a woman during the Renaissance; a wife's husband's extramarital indiscretions were his business. Women were watched over and chastity belts really existed, especially in Florence, to keep women from unlawful intercourse and from pleasuring themselves. But Francesca Bentivoglio, Galeotto's wife, was an exceptional woman whose father just happened to be the ruler of Bologna. Her rival was a beauty known as the Peacock, whom Galeotto was rumored to have secretly married before meeting Francesca, making him a bigamist. Francesca's father knew about the

affair and tried to get his son-in-law to mend his ways but failed. When Francesca finally discovered the truth, she fled home, certain that Galeotto would poison her. Through the good offices of Lorenzo *Il Magnifico*, she returned to Galeotto, but only to have him assassinated. The murder was slapsticks comedy, with three assassins hiding under the bed and one behind the bedroom door. In the ensuing struggle it was purportedly Francesca who delivered the decisive blow, a dagger plunged into her husband's chest. But before dying Galeotto had done at least one thing right, he had fathered Astorre Manfredi, as I said, the most beautiful boy in Italy.

Antonio Maria Ordelaffi, who was both young and handsome and had gained access to Caterina thanks to the messages shot over the walls of Ravaldino by arrow, immediately offered Francesca his hand in marriage, Bologna being infinitely more desirable than Forlì. Bologna laughed at the offer but decided that with Galeotto dead it was the perfect time for it and Milan to send troops to bring Faenza over to their sides. Lorenzo *Il Magnifico*, although an ally of Milan, didn't want the Milanese to extend their control so far to the south. Lorenzo lacked troops but not intelligence. He spread rumors about Faenza being sacked by the troops from Bologna and Milan, the troops outside of Forlì, the troops that Caterina had prevented from entering her town. They were now ready to descend on Faenza, said Lorenzo, rousing the inhabitants into action. The outcome was chaos that Pope Innocent VIII ended by issuing an edict, in 1488, confirming three-year-old Astorre Manfredi as lord of Faenza and named an eight-member regency of noble citizens to care for the lad and the city-state. The boy had now embarked on the world stage. His mother, Francesca the assassin, remained safely in Bologna. At the same time that little Astorre was made prince of Faenza, the child Ottaviano was confirmed as ruler of Imola and Forlì, under the regency of Caterina.

Humanism played a great part in the education of the young Astorre. It consisted of classical authors, especially Cicero, and included studies in philosophy, history, rhetoric, grammar, mathematics, poetry, music and astronomy. Based on the Greek ideal of a sound mind in a sound body, it included also archery, dance and swimming. There was hunting, which boys took to naturally. Humanists insisted on the genius of man, on morality and on the extraordinary potential of the human mind. Schooling was for rich boys but places were available for poor students of recognized ability. A model education combined the classics with the basics of Christianity. Once a boy developed himself intellectually and physically, he was in the ideal position to become an ideal man, as well as having prepared himself for the best possible afterlife. Latin as well as Tuscan vernacular were in usage. Dante wrote his works in Tuscan Italian, as did the

wonderful Boccaccio. One of Caterina's lovers, Pietro Bembo, helped establish Tuscan Italian as the language of the entire peninsula.

Erasmus was named the Prince of Humanists. Before the arrival of humanism men believed in eternal salvation after death, but philosophers such as Erasmus preached the enrichment of life in the here and now. According to him, the church had to free itself of superstitious and corrupt behavior. It had to drop its pomp, relics and beads used as magical charms. Cults based on saints and indulgences, the purpose of which was to make money by reducing the time believers would spend in hell, had to be proscribed. (One priest was fond of telling people that as soon as a coin rings in the bowl, the soul for whom it is paid will fly out of purgatory and wing straight to heaven.) He fiercely believed in free will, without which human moral action would have no meaning. He accused monks, priests and popes of living in luxury after taking vows of poverty, of caring for their own needs before those of their flocks. Life began in the womb, he wrote, and one shouldn't be baptized until old enough to accept Christ. He believed that lust was a natural body function like the need to eat. He denounced those who waged war as beasts and he pitied the stupidity, ignorance and gullibility of the ''faithful''. Erasmus favored circumcision. (He would have been better off letting boys decide for themselves, after puberty, as he did for baptisms.) While on penis-related subjects, I can add that he is idealized by gay groups for being homosexual; heteros furiously deny it. This reminds me of those historians who believe that the Borgia should rot in hell for their iniquity, while others make a saint of Alexander VI. The truth, naturally, is that no one will ever be certain one way or another about either Erasmus or Alexander.

Thanks to Gutenberg's press, Erasmus' books were known far and wide. Nearly 4,000 pages could be produced by movable type per week compared to several pages that were hand copied. Erasmus could thusly publish thousands of copies of his books, making him a best seller (750,000 of his works were sold during his lifetime alone). The advance was due to three factors: the use of the screw press, known since antiquity and used for crushing grapes and olives; the invention of metal type, in this case finding a perfect alloy consisting of lead, tin and antimony (which gives type its hardness); and the proper ink, which was oil based, more durable than water based. Gutenberg's press played a key role in the dissemination of knowledge to the masses, breaking forever the monopoly of literacy held by the nobles. By year 1500 there were 77 cities throughout Italy that had printing shops.

Erasmus formed a long friendship with Thomas More, a supposed humanist whose reputation was considerably muddied by the six executions for heresy during his chancellorship. More was against the Reformation which cost him his life under Henry VIII who died in his bed in terrible

pain, small retribution for the thousands of woman, boys and men he'd had hanged for one reason or another.

It's of interest to know what else was going on in the world at this time, a time especially harsh on boys. In 1485 the English king Richard III gave orders for his two nephews, Edward V (who had just been crowned king), age 13, and his brother, Richard Duke of York, age 9, to be smothered to death in the Tower of London. According to Alison Weir's wonderful book *The Princes in the Tower*, the boys certainly suspected what awaited them, as they had grown increasingly melancholy. Then, suddenly, they ceased appearing at the windows of their chambers. Richard was given a summary burial at his death, due to his role in the murders, and has been despised throughout history ever since, giving both Shakespeare and Sir Lawrence Olivier moments of creative glory. There can be no more heinous crime than the killing of children, and what awaited Astorre and his brother was even worse as they had marks of torture on their bodies and both were said to have been abused sexually before being thrown into the Tiber.

Despite the fact that Cesare had murdered his brother and Alexander's favorite son, Juan, both father and the remaining son, Cesare, now formed a tandem (it is difficult to count the insignificant Jofrè), the purpose of which was to extend Alexander's power and to give Cesare enough strength so that he would be able to replace the pope, at his death, becoming the first ruler of a unified Italy since the Romans.

To get things going, Alexander arranged a rapprochement between Louis XII of France and the Vatican. This the pope accomplished thanks to three of the new king's needs: the need to conquer Milan; the need to reconquer Naples, lost with the death of Charles VIII; and the need for a divorce so that Louis could marry Charles' widow. Louis offered Alexander a huge sum of money and gave Cesare, whom all recognized as the new rising star, the duchy of Valence. Cesare would also be given command over several thousand French troops. Satisfied, Alexander threw in a cardinal's hat that the French had requested for years. Not to be outdone, Louis raised the stakes by offering to find Cesare a noble wife.

When Cesare realized that he would soon be meeting Louis in person, he decided to turn himself into a perfect male by force of exercise, physical exercise as well as exercise in arms and horsemanship. He spent hours at the task and contemporaries agreed that there was not a finer looking Italian in all of Italy, with the exception of Astorre Manfredi who began to draw artists and sculptures to Faenza to capture his face for eternity. The artists who flocked to do Astorre honor wielded an art that was reborn, one that took its roots in humanism and in classical antiquity. It was based on classical texts rediscovered thanks to the likes of Cosimo de' Medici and thanks to commissions by the powerful Julius II. It was accompanied by technical advances that improved the quality of oil paint adopted by Titian,

Tintoretto and Uccello. Da Vinci perfected the art of painting thanks to lighting and perspective, as well as incredible detail in anatomy and landscape.

Cesare's face may not have equaled the beauty of Astorre's, but his good looks were increasingly disfigured by the ravages of syphilis. The syphilitic rashes, euphemistically called "flowers", came and went like the tide, leaving him handsome or disfigured *selon*. He took to wearing masks during his bad days, the effect of which enhanced the fear people already had of him.

When the time came, Cesare set off for France with cartloads of precious gifts. He was beautifully dressed in black and white velvet, pearls and gold chains and precious gems attached to his clothes and boots, his horse was attired in gorgeous livery and silver bells. In addition, he had not forgotten the cardinal's hat to be presented to Georges d'Amboise, Louis' trusted counselor. Cesare was offered the sister of the king of Navarre, sixteen-year-old Carlotta. Louis wrote Alexander a description of the wedding night, telling the pope that Cesare honored his wife eight times in a row. Louis added that he had done the same with his new wife--thanks to the divorce Alexander had accorded him--but confessed that he had nonetheless done less well as his sessions had been broken up, twice before dinner, six times afterwards. Alexander replied that he was awed by the king and proud of his son but not surprised by his virility. Carlotta was immediately pregnant. Charles' former wife wasn't.

As Louis XII's troops descended into Italy, Ludovico Sforza fled Milan with all the booty he could carry and Federico did the same in Naples, choosing the island of Ischia for his exile. Ludovico was later captured by the French and spent the remaining years of his life in prison, Federico was awarded a pension and died in the French town of Tours.

Now that Alexander and Cesare were aligned with France against Milan and Naples, Lucrezia's new husband Alfonso, illegitimate son of the former king of Naples Alfonso II, was an embarrassment that the two men eliminated by eliminating Alfonso himself. The boy had dined with the pope and was on his way home when waylaid by men with daggers. Wounded, he was taken to the Vatican where the pope gave him his own rooms. Instinctively knowing what was in store for the lad she loved, Lucrezia hovered over him day and night. Alfonso knew who was responsible for his injuries, and when he had recuperated enough, he took a potshot at Cesare with a crossbow as he passed through the garden below Alfonso's window. Cesare was unscathed, but his reaction was immediate. He sent men to clear Alfonso's rooms of both Alfonso's sister, Sancia, and his wife, Lucrezia. When they refused to budge, the men told the women that they were acting under orders from the pope himself. If the two women doubted their word they could ask the pope who was in an adjoining apartment. As

they left to do so, the doors to Alfonso's rooms were closed and Alfonso strangled. Cesare made no pretense of innocence, maintaining that since Alfonso had tried to kill him, he was only protecting his life.

Cesare then left Rome at the head of thousands of French troops and headed for the Romagna and the city-states he was set on conquering in the name of the pope because they were, after all, Papal States. On his way he visited his dear sister Lucrezia who was recuperating at Nepi after the loss of her beloved Alfonso. One wonders what they had to say to each other....

One of the men accompanying Cesare was the artist Pietro Torrigiano. His story is singular because Torrigiano was a sculptor under the patronage of Lorenzo *Il Magnifico*. He is credited with bringing the artistic segment of the Renaissance to England where he finished out his life. But through a quirk of human nature, he is known today as the man who broke the nose of Michelangelo. Torrigiano had been one of Michelangelo's lovers and, in a fit of jealousy, smashed the great artist in the face. Knowing how furious Lorenzo would be at his disfiguring Michaelangelo, Torrigiano fled. As Cesare was offering money to new conscripts, and as Torrigiano needed money, he joined his troops. Later he would become renown for sculpting the memorial to Henry VII of England, a man as atypical as Torrigiano.

From Nepi Cesare went on to Rimini to capture the city-state from the Malatesta. The Malatesta were a family of hotheads, schemers and murderers who ruled Rimini from 1295 until the arrival of Cesare who extinguished them with the ease of blowing out a candle. The first Malatesta was a hunchback, Giovanni, who killed his wife Francesce and his brother Paolo when he discovered them in flagrante delicto.

The Malatesta were often condottieri in the service of other Italian city-states. The most famous was Sigismondo. He took up arms at age 13 and became lord of Rimini at 15. He murdered his first wife and was known for his treason, first against the pope, then against the Sforza, the Florentines and finally the Neapolitans. After drowning his second wife he succeeded in betraying Siena, Venice, the Sforza for a second time and Florence again. Pope Pius excommunicated him for acts of sodomy on his own son. He was also accused of incest with his daughters, also par for the course during the period. Most of the above city-states raised troops to get rid of him, under the direction of Federico da Montefeltro. He fled to Venice where the Serenissima, who never did anything like the others, took him in. He plotted to assassinate the pope but returned home instead to peacefully die in his bed.

On his way back from Rimini Cesare came upon the sister of the ruler of Rimini whom he had just chased from power, the grandson of Sigismondo. Cesare immediately sequestered and raped her over a period of months, denying any knowledge of her whereabouts. Anyway, he scoffed, he didn't need to rape women as they came to him willingly from

everywhere. Which was true. Ambassadors from many city-states were nonetheless so upset by the abduction that they joined forces in demanding that Alexander severely punish his son. Alexander too was reported as being upset, but in the end, what could he do? The woman was eventually restored to her husband but from what she reported later, either she was suffering from Stockholm syndrome or her months with Cesare hadn't been all that traumatizing.

The time had come for Lucrezia to marry again, a marriage which would, naturally, benefit the pope. Alexander thusly chose the son of Duke Ercole of Ferrara, another Alfonso, Alfonso d'Este, for his daughter Lucrezia. Behind closed doors the Duke of Ferrara laughed at such pretention. His family was noble, old and wealthy, that of Alexander hick parvenus. Ercole had heard stories about them all, that Alexander had prostitutes from the best bordellos brought to him after dinner, that Cesare slept during the day and whored at night, that both he and his dad had shared Lucretia, that they were murderous slime, socially nonexistent and morally rotten to the core.

Yet ... his own boy was perhaps no better. Alfonso was known to have two interests in life, making cannons in his own personal foundry and parading around town at night, his sword in one hand, his erect cock in the other. His former wife had been so fed up with him that she turned to women for satisfaction. Stories of incest, sodomy, rape, murder, *et j'en passe* may seem exaggerated, but personally I believe they represent just the tip of the iceberg. The repressive atmosphere during the deep darkness that followed the fall of Imperial Rome was such that when the light finally came, when the period known as the Renaissance finally rose from ancient Rome's ashes, the liberation--intellectual, artistic and sexual—was such that Italy knew few bounds. And this liberation came to a people that just happened to be among the most beautiful created by the fertile mind of God.

But the wedding did take place since Louis XII of France wanted it, all because he needed the Borgias to further his ambitions. The price Ercoli demanded would have been dismissed out of hand by any other person in Italy, but not Alexander who disposed of literally bottomless resources, resources brought in, in multiple ways, every single day, via every church in the country. Alfonse was 26, Lucrezia still only 21. Parties were thrown in Rome prior to her leaving the city, one of which, in 1501, was the famous Banquet of the Chestnuts already described, during which prizes were given to those who could come the most times and copulate with the most prostitutes. Some say Lucrezia was present. Some put Cesare there. Others, like Puzo in his *The Family,* place them both. All named Alexander.

The trip to Ferrara and the celebration there cost a fortune, but the wedding night came off well. Alexander was told that Alfonso had

contented Lucrezia that night and then took his pleasure with other women during the day. The pope supposedly thought this just fine as Alfonso was a young man and, as such, multiple adventures were good for him. The historian Burchard wrote that all the talk of lubricity inspired the pope to increase the number of prostitutes he welcomed into his rooms that night. As always in Italy, love was indeed in the air.

In Forlì love was also in the air. Caterina decided to see Antonio Maria Ordelaffi. Their relationship lasted months, during which the Forlivesi happily anticipated the coming marriage. After all, Caterina, decided and intelligent as she was, was nonetheless a woman and as such needed male direction. (No matter what she accomplished, the idea that she depended on men would hold true until her death.) But Caterina had other ideas. She had had her eye on a stable boy, Giacomo Feo, since he was fifteen. Now seventeen, tall, lithe and supranormally handsome, his contemporaries tell us he was big where it counted. When Caterina found herself pregnant, she secretly married the kid.

All hell broke out in every direction. Forlivesi and Imolesi couldn't accept the primacy of a stable boy over their cities, and Bologna, Milan, Florence and Ferrara proclaimed that they had youths of noble birth who could satisfy the countess at least as much as Feo. The city that eventually won out, should Caterina choose one of their boys, would not only broaden its territory thanks to its influence over the two city-states, but it would control a major artery through the Apennines. Foiled attempts were made on the lives of both the countess and her lad, but she brought her pregnancy to term, giving birth to a baby boy, Bernardino. The marriage and the baby were kept secret because she did not want to undermine the ascension of Girolamo's son Ottaviano. She thusly decided to end any rumors concerning one or the other by punishing the rumormongers. She had them systematically beaten, many of whom were permanently maimed and at least one was killed. But it was a wonderful period for Caterina. A visiting ambassador was allowed into the inner sanctum of Caterina's palace where she and Giacomo were playing with Catherina's children by Girolamo and her son by Feo. He described the husband and wife, in the light of the setting sun, as pure angels.

In 1492 two major events occurred. Lorenzo *Il Magnifico* died, bringing an end to the golden age of the Italian Renaissance, and Roderigo Borgia became Pope Alexander VI, the warrior pope who would, in his way, also aid in the demise of the Renaissance. (Naturally, 1492 was also known for Columbus' discovery of the Americas and the year Magellan germinated the idea of circumnavigating the world.) Caterina was thrilled as Alexander was the godfather of Ottaviano, the heir of Forlì and Imola. The new pope raised troops against the invasion by the French king Charles VIII. Alexander requested Caterina's help which was refused. In

reality, Giacomo Feo, the stable boy, now decided politics for the two city-states, certain that he knew as much or more than seasoned kings, counts, ambassadors and other diplomats. But Alexander hadn't gotten where he was for nothing: he put two and two together and offered Feo 16,000 ducats for his help, which Feo accepted. When the French under Charles finally got to the Romagna they took the town of Mordano, defended by Caterina's troops. The town fell to far superior forces and Mordano's army and citizens were raped and murdered down to the last one. The massacre was such that Caterina immediately swung over to the French side, earning the enmity of the pope, Florence and a good number of other states. An ambassador traveling through the region declared, after meeting with Feo and Caterina, that she would gladly forfeit anything, Forlì, Imola, even her own children--she would, in fact, sell her very soul to the devil or give up all her property to the Turks--rather than lose her precious Giacomo Feo.

It was now 1495 and her son Ottaviano, age 16, was a man. In an attempt to gain what was his, he went up to his mother and Feo and demanded to be recognized as the new count of Forlì and Imola. An argument ensued that ended with Feo slapping the boy who stormed out of the room red-faced. A week later, as Feo was riding through the woods along with Caterina, a group of friends approached them on horse. As Feo chatted amiably with one, another stuck a dagger in his back. Caterina had the presence of mind to turn and ride off to the impregnable shelter of Ravaldino. Feo's bodyguards also took flight, leaving the handsome boy to fall from his horse into a ditch.

The people of Forlì remembered the heads Caterina ordered cut off after the assassination of Girolama. So when the murderers of Feo came riding into the town square, their clothes filthy with his blood, shouting to all the account of their exploits which, they maintained, were designed to give power over Forlì and Imola to their rightful count, Ottaviano, a group of nobles thought best to go to Ravaldino to find out what had really happened. When they returned, they ordered the arrest of the assassins. The reprisals were indeed terrible. The murderers had their heads axed open, from the top to the chin. Their wives and mistresses and children were slaughtered. Their houses were torn down brick by brick. Two babies associated with them, age three and nine months, along with their nurses, were bludgeoned to death. An accused priest was dragged behind a horse, his head fractured against the cobblestones, as Caterina had ordered done to Girolamo's assassin, old man Orsi. Under torture another conspirator gave out the name of her son Ottaviano, known by all to have hated Feo for usurping his rightful place as count of Forlì and Imola. Caterina had her son arrested, an act so horrifying that the inhabitants followed the boy to the gates of Ravaldino where Caterina dispersed them with cannon fire. After a stormy meeting with his mother, the boy was put under house

arrest. At Feo's funeral all of Forlì and Imola turned out, so afraid were the populations of their countess. Heaven entered the act by bringing down a plague on the people: rashes appeared on their genitals and their lymph nodes swelled up. The syphilis epidemic had begun. Caterina ordered her palace torn down because it had sheltered both her and Feo, and his statue in bronze was raised in his honor. A new palace was build on the grounds of fortified Ravaldino. Its furnishings and gardens were so exquisite that Caterina called the place Paradise. She sent Ottaviano to Florence to learn the art of war. The sixteen-year-old lad, a veritable Don Juan like his father Girolamo, left behind mistresses and bastards.

Caterina had eight children. Bianca Riario was her only girl and Caterina destined her for the handsome Astorre Manfredi of neighboring Faenza. All the surrounding powers had their say in the matter, some for and some against, but the negatives and positives equaled themselves out. For Caterina the union of the lad, age ten, and the lass, age fourteen, would unify the region, as Faenza was exactly in the middle between Forlì and Imola. Faenza was ruled by a Council which was doing an excellent job of both educating the young Astorre and of governing the tiny city-state. A pretender, however, Ottaviano Manfredi, Astorre's cousin, decided that the time was ripe for him to take power from the boy who was still a child. The resulting disorder attracted the attention of Venice who was always on the lookout for an easy kill. Bologna came to the same conclusion, as did Milan. All three decided to descend on Faenza. The brouhaha dissuaded Caterina from pursuing the marriage with Astorre and it was therefore annulled. Bianca would finally find a suitor, a count from the region of Parma, when she attained the ripe old age of twenty-two.

For Caterina, marital bliss occurred much sooner. At age thirty-three she fell in love with Giovanni de' Medici, thirty, perhaps the first veritably educated man in her life, who was also handsome and charming and, said one wag, a boy for whom she would kill father and mother to keep near her. They were secretly married because of Ludovico of Milan's enmity towards Florence. Knowing that he would find out anyway, Caterina tried to soothe Ludovico's anger by naming her only child with Giovanni, Ludovico Sforza de' Medici. Incredibly, her new husband Giovanni had inherited, in spades, the ills of his ancestors: he died in Caterina's arms, probably of complications due to family gout. In his memory she renamed her child Giovanni Sforza de' Medici.

That Caterina's private life was in shambles didn't mean she couldn't try to find happiness for her children. So when Alexander VI, her son Ottaviano's godfather, suggested a marriage between the boy and Lucrezia, Alexander's daughter, she knew that this would be the first step in turning over Forlì and Imola to the pope. Such a marriage could also turn out to be disastrous for her boy, Ottaviano. Caterina remembered that Lucrezia's

first husband had been declared impotent after three years of marriage despite the boy's outcry that he'd had her "at least a thousand times," and the fact too that he'd fathered bastards. So to protect her boy Caterina refused Alexander's offer, and in the nick of time too. The next candidate, Alfonso, was strangled on Cesare's orders.

Alexander decided on the direct approach and sent Cesare to bring Forlì and Imola into the lap of the Papal States. Caterina put the finishing touches on the defenses of Ravaldino just as Cesare arrived at the head of an army of twelve thousand of Louis XII's French troops. After promising her money and a palace of her own in Rome, the tone between the two--Cesare on his white charger facing the drawbridge to Ravaldino, Caterine atop the crenellated tower--turned sour as one insulted the other. They split up but after a few hours of reflection Cesare returned. This time Caterina was standing on the drawbridge. Cesare dismounted and approached the edge. Luckily for him, he was in beauty that day. The terrible traces of his syphilis had temporarily disappeared. Handsome and gorgeously dressed in black velvet, a rarity during the period when both sexes preferred bright colors (after the austerity of the Middle Ages), he decided to trade the filthy language he was partial to with the troops (similar to today when, in the locker room, it is impossible to hear a single sentence without the obligatory insertion of fuck) for the sparkling oratory of the likes of Cicero. Caterina too was in beauty, her breasts propped up by a tight bodice. She was immediately aware that Cesare had come to seduce her with a stunning smile similar to that used by Stanley Kowalski to mollify his wife Stella. Caterina, with the same intention, turned a welcoming shoulder in his direction, he held out a hand to touch it, she enticingly took a step back in the direction of the door to Ravaldino, he followed ... until he felt the drawbridge rising under his feet. He jumped off just in time to see Caterina disappear behind the closing door. Cesare, his face red with shame for having been tricked, stormed off.

Sadly, Cesare would win out. What Caterina had pointed to when the Orsi had put a dagger against the throat of her son when ordering her to surrender Ravaldino, what one contemporary had referred to as her "cunt" in a letter, would soon be not only his, but his until he himself felt that his humiliation of her had gone on long enough. (Although some writers during the period suggested that she grew to *like* Cesare and his form of humiliation. Naturally, we'll never ever know.)

At any rate, Cesare immediately went back to his obscene military language and ordered an all-out attack on the citadel. I won't go into the actual destruction except to say that she was betrayed from inside the walls, walls opened to Cesare and his French troops. The Italians inside were spared but ransomed; the mercenaries under Caterina had their throats slit. She stepped over seven hundred strewn corpses on her way out of

Ravaldino, in time to see her monument of bronze to her beloved Feo being carted away prior to being melted into cannon balls. Feo was symptomatic of what had undermined her place in Forlì and Imola: she had fought for her own pleasure and a place in the sun for her children; she had known hundreds of lads and wealth and luxury beyond measure; and so as one citizen summed it all up as she was hauled away, "She had put her faith in herself and in the walls of her fortress, and none in the people she ruled".

The French commanders observed the fate of the women left behind, their thighs spread as the men lined up. They knew that the prettiest had already been put aside for themselves later on. Realizing what was in store for Caterina, several tried to save the countess by telling Cesare that they had precedence over her and would assure her safety right up to the moment she came before King Louis XII. This hiatus ended in an exchange of money. Cesare retired with the countess while the French officers, rich, sought the comfort of the naked forms awaiting them under the covers of their own beds. One of them was heard to say, as he unbuttoned his superb military jacket, "Well, at least she won't be wanting for fucking."

As with all seventeen-year-olds, Astorre Manfredi had everything to live for. Of medium height, with a boyish chest and slim waist, his eyes were blue and his hair as blond as gold--curly waves of which descended to his shoulders. He was courteous, had a good word for everyone, and was as aware of his charm and sexual appeal as is every Italian boy, then as today. His family had ruled the city-state of Faenza for two centuries, and although there had been some bad apples, the Manfredi, in general, had done somewhat better than the other lords, dukes and princes of the Romagna. Astorre himself was loved. Although the real power behind Faenza lay with the Council that had been regent since Astorre Manfredi was named lord at age three, he had his word to say and that word was listened to more and more frequently. Faenza was one of the few veritable free spirits to exist outside Florence, and it was more of a Republic than even the Florentine city.

Indeed, Astorre had everything to live for, and perhaps even a bit more as he had received the best education available. Private tutors had instructed him in Latin, even if his daily speech was in the Italian vernacular. He had read Homer and Plato, the Greek tragedians, Suetonius and Xenophon and Plutarch, he had studied the texts of Cicero and was himself on the road to becoming an accomplished speaker.

Puberty had come later than it does today, but he had already known girls and women. In fact, his extreme beauty brought blushes to the maidens in the market; today he would star on American Idol. His marriage to Caterina's daughter Bianca had fallen through but it was of little consequence as there were plenty of other matches to be made with girls from far more important towns than were Forlì and Imola.

Faenza was well fortified, but its strategic location meant it was in continual danger from this power or that. Like the atomic bomb today, Faenza, being surrounded by powers such as Bologna, Milan, Florence and Venice, was in a strategic position because if one power dared to attack, the others would tear it to pieces in order to maintain the status quo. Faenza was fortified, but with Cesare prowling around the region the citizens of the city-state decided to add to their fortifications and ensure that neighboring cities would come to their succor if and when needed.

Astorre's first appeal for support went to neighboring Bologna. After all, his mother was the sister of Giovanni Bentivoglio, the lord of Bologna. Bentivoglio sent a thousand troops to Faenza but was later forced to withdraw them due to pressure from the French king Louis XII and also the pope who threatened excommunication. Louis thanked Bentivoglio for the withdrawal by taking Bologna under his wing, thus preserving the city from future ravages by Cesare. The pope also sent a note of thanks. As a sign of further capitulation, Bentivoglio agreed to feed and house a number of Louis and Cesare's soldiers. Astorre appealed to Venice, a power he could usually depend upon, but Venice too was afraid of Louis and besides, when Louis overran Milan he gave certain lands adjoining Venice to the Serenissima who was now in his debt.

When Cesare did more than prowl, when he attacked and ravaged neighboring Forlì and Imola, Faenzans were armed and readied for action. At first Cesare tried charm. He met with the Council and with Astorre, informing them that the time had come for Faenza--like Forlì and Imola--to return to the lap of the Papal States under the direction of their pope, Alexander VI. Nothing would change other than papal troops being stationed in the fort, in addition to Faenzans being enrolled in the ever-more-numerous papal armies. Astorre and the Council didn't accept Cesare's offer, as he probably knew they wouldn't, but it gave Cesare a chance to weigh them both. He loved the boy as did the Faenzans, and he was known to bed lads that caught his fancy, a bent that amused his men, many of whom shared the same drift.

Cesare had far bigger fish in mind than tiny Faenza but he couldn't just bypass it. It was at the entrance to the Apennines and it controlled an important route, the Via Emilia. Anyway, if he let a little fish get away, just because he liked the ruling prince, what chance would he have with bigger states? So he attacked. To his immense surprise the Faenzans defended themselves tooth and nail, even the women took up arms. Priests melted down sacred objects to provide money. The wealthy gave up their stocks of wheat and wine. The siege went on and on until the coming of winter, the winter of 1500, more than normally cold and snowy. Leaving enough men to make certain that Faenza wasn't supplied in food and weapons, Cesare went to spend winter in Cesena, a locality he liked so much he was thinking

of making it, when all power was in his hands, the capital of the Romagna. He spent money like water, offering games, tournaments and processions, and organized huge festivities at Christmas and during Carnival. He showed his prowess by challenging the local boys to wrestling matches and horse races, all of which made him immensely popular. His admiration for the people of Faenza was such that when a merchant escaped Faenza and came to Cesena with important information concerning which parts of the walls were the less secure, Cesare had the man hanged.

With the coming of spring, in March to be exact, Cesare returned to Faenza where he bombarded the walls of the city for five months, concentrating on the spot revealed by the Faenzan traitor. As food and water were lacking and the dead were piling up, as there were fewer stones and hot pitch to cast down on the invaders, Astorre and the Council were obliged to seek a truce. Cesare had no reason to give the Faenzans anything. Victory was his. But he did like the lad, and it had always been his policy to be as lenient as possible with a population. In that way he could count on the defeated to provide him with food once they had returned to the fields, as well as to give shelter for his men and horses and furnish the cannon fodder, their sons, necessary to win battles. In addition, the Council paid him personally 40,000 ducats. So, good-humouredly, he offered the boy what he wanted, and the boy wanted everything. He wanted Faenza free of foreign troops, he wanted Faenzans to be able to keep their possessions, and he wanted Cesare to forbid sacking and rape. All Astorre had to do in exchange was sign over the town to Alexander VI, which he and the Council agreed to do.

Astorre and his fifteen-year-old brother Gianevangelista were given their freedom, but to Cesare's astonishment they wanted to accompany him to Rome, as today kids want to see the lights of New York. Both boys also deeply admired the most virile, courageous and experienced warrior in recent Italian history. To learn from him would make them men on the way up; Cesare was their elevator to the very top floor. It was a fatal mistake because bright lights rarely come without the accompanying greed, vice and corruption that carpet the walls in shadows, as the French say.

The year was 1501. Caterina was taken to the Castel Sant'Angelo. She was said to have deeply regretted those she had murdered after the assassinations of Girolamo and Feo, a score for the first, two score for the second. Life supposedly meant little at the time, yet I remain convinced that individuals during the Renaissance wanted to live out their lives, just as we do today, to the last moment. They certainly were barbarous, hanging people until they were nearly dead and then cutting them down, still alive, so they could watch themselves be disemboweled or have their hearts cut out still beating, or, the horror of horrors, have their privates cut away and stuffed in their mouths to suffocate on. The rape of women was an essential

perk of war, as was ransacking and destruction. Children died unnecessarily, some before the eyes of their parents. So Caterina had reason to repent and beg for God's forgiveness. We certainly have reason to be thankful for our own more civilized times ... if, naturally, one excludes the Great War responsible for 20,000,000 deaths, the Second one that caused twice that, and more recently the slaughter of 8,000 boys over the age of 13 in Srebrenica, all of whom certainly begged for their lives right up to the last horrifying second.

Caterina was taken to Castel Sant'Angelo and locked away out of the reach of those like Cesare and his close friends who would be able to crow over having possessed the charms of the Cleopatra who hadn't gotten away. Her pain deepened when she discovered that her sons, Ottaviano and Cesare, were doing just fine under the rule of Alexander, from whom both boys sought the red hat of a cardinal. With mistresses and bastards galore, they were certainly on the right path to seeing their wishes fulfilled. News from Florence informed her that her last husband's brother was dilapidating the fortune Giovanni de' Medici had willed to her and his son, little Giovanni.

At age ten Caterina had visited Florence with her father Galeazzo Marie Sforza and had been welcomed by Lorenze *Il Magnifico* himself. Thanks to the intervention of Louis XII, who respected her as a ruler and as a warrior, she was freed from Castel Sant'Angelo--after signing over Forlì and Imola to Alexander. As she left the castel she crossed paths with Astorre Mandredi who was being imprisoned. The year of his imprisonment was 1501. She made her way back to Florence, the most beautiful and cultivated city of the Renaissance, where she would die. In an ending that was almost a fairytale of beauty, she was met there by her sons Ottaviano, Cesare, Galeazzo, Sforzino, and Carlo--the son of Feo. Her only daughter, the loyal Bianca, was also waiting for her, holding in her arms little Giovanni, the son of her last love, Giovanni, whose fortune his brother had not entirely dilapidated--in fact, there remained enough so that Caterina could live in comfort and offer sums to her sons who never ever stopped making requests for this and that, just as they had, when infants, lustily and eagerly suckled at the breasts of their wet nurses.

To save her soul she made donations to convents and churches, especially to the convent of Muratte where she asked to be interred. These donations were to Christ, for it is to Christ that women turn when they are no longer of an age to welcome virile lovers. She passed away at age forty-six. The year was 1509. Her tomb was desecrated 300 years later and her remains lost; Muratte became a prison.

But before we finish with Caterine, perhaps just a word about her last son, little Giovanni, son of Giovanni de' Medici. Different from the other Medici, he spurned intellectual activities in favor of martial interests. He

often ran away from home and liked the company of simple farm boys. At age twelve he killed a boy from a rival gang Giovanni had formed, and at age thirteen he raped a boy of sixteen. Trying desperately to save him, Florentine nobles put him under the control of an ambassador, Salviati, who was named to Rome. There Giovanni slummed with lowlifes, in perpetual trouble. He became a condottiere and was known for exclaiming, "I rule with my ass in the saddle and a sword in my fist!" Pope Leo X chose him first to police Rome and then to form an army using men of normally irredeemable depravity that only he had the force to make into manageable soldiers. He specialized in lightening strikes with a preference for ambushes. His motto was, "I embrace my rivals in order to strangle them." When his patron Pope Leo X died, Giovanni added black stripes to his armor, for which he is known historically as Giovanni dalle Bande Nere. He married Salviati's daughter and had a son destined to become lord of Florence. Severely wounded in battle, he had to have his foot amputated; ten men were needed to hold him down. He died five days later of gangrene. He was the very last of the condottieri. Of his direct descendants, other than fathering a Florentine lord, one, Marie de' Medici, became Queen of France--but led a terribly sorrowful life. (The Florentine lord he sired was Cosimo I who would rule Florence, whom we'll discover in the life of Michelangelo.)

For Cesare, Caterina, Forlì and Imola were an interlude to much bigger acts of bravura. We went on to take Urbino, the citadel of the Montefeltro and a dozen other city-states. Along the way he heard stories about some of his captains, traitors in the pay of Roman nobles eager for the reign of Alexander to come to an end by assassinating their leader, Cesare. He invited them to a dinner at one of his palaces and on an agreed signal troops surrounded and dispatched them all. He moved on to Siena, sacking, destroying, maiming, killing and raping. Those who wouldn't give up their money were tortured; if they were found to have nothing to give up, their throats were slashed. (Much more in my book *Cesare Borgia, His Violent Life, His Violent Times*.)

Cesare was no fool. He knew his father would not live on forever. He had thusly looted Italy of every ducat confiscatable, he had storerooms of weapons at his disposal and his troops loved this handsome fearless man who conceded their every wish as long as they remained loyal to him. What he didn't count on was *his* nearly dying at exactly the same time as his father, which is precisely what happened. What he didn't count on either was the election of a new pope as vigorous, intelligent and belligerent as Alexander had been.

He and his father had been invited to a banquet after which they both fell seriously ill. Illness was nothing new to the Renaissance. I haven't gone into the subject, but all the actors in this book, all without exception, had

fallen ill multiple times throughout their lives. Lucrezia, for example, could nearly be described as being continuously sick--especially following her many miscarriages. Illness came from literally everywhere, bad food, incredibly diseased water that one drank or swam in; illness came from common flue, from typhus, cholera and malaria; from flees and rats and dogs and other people. Illness came through breathing, sweating, defecating and fucking. Illness favored the months of July and August, hot muggy months propitious to dysentery. All of Alexander's predecessors, Innocent, Sixtus, Pius and Calixtus had died during those months. And it was now July and both Cesare and Alexander were at death's door. Perhaps they believed, as did the people, that they had been poisoned during the banquet. Perhaps, as some said, they themselves had tried to poison their host--an ever-criticizing cardinal they both could well do without--but somehow they had drunk their own means of murder. As Alexander was now seventy-three, he was in more danger than his young son. They were both bled although, unlike his father, Cesare was plunged into cold water, the accepted cure for fever. Alexander received last rites but not Cesare, a former cardinal, who vaunted his atheism.

Alexander did die. The year was 1503. Was he guilty of some of the most heinous crimes known to humanity--even, as we shall see, the buggering of Astorre Mandredi and his fifteen-year-old brother before ordering them to be strangled and thrown into the Tiber? Or, as one recent source claims, did he die a misunderstood saint? There is only one response: God will know His own. Let Him decide who goes into the eternal flames or who gets access to the 72 virgins. As for me, I've spent a lot of time reading about this unique creature without whom--and without miscreants like him--history would be a far more boring concern. But ... one doesn't touch children. If Alexander had harmed Astorre, if he did survive happily until the ripe old age of seventy-three (and he did), if there is no eternal punishment, if death is, in fact, just eternal nothingness, if, in a word, there is no justice for boys as innocent as Astorre and the 8,000 Srebrenicans--if you've come up with the answer to all that, then you're a better man than I am Gunga Din.

Nearly overnight Cesare lost it all. His palaces were sacked and the lands he had conquered were recovered by the counts, lords and princes he had overturned. He was carried away by litter to recuperate at his sister's retreat of Nepi. In Rome Pius III was elected but immediately passed away, replaced by the powerful Julius II, a mortal enemy of the Borgia. The conclave, which had felt itself so threatened that it met in the Castel Sant'Angelo, had lasted a single day, one of the shortest in history. Strong in body and mind, intelligent, handsome, arrogant and utterly ruthless, the new pope had contracted syphilis but with age he replaced the lust of the loins with that of the stomach, devoting himself to roast pig and strong

wines. His temperament was described as melancholic, capable of the greatest furies. He created the Swiss Guard and put Michelangelo to work on the Sistine Chapel (and the Guard's uniforms). He refused Henry VIII's divorce, ending the Catholic Church in England, and he brought war and peace to the continent according to his whims, and was only prevented from uniting Italy into one country by the emergence of someone still more powerful than he, the Grim Reaper. The year was 1513.

Julius issued a warrant for the arrest of Cesare, accusing him of the murders of his brother Juan, his sister's husband Alfonso, Astorre Manfredi and Astorre's brother, as well as many others. But in exchange for his giving up the wealth he had horded and the fortifications in the Romagna still in possession of those who remained loyal to him, he was allowed exile in Spain. He retired to Chinchilla, a mountain castle in the heights near Valencia.

Cesare's rout was such that even King Louis XII, who had called him his dear son, sent word to Ferrara and Alfonso, Lucrezia's husband, that he was free to leave her as France no longer recognized her as being his legitimate wife. Luckily for Lucrezia, Alfonso had grown to love her, and this despite the fact that she had never stopped welcoming lovers into her bed. Other scandals continued to haunt her. One of Alfonso's brothers, Ippolito, who happened to also be a cardinal and was known for his unbounded lustfulness, had fallen in love with a local beauty. The girl claimed that she far preferred another of Ippolito's brothers, Giulio, whose beautiful brown eyes alone were worth more than all of Ippolito. In response the cardinal waylaid his brother and tried to cut out those wonderful eyes. Alfonso forced Ippolito to ask for pardon, but as Giulio suffered horrible pain and the near total loss of sight, he decided to get revenge on both brothers, Alfonso and Ippolito, by having them killed. He united his forces with still another of his brothers, Ferrante. Their conspiracy was discovered, however, and although Alfonso would not have them executed, he did send them to prison. Ferrante died in his dungeon forty-three years later, Giulio endured for another fifty-three.

Caterina gave herself to Christ; Lucrezia, despite ever-increasing amounts of donations to convents and churches as she grew older, never abandoned that part of herself that wanted to be a woman to men of flesh and blood. Right up to the end she continued affairs with men, the two most important being Francesco Gonzaga and Pietro Bembo, for whom she wrote letters of stupefying sensuality (for the period).

Right up to the finish line she continued to give Alfonso children, five in all, of whom three were the precious boys who would assure that the name d'Este would live on in a plethora of youths to this very day. At age thirty-nine she died giving birth, birth to a child and birth to a star, her star, that shines as brightly now as it did 500 years ago, solid proof that it is

better to use life and be used by it than to flee the storm, dodging the droplets, seeking an illusive shelter that exists, in the end, for none of us.

In the mountain retreat of Chinchilla things turned badly for Cesare when his exile turned into captivity. Isabella of Spain decided to follow Julius' lead in prosecuting him for the deaths of his brother Juan, duke of Gadía, and Lucrezia's husband, Alfonso of Aragon, both of Spanish lineage. He escaped, climbing down a rope. He made his way by boat and trek to Pamplona in Navarre, to his brother-in-law Juan of Navarre who put him at the head of his troops. As the city-states in Spain were in constant upheaval just like their Italian counterparts, Cesare was constantly at war. His last day found him chasing a band of rebels. At age thirty-one he was still in the full glory of his bravado and virility and so thought nothing of outdistancing his men. Alas, the rebels he was chasing turned to face him and, highly outnumbered, he received many blows, one of which was the fatal plunge of a dagger to his throat, just above the armor. He fell into a ravine, just like Catherine's stable boy husband, Feo; he was stripped naked as Feo had been; but his genitals had not been mutilated, as Feo's--his were covered by a rock by one of the attackers who recognized him. Juan of Navarre had the body buried in the small church of Viana where it lies to this day. Cesare often compared himself to that other Caesar, and as they died nearly on the same day it can perhaps be said for one as for the other: *Aut Caesar, aut nihil*! -- Either Caesar, or nothing! The year was 1507.

In the spring of 1501 a new prisoner was added to Castel Sant'Angelo on the very day that Caterina was freed. Astorre Manfredi, her would-be son-in-law, had lost the town of Faenza to Cesare after a brave defense. He and his brother Gianevangelista had accompanied Cesare to Rome to learn about life and war. But unlike Caterina, the young nobleman had not earned the admiration of the French and was consigned to the lowest cells. In 1502 the unfortunate boy suffered the fate that Caterina escaped: he was strangled in the prison and his body dumped into the Tiber. Johannes Burchard wrote that both boys had been participants in an orgy along with a large number of very young girls. Whether they freely consented to take part or were forced to will never be known. Whether the orgy even took place will never be known. Cesare was said to have been involved--it would have been far from his first. Perhaps his father took part too. Burchard only says that "a certain powerful person sated his lust" on the boy. Many historians say the bacchanalia never happened. Machiavelli gets into the act too because he was there, physically there to give Cesare advice, one piece of which we find in his book: "When a prince assumes power over a conquered territory his first obligation, if he wishes to preserve that power, is to destroy the rulers in place." Every time, in Italian politics, that this principle hadn't been observed, the prince lived to regret it. Turks

systematically had their brothers garroted as their very first act on ascending to the throne. It's true that had the boy lived he might have eventually become a problem for Cesare. But a more likely eventuality is that Astorre, already immensely popular in his hometown, might have outshone Cesare himself in public adulation, an intolerable risk to a man who wore impeccable black velvet and paraded around on a white charger adorned with bells, his stirrups made of gold.

Burchard says that Astorre and his brother Gianevangelista were fished from the Tiber, attached together with a stone tied to their necks. The bodies of the aforementioned females were also discovered, tied together in the same fashion. The boys' bodies had torture marks. Cesare pushed his fiendishness to extremes by greeting an envoy from Venice and springing on him the news of the murders, knowing that Venice had taken a special and highly favorable interest in both Faenza and Astorre Manfredi. The envoy was said to have not even blinked, unsurprising for a city where slaves could still be purchased, their prices varying from six ducats for a man to a hundred for a beddable girl. Burchard ends his story by saying that "The young man was of such unequaled beauty and intelligence that it would be impossible to find another as sterling as he in all of Italy." The boy was 17. The year was 1502.

DONATELLO
1408 – 1466

Donatello's art seduced Cosimo--as his body did many a Florentine male--who put up with his every caprice. When a merchant refused a bronze head that Donatello had spent a month producing, arguing that a month's labor wasn't worth so much, Donatello sent it hurling from the heights of a tower where it had been taken to capture the best light, all the while protesting that he was an artist, not some laborer paid monthly wages. Cosimo commissioned a bronze statue of *David* from Donatello, a hero prized by Florentines because he had overcome the tyranny of Goliath, as many Florentines dreamed of the reestablishment of a Republic. The result pleases some; for others it is a girlish body with minimal male equipment. Mary MacCarthy called the androgynous bronze "a transvestite's and fetishist's dream of alluring ambiguity." One can hardly imagine this *David* winning a victory against Mighty Mouse let alone Goliath. Donatello placed his earnings in a basket in his studio and told his assistants to serve themselves with what they needed, but lovers who looked elsewhere were threatened with death by the artist who would run after them wherever they fled, a form of exercise that kept him alive until age eighty. He once requested permission from Cosimo to follow one of his runaway boys to Ferrara where he planned to kill him. Cosimo warned the

Count of Ferrara who managed to put the boys together, both of whom immediately broke down with laughter and shared a kiss. One of my sources claims that ''laughter'' in this sense was a *mot à clef* meaning to fuck.

Donato di Niccolò di Betto Bardi was born in Florence and started his early training in a goldsmith's workshop, followed by a stay in the studio of Lorenzo Ghiberti who spent 21 years completing the bronze doors of the Baptistery of Florence Cathedral that Michelangelo called the ''Gates of Paradise.''

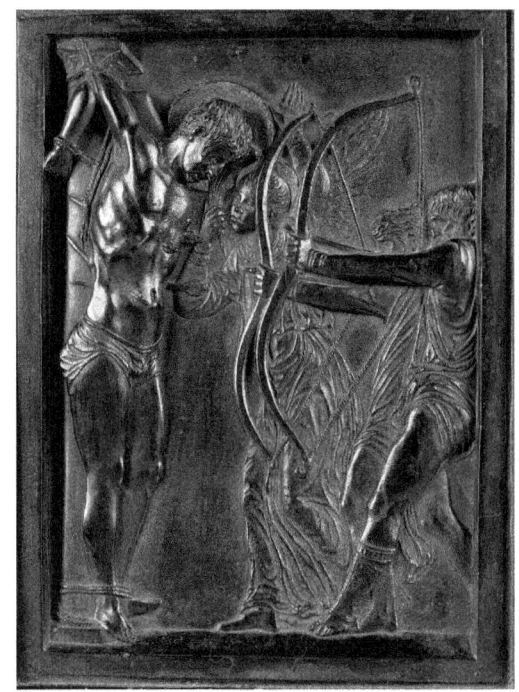

ANTONELLO DA MESSINA
1430 – 1479

His exact name is Antonello di Giovanni di Antonio. Born in Messina, Sicily, he studied under Niccolò Colantonio in Naples. He set up a workshop in Reggio Calabria and was known for his flags and banners, cloth bearing a symbol or coat of arms, called a banner of arms. He studied in Venice, influenced by Piero della Francesca and Giovanni Bellini. His later works, unfinished, were completed by his son Jacobello. Vasari states that Antonello introduced oil painting into Venice. He painted the altar of the Scuola di San Rocca of which his St. Sebastian once formed part, although some attribute the St. Sebastian to his son Jacobello. Antonello was inspired by the schools of Bruges and Brussels. He died at home in Messina. His paintings are noted for their geometry, and their use of space and light.

From the windows of his palaces one views Sicilian landscapes and Sicilian blue skies. It was at home on Sicily, in Messina, that he died.

The landscape behind his St. Sebastian shows Venetian palaces, canals and lagoon. The richly dressed population seems unconcerned about the youth's suffering, as does the sleeping soldier. Antonello brought life into the eyes of his figures, adding a psychological dimension, says Wikipedia, "crucial to the history of European painting."

His St. Sebastian, in the Museum of Dresden, shows a handsome boy, life-size, against a backdrop of palaces and blue Sicilian sky.

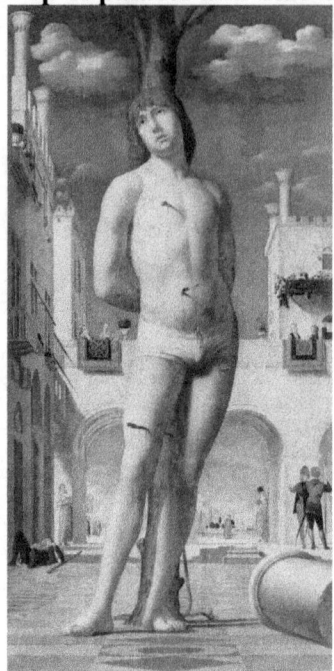

MANTEGNA
1431 – 1506

The workshop of Francesco Squarcione, in Padua, that I mention in the life of Cravelli, was extremely successful, and those who found a place there, nearly 150--Uccello, Filippo Lippi, Donatello, etc.--were lucky, as Squarcione, a former tailor, was passionately moved by humanism and Greek art, traveling the width and breadth of Italy and Greece to collect antique statues and vases. His collection was open to all, especially to those who wished to do drawings of the artifacts. But more than his collection and his other apprentices, it was Mantegna his preferred student. Mantegna's masterpiece is said to have been the frescoes of Sant'Agostino degli Eremitani, most of which were bombed into fragments in 1944.

He executed his first St. Sebastian in Padua, perhaps in thanks for his having survived the plague. A rider with a scythe is present in the upper left corner of the clouds, but one must look very hard to make it out:

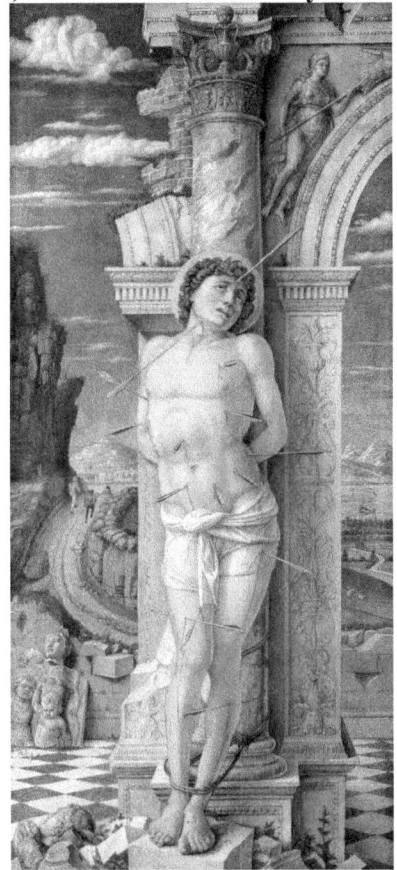

It seems that Mantegna's style, the portrayal of rocks and marble, the rigidity of forms, the bony muscularity, came through Squarcione and his collection, of which Mantegna did countless studies. But he was also influenced by the Bellini, He married Jacopo Bellini's daughter Nicolosia. Jacopo Bellini was a pioneer in oil paintings and formed, with his sons, a renowned workshop in Venice.

Mantegna left Padua young, the cause being, partially, Squarcione who had, for no reason known to us, turned against his favorite disciple. He became court artist to Ludovico III Gonzaga of Mantua (discussed further elsewhere). Gonzaga paid him a princely sum, as he was the first artist that the extremely artistic Gonzaga had allured. Mantegna built a mansion and filled it with art--all lost--but the worst calamity was the death of his boy Bernardino.

The second St. Sebastian was presented by Ludovico's successor, Frederico I, to his daughter for her wedding to Gilber, Count of

Montpensier. It is now in the Louvre. The painting shows clearly Mantegna's interest in ancient ruins.

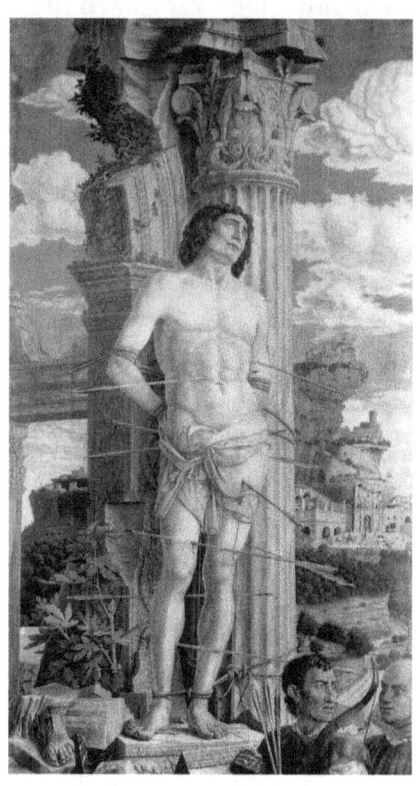

Called to Rome by Innocent VIII, he painted frescos later destroyed by Pius VI. It was in Rome that Mantegna met Djem Sultan who had gained the capital after losing a battle fought with another with another over who would become sultan. Djem had first gone to Rhodes where the Knights Hospitaller kept him prisoner in exchange for gold from the new sultan. In Rome Innocent tried to convert him to Christianity and used him to mount a crusade against his own people, both without success. The sultan paid the pope 120,000 crowns to keep Djem in luxurious imprisonment, at the time a sum equal to the entire yearly papal revenues. Enlisted by Charles VIII to help capture Naples, Djem died. The Ottomans wanted his body back for descent burial and succeeded four years later, when they'd offered enough gold. As Rome could not match the freedom and friendship he had known in Mantua, Mantegna returned there where he painted nine tempera pictures known as the *Triumphs of Caesar*, his existing *chef d'oeuvre*, now in Hampton Court, England.

His wife died and in his 70s he fathered a son, Giovanni Andrea. After his death his boys had a beautiful monument built in his honor in the church Sant'Andrea.

On the lower right-hand corner of his last Sebastian one sees an extinguished candle with a banner that reads: Nothing is stable that is not divine.

CARLO CRIVELLI
1435 – 1495

Born in Venice to a family of painters, Crivelli studied, as a boy, under Jacobello del Fiore, and then under Vivarini. He studied in Padua under Francesco Squarcione but left after serving six months imprisonment for having seduced a certain Tarsia Cortese, wife of a sailor. He worked in tempera (pigment mixed with egg yolk) and his polyptychs (many sections), with the exception of an altarpiece at Ascoli Piceno, have been divided up and dispersed. He was a follower of Mantegna and favored landscapes with fruit and flowers, a specialty of the Squarcione workshop. His works were often called grotesque due to their depiction of suffering, agony and open wounds, but nothing in comparison to Caravaggio, later on. His younger brother was both his student and his collaborator.

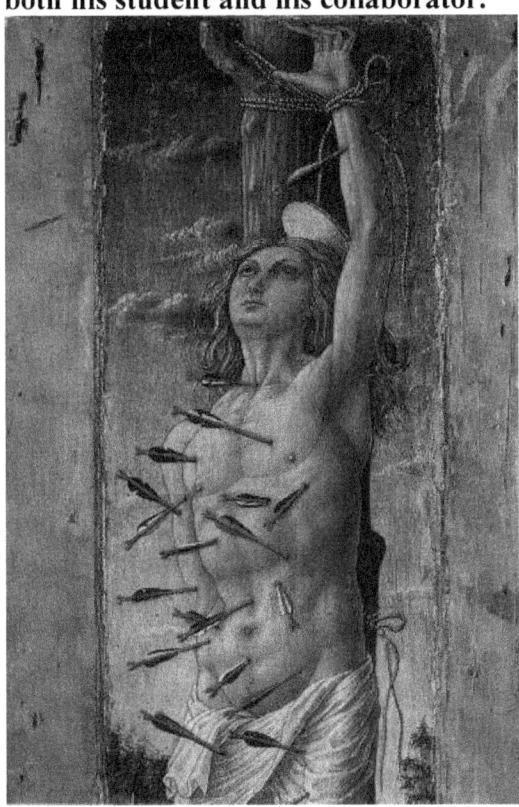

VINCENZO FOPPA
1430 – 1515

Contemporary with da Vinci, he trained in Padua and was highly influenced by Mantegna, gaining a reputation in perspective. Most of his paintings have been lost.

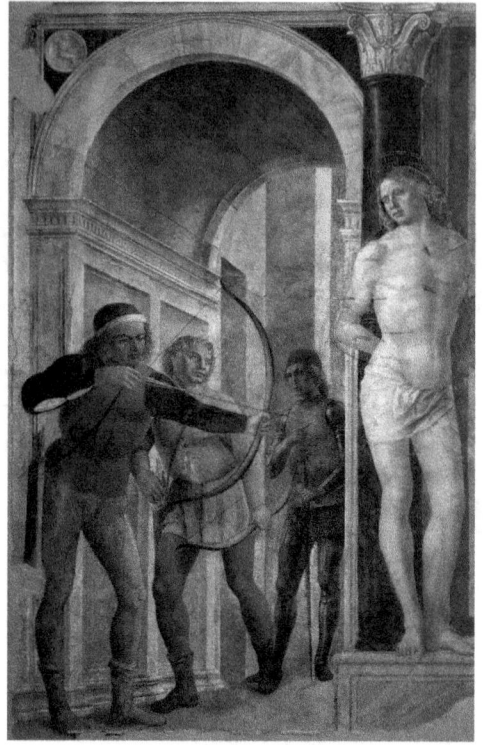

JULIUS II
1443-1513

I won't go into the life of Alexander VI as it was thoroughly covered in the first chapter. Julius II was different from the other popes, with the exception of Alexander, in having balls, big brass balls like those shown peeking through the waist-length armor of Leonidas, whose statue, on a high pedestal, is in the midst of the town of Sparta, should you ever get that way.

Guicciardini, the great Florentine historian, alive at the time, had this to say about Julius: "He was a soldier in a cassock; he drank and swore heavily as he led his troops; he was willful, coarse, bad-tempered and difficult to manage. He would ride his horse up the Lateran stairs to his papal bedroom and tethered it at the door." And he loved being called the Warrior Pope.

Peter O'Toole portrayed him perfectly in the series *The Tudors*, both his character and physically, but only at the very end of his life did he resemble the painting by Raphael where he comes through weak and sickly,

inappropriate for a man who had led armies and reigned supreme over European diplomacy. His life was largely covered in the first chapter, but some details and anecdotes need be furnished. For example, Raphael shows him wearing a beard, a practice forbidden by canon law, but he only did so for a year as a sign of mourning at the loss of Bologna, a vital Papal State.

Born Giuliano della Rovere (we'll call him della Rovere until he becomes pope), he may have been both the son *and* lover of Sixtus IV, an accusation made also against Alexander VI and *his* bastard son Cesare (several sources, existent at the time, maintain that this was so, but then Julius and Sixtus, Alexander and Cesare, had many enemies). He was educated among Franciscans by Sixtus himself, and was Sixtus' altar boy when Sixtus became pope. Della Rovere was endowed by the same Sixtus with numerous bishoprics, making him a wealthy young man. He was a papal legate in France for four years, which served him mightily when Alexander became pope and he had to flee to France to escape Alexander's wrath because he had accused him of buying the papal election. He convinced the French king Charles VIII to intervene in Italian affairs by invading Italy, but Alexander, subtle, intelligent and *in power*, outmatched della Rovere who had to wait for Alexander's death to have a try at the Vatican, but another was elected, Pope Puis III, who luckily had only 26 days to live. In the meantime della Rovere gained Cesare's support due to Cesare's illness which nearly finished him off, and due to della Rovere's promise to reinstate Cesare as head of papal troops and assure him that he would retain all of the land he had conquered under his father Alexander. Cesare was no fool except this one time. He gave his support to della Rovere who was unanimously elected pope except for two votes, della Rovere's own and the French Cardinal d'Amboise who wanted the job for the glory of France (receiving della Rovere's vote, out of friendship, in the attempt). Naturally, the usual bribes--money and a mightier position in the food chain--won the day. Cesare was killed, as related earlier, and Julius II erased every remaining trace of Alexander. As Nigel Cawthorne wrote, ''I will not live in the same rooms as the Borgias. Alexander desecrated the Holy Church as none before. He usurped the papal power by the devil's aid, and I forbid under the pain of excommunication anyone to speak or think of Borgia again. His name and memory must be forgotten. It must be crossed out of every document and memorial. His reign must be obliterated. All paintings made of the Borgias or for them must be covered over with black crepe. All the tombs of the Borgias must be opened and their bodies sent back to where they belong--to Spain.'' The Borgia apartments would remain sealed for over 300 years!

One of the major problems for the new pope was Henry VIII who wanted a divorce. A papal dispensation had already allowed Henry to marry Catherine of Aragon who had been Henry's brother's bride for six

months before he died, leaving Catherine a virgin as he had been to ill to be operative--although the day after the wedding he bragged to his friends, "Last night I visited the depths of Spain." The refusal to allow the divorce would end Catholicism in England, all because the king wanted to amuse himself with five additional wives."

The second problem was the Papal States, governed by lords, dukes, princes, et al. that the pope wanted returned to the bosom of the church. In a series of wars far too complicated and ephemeral to discuss here--the War of the Holy League, the Italian Wars, the Battle of Agnadello, the War of the League of Cambrai, among others--he tried but failed to unite Italy. A dream that came to an end due to fever, the universal murderer of the times.

He had put Michelangelo to the task of constructing his tomb, commissioned in 1505 and finished in 1545. It was originally intended for St. Peter's Basilica but wound up in the church of San Pietro in Vincoli. Although the actual tomb is colossal, with 7 statues, including the magnificent *Moses*, the original would have been far bigger, comprising 40 statues, some of the unfinished ones now on view in the Louvre. Only the *Moses* has a commanding presence and an anecdote has it that it was so lifelike that when finished Michelangelo struck it on the knee with a hammer, saying "NOW SPEAK!" The hammer mark can be seen today. As for Julius, he was buried far from his monument, in St. Peter's Basilica.

Michelangelo had also been appointed to paint the Sistine Chapel, named after Sixtus IV who restored it. Julius was said to have appreciated the physical beauties of the men painted by Michelangelo but part of their beauty was destroyed forever when one of Michelangelo's associates, Daniele da Volterra, was ordered to cover up the genitals following the genius' death. But he didn't touch the acorns and oak leaves present, the first representing the male glans and the second the renewal of sexuality, among other things. The central *Creation of Adam* is certainly the most stirring work of art known to humanity.

One of Julius' lovers is thought to have been Giovanni Alidosi who accompanied della Rovere to France. Julius made him a cardinal and he served as an intermediary between the pope and Michelangelo, as both were headstrong and difficult (just the negotiations concerning the Sistine Chapel, before a single brush stroke, took two years). As mentioned above, Julius lost Bologna and as a consequence Alidosi had three persons found guilty of aiding both the Bolognese and the Venetians. They were strangled to death under his orders. Of Alidosi, Cardinal Bembo said, "Faith meant nothing to him, nor religion, nor trustworthiness, nor shame, nor anything that was holy." Much hated, Alidosi was often caught and tried by various rulers, notably those of Bologna and Urbino, ruled by the pope's nephew, Francesco Maria della Rovere, but instead of dispatching the reviled

cardinal he was always given a trial, time enough for Julius to intervene in his favor. As Francesco had been appointed general to conquer Bologna and had failed to do so, he was summoned to Rome to explain himself to his uncle the pope. After the meeting, while heading back to his lodgings on horseback, accompanied by a group of his soldiers, he crossed the path of Alidosi who was on his way to dine with the pope. Alidosi saluted Francesco in an arrogant way that displeased one of Francesco's followers, just a youngster, who dismounted and knifed Alidosi, sitting on his mule, in the throat. From then on it was an eating-frenzy of boys out to kill each other. Francesco's men won out, and while Alidosi's went scurrying away, Francesco's took turns slicing off pieces of Alidosi's face and plunging daggers into his body. Julius had the pieces interred and realpolitik obliging, suffered his pain in private.

Another lover was supposedly Luigi Pulci, a poet described by Cellini as being beautiful and talented. The Venetian diarist Girolamo Priuli maintains that Julius brought to Rome "some very handsome young men with whom he was publicly rumored to have sex, and he was said to be the passive partner." When attacking Bologna a sonnet circulated, advising Julius to return to Rome where he could content himself with "Squarcia and Curzio in your holy palace/keeping the bottle in your mouth and a cock up your ass." It *was* true that he drank a lot.

Julius made plans to demolish the old basilica of St. Peter's and replace it with a huge basilica, the whole serving to house Julius' final resting place, the greatest tomb ever erected. Michelangelo was chosen to design it as well as to build the basilica, but over the next 120 years the combined efforts of popes and architects were needed to see it through. It is believed that St. Peter was crucified there, at the emplacement of the current obelisk, by Nero who held the Christians responsible for the burning of the city. As for Julius, Michelangelo finally finished his tomb after 40 years of bargaining and labor. Julius wasn't interred there though. For all his efforts he was accorded a simple slab of marble on the floor of the basilica, that people walk over every day, little aware of the headstrong warrior beneath.

BOTTICELLI
1445-1510

At that time in Florence there existed special letterboxes that citizens used to denounce other citizens. It was in this way that Botticelli came to the attention of the authorities. He was accused of "keeping a boy." An investigation took place but as ironclad proof was unavailable the charges were dropped. As he was now well known and visibly had only a few more years to live (six, as it would turn out), the Office of the Night responsible

for such cases turned a blind eye. His reputation didn't seem to have suffered as afterwards he was appointed to decide where Michelangelo's *David* would be placed in Florence, housed to protect it from the elements or, as Michelangelo wished, outside in view of all in the splendid Piazza della Signoria. It was decided to put it outside, but the original was later replaced by a copy so that the original could be protected inside.

His self-portrait in his *Adoration of the Magi* is exquisite. He later turned towards the cretin Savonarola and burned part of his gorgeous oeuvre, to our eternal loss (if true, which is doubted by some). The great Guicciardini in his marvelous *Storie fiorentini* tells us more about Savonarola: "There were no more games in public, and even at home they were played in an atmosphere of fear. The taverns, which had been the meeting places for all the rowdy youth who enjoy every vice, were all closed up. Sodomy was ended and women abandoned showy and lascivious clothing, and young men resolved to live in a saintly and civilized way. They went to church regularly, wore their hair short and cast stones and cursed dishonest men, card players and women who dressed lewdly. They went to the carnival and collected all the dice, cards, paintings and corrupt books, and burned them publicly in the Piazza della Signoria. Savonarola brought help to men who abandoned pomp and vanities, and restricted themselves to the simplicity of a religious and Christian life."

Botticelli came into the world as Alessandro di Mariano di Vanni Filipepi, in Florence, and when young was called Sandro, the diminutive of Alessandro. Botticelli means "little wine barrels," a name at first applied to his flabby brother, although for some reason it spread to the whole family. As with Verrocchio and many other artists, he too began as an apprentice goldsmith. At age 17 he was admitted into the workshop of Filippo Lippi who taught him perspective and techniques in fresco, as well as the beauty of pale colors in contrast to the brighter palate that Botticelli favored. Luckily Botticelli entered the service of Giuliano de Medici, later assassinated, as we saw, in Santa Maria del Fiore. Under the protection of Lorenzo *Il Magnifico* and Medici patronage in general, he became famous and rich, and enriched our lives and knowledge by producing paintings of Lorenzo, Giuliano, Cosimo, Piero and Giovanni de' Medici. Then Savonarola entered the stage and a part of Botticelli's works went up in smoke (again, supposedly, as Vasari--about whom we'll learn more in the chapter on da Vinci--doesn't say a word about the bonfire), followed by Savonarola himself, burned at the stake.

His paintings are to be discovered in situ in museums, a wonderful reason to travel throughout Italy, and a wonderful place to make acquaintances (where I met my very first lover, in the Salle des Vases grecs in the Louvre, the story of which can be found in my *HOMOSEXUALITY – Volume Four – Modern Times*). As my purpose here is not to evaluate art--

which is also far beyond my competence--I can only repeat what we all know, which is that the *Birth of Venus* and his *Primavera* are irreplaceable masterpieces (and the lad on the far left of *Primavera* is to die for). Later modern-day Savonarolas tried to cleanse him of a homosexual stain by maintaining that the Venus in the *Birth of Venus* was an unrequited love, Simonetta Vespucci, who sat as the model--it turned out that she had been dead for years before he painted it.

Incredibly, he went into an artistic eclipse due to the eminence of Michelangelo, da Vinci and Raphael, but reason won out and today he is firmly in the firmament of da Vinci and Michelangelo. He did little painting after Savonarola's bonfire of the vanities, most of which were on the lines of ascetic religious themes. It's true that the bonfire occurred in 1497 and his great triumphs years earlier, *Primavera* in 1482 and the *Birth of Venus* in 1486. At his death he was poor and unaccompanied to his final resting place.

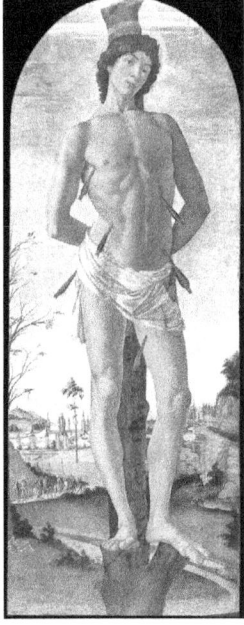

PIETRO PERUGINO
1446 – 1523

As one of the first Italians to turn to oil in painting, his reputation gained him pupils such as Raphael. He himself studied in Perugia--from whence came his name (he was born Pietro Vannucci)--in the workshop of Andrea del Verrocchio along with da Vinci, Ghirlandaio and Filippino Lippi. He was drawn to Rome by Sixtus IV to paint frescos for the Sistine Chapel, alongside his companion Pinturicchio.

Afterwards he left Rome for Florence where he and another Perugian painter, Aulista di Angelo, were convicted of assaulting a man with the intent of murdering him. Di Angelo was exiled while Perugino got off with a fine.

Along with his pupil Raphael, he painted the interior of a building for bankers in Perugian, a very extensive project that Michelangelo saw and declared mediocre. Perugina brought an unsuccessful suit against him for defamation. Such was the reputation of Michelangelo that the loss of the suit cost Perugino a large number of his students.

Worse still, Julius II called him to Rome to work on the Vatican, but then replaced him by his apprentice Raphael. Death in the form of the plague brought release. He was hastily buried, as were most plague victims, in an unmarked tomb.

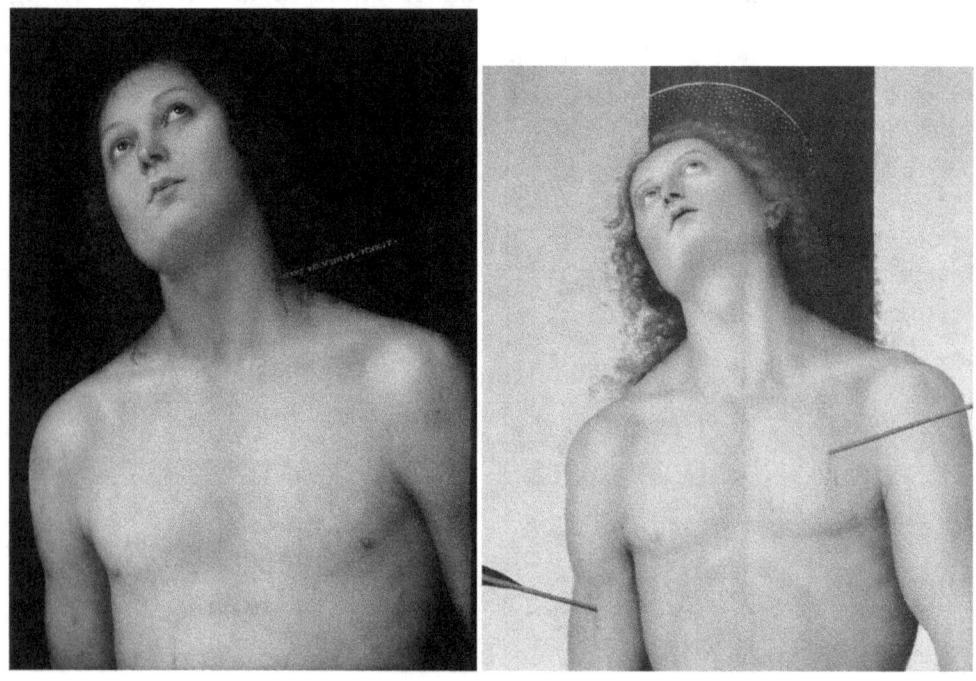

DA VINCI
1452-1519

Leonardo was gorgeous and so were his boys, beginning with Salaì, magnificent in da Vinci's two paintings, *St. John the Baptist* and *Bacchus*, the absolute ultimate in homoerotic art. The beauty of Leonardo can be admired in Francesco Botticini's *Tobias and the Three Archangels*, Leonardo shown as the first angel; and Verrocchio's *Archangel Michael*.

Salaì was Leonardo's nickname for his boy lover, meaning Little Devil, bestowed when Salaì, unmanageable and stubborn, hotheaded and careless, proved to be a liar and a not-so-accomplished--although highly assiduous--thief. This at the prepubescent age of ten. A very close friend of Leonardo's, Giacomo Andrea, was present during one of the first meals shared with Salaì. It is suspected that Leonardo's idea for the Vitruvian Man, the male body made up of two superimposed figures showing four arms and four legs, was originally Andrea's invention, and bares an amazing resemblance to Leonardo himself. Of Salaì Andrea said he was a glutton who ate as much as four monks, spilled the wine and broke whatever his fingers came upon. Another friend, the painter, architect, writer and historian Giorgio Vasari, famous for his book *Lives of the Most Excellent Painters, Sculptors and Architects*, wrote that Salaì was ''a graceful and beautiful boy with curly hair and a delight to Leonardo.'' There is no doubt that he was Leonardo's bedmate, the only question being from what age? Along the line Leonardo drew him with a huge erection, a drawing called *The Incarnate Angel*. But Salaì was such a trickster that he may have drawn in the phallus himself on one of his master's many drawings of him. (Another drawing is entitled *Salaì's Ass*, the boy's buttocks shown surrounded by penises.)

Numerous times Salaì made off with Leonardo's money, but as the painter had endless commissions, he was rich and, at the end of his life, even wealthy. Salaì is said to have bought clothes with most of the lucre he swiped, at one point possessing thirty pairs of shoes. Throughout his entire life he remained by Leonardo's side, at times replaced, as with the handsome Melzi. Melzi to whom Leonardo left half of his fortune, the other half going to Salaì. But most importantly, both boys remained loyal to the master, both present at his side to witness his last breath.

Some find it incomprehensible that Leonardo, known for his exactitude (most sources say it took him 4 years to paint the *Mona Lisa*, others as long as 14), painted *John the Baptist* as an erotic young man and not the usual old prophet in most paintings. The surprise is greater still when we learn that in Leonardo's painting the Baptist was at first totally nude, and that only later were animal skins added (which reminds me of the ''artist'' Daniele who covered up the genitals of Michelangelo's Sistine Chapel men, earning the sobriquet ''the painter of breeches''). At any rate, Leonardo kept the painting with him to the very end, understandable as *John the Baptist* is the most beautiful portrait of a young man that has ever been put on canvas. He kept the *Mona Lisa* until the very end too, at the Chateau of Clos Lucé, a chateau given to him by François I, who is believed to have held his head as he expired, perhaps his last gaze on Salaì at his bedside or Salaì, much younger, the model for *John the Baptist*.

Maybe his last gaze was on the *Mona Lisa*, one might say. But it didn't matter. Both the *Mona Lisa* and the *John the Baptist* had the same

enigmatic smile, because *La Giaconda*, too, may have been of Salaì. This is a hypothesis forwarded by some. But perhaps stranger still is the painting called the *Monna Vanna*, a lookalike Mona Lisa right down to the smile, but this one thought to have been painted by the boy Leonardo considered his best pupil, the selfsame Salaì, a self-portrait Salaì did of himself, with breasts. At any rate, at his death the *Mona Lisa* was bequeathed to Salaì and sold to King François I for 4,000 écus. Supposedly a huge number of highly erotic drawings were destroyed at the time by a resident priest, whether under da Vinci's orders or not is unknown.

No one will ever know why the child Salaì was chosen by Leonardo. Leonardo himself said he had come upon him while the child was drawing, and seeing potential, he made enquiries into his family. Finding them poor, he made them an offer they couldn't refuse. Leonardo was thirty-eight, an age when a man begins to think of settling down, tired of running after boys his ever-so-slightly decline in beauty was more and more compensated for by a few easy coins, of which, for him, there was no dearth. Already, at age twenty-four, he'd been arrested by the Florentine Office of the Night, he and a gang of his friends, all accused of sodomy. He got off as the charge was difficult to prove, but it shows that, like other Florentines, he was no parvenu to male-to-male intercourse. His interest for those of his own sex was already well known, as reflected by the male nudes that studded his canvases and notebooks, erotic proof of the mystical attraction men have had for each other since Adam fled the Garden of Eden to a land east of Eden known as Nod, where his sons Cain and Abel inaugurated the eternal spiral of murder. The boy Leonardo and his friends were accused of sodomizing was an apprentice goldsmith, Jacopo Salterelli, age 17, a notorious rent-boy. At that time in Florence there existed special letterboxes that citizens used to denounce other citizens. It was in this way that Leonardo and his companions had come to the attention of the authorities. There were two enquiries, at a month's distance, neither of which turned up enough evidence for a conviction, a conviction that held the death penalty. But as already stated, even if convicted one usually got off with a fine and a slap on the wrist, so common was the event. Serge Bramly in his *Leonardo* concludes: "The authorities were prepared to turn a blind eye to various sexual misdemeanors--homosexuality, incest, bigamy: fairly common forms of behavior, after all--on the condition that public order was not disturbed and that a minimum of discretion was observed." But Leonardo must have suffered nonetheless now that everyone in Florence knew about his indiscretion, including his father.

Leonardo's exposure to boys was literally limitless. In the workshop artists and their models came and went as they discussed artistic issues and gossiped, most of who were sexually available. And as Leonardo gained in reputation, he was surrounded by a constantly renewed court of extremely

beautiful boys and young men, friends and models, many of which adorned his paintings and notebooks--thighs, buttocks and penises from repose to full erection, or, in his words, "long, thick and heavy" to "short, slim and soft." Leonardo continues: The male member "has a mind of its own. When we desire to stimulate it, it obstinately refuses, or the opposite. When a man is asleep it is awake, and when he's awake it's asleep. It remains inactive when we want action, and wants action when we forbid it." He maintains that "it" can at times be dangerous, inundating the world with human beings the world in no way needs, as well as being the entry point for diseases (syphilis having reached Italy in 1495). On one page of his notebook he noted: "A woman's desire is opposite to that of a man's. She wants the size of his member to be as large as possible, while he wants the opposite, so that neither gets what he's after." A friend proudly wrote him about the son the man had just given birth to. Leonardo's response was unexpected to say the least, "I had once thought you to be a prudent man, but now have proof to the contrary, for you congratulate yourself on bringing forth an enemy whose energies will be directed at gaining his freedom, freedom that will only come with your demise." Despite his pessimism Leonardo, both gorgeous and good natured, must have made a lot of boys extremely happy.

The aforementioned Vasari wrote that "there is something supernatural in the accumulation in one person of so much beauty, grace, strength and intelligence as in da Vinci." Da Vinci was also said to be preternaturally gentle for the period, kind to rich and poor alike, generous, always in good humor and possessing a sense of humor. Vasari goes on to say, "Leonardo had such a great presence that one only had to see him for all sadness to vanish." As a person he personified what Plato would call the perfect alloy of *virtu*, intelligence and knowledge. Leonardo was born, out-of-wedlock, in 1473 in the Tuscan hill town of Vinci, near the Arno River that flows through Florence. His father was a wealthy legal notary and his mother a peasant. His full name was Lionardo di ser Piero da Vince, meaning Leonardo son of Messer Piero from Vinci. He lived his first five years with his mother, then with his father who married four times, but never Leonardo's mother. He was a bastard but that had few ill effects in Renaissance Florence. Caterina Riario Sforza de' Medici, whom we met above, was also a bastard, yet she received an education equal to that of boys. On the other hand, bastards could not hold certain positions. They couldn't be notaries, the position of his father which would certainly have become his own had he been born in wedlock--to the loss of the entire world. He couldn't become a doctor, either, a pursuit he might well have chosen, given his love of science and dissection. In the case of bastards only the father's name was registered, the opposite of today. Leonardo was an extremely private person all of his life, and only wrote of two incidents that

marked him, the first a kite that swooped down over his cradle, the tail of which caressed his face, the second was discovering a cave while exploring the mountains, and although fearful of the monsters it might contain, he nonetheless overcame his fear by venturing inside. A little later he painted the monster he'd imagined on a shield, the perfection of which pushed his father to sell it to an art dealer who in turn sold it to one of the most redoubtable lords of the time, Galeazzo Maria Sforze of Milan.

At age fourteen he was apprenticed to the painter Andrea di Cione, known to the world as Verrocchio, in whose *Archangel Michel* we see the incredibly beautiful Leonardo. The choice of Verrocchio was fortuitous as his paintings are exquisite, the demonstration that Fortune never ever stopped looking over Leonardo's shoulder. Verrocchio's shop was in Florence, another lucky break as it was then, as today, arguably the most beautiful city in the world. Verrocchio never married, but this was true of half of the male population of Florence for whom freedom to live their lives as they wished was of prime importance. Happily for them, they hadn't lived in the times of the great Augustus who obliged the nobility to marry before the age of thirty so that Rome would have the men it needed to run the city, farm the land, and enforce its army. But when a Florentine did marry, it was around the same age as in ancient Rome, thirty. Verrocchio's apprentices included Ghirlandaio, Botticelli and Botticini, whose *Tobias and the Three Archangels* features da Vinci. At age twenty Leonardo's father set him up with his own workshop, but his love for Verrocchio was such that they worked together until Verrocchio's death. Verrocchio was a father figure, perhaps the most important man in the artist's life.

Verrocchio was described by Bramly as "a sort of one-man university of the arts." He knew and taught literally everything with the exception of huge wall murals, the reason for the disastrous destruction of the *Last Supper*, discussed herein later. When Verrocchio was only 17 he had struck a boy, age 14, with a stone, killing him. He was jailed but released when it was proven that the incident had been an accident. Verrocchio was nonetheless haunted by what he had done to the very end, especially as he was a good man, sensitive in the extreme. Verrocchio's father died the year of the accident and Verrocchio found himself at the head of a family consisting of his mother and six brothers and sisters. Years later, now well-off, he was still providing for them as well as his nephews and nieces. Verrocchio was apprenticed to a goldsmith and began learning the skills of drawing, engraving, carving and metallurgy, followed by other jobs in which he would master sculpturing, painting, the basics of architecture and his favorite subject, mathematics. He was commissioned to make the tombstone for the person who started the Italian Renaissance, Cosimo de' Medici. Verrocchio established his own workshop, a large room with all the instruments an artist uses on the surrounding walls, plus sculptors'

turntables, workbenches, easels and kiln, as well as shelves bent by the weight of busts and plaster body parts. The production of the workshop was phenomenal as it touched numerous aspects of daily life. Verrocchio and his apprentices turned out banners, coats of arms, caparisons for horses, designs for embroiderers and weavers, pieces of armor, candelabras, bells and furniture, as well as decorating wooden chests and painting canvas for tents. Whatever could be artistically created or ornamented was undertaken by Verrocchio. Around the workshop and upstairs were the living quarters for the boys and the kitchen.

An apprenticeship lasted around thirteen years, which started with sweeping the workshop and cleaning the materials, moved to the rudiments of drawing, making paintbrushes, preparing canvases and pigments freshly ground every day; sculpting, painting, drawing, decorating; even learning how to make salts out of human excrement--from dawn to dusk, seven days a week. One of the most incredible contracts given to Verrocchio was the placement of a round ball with cross on the very top of the dome of the cathedral Santa Maria del Fiore. In pictures it looks tiny, but it measured six meters across and weighed over two tons. Placed on the dome built by Brunelleschi, the widest to exist at the time, without buttresses or external supports, the dome was considered a miracle, the completion of which Brunelleschi kept secret. A modern understanding of how he did it, based on physical laws calculating stresses, finally ended the enigma, but at the time Brunelleschi had relied on intuition and large-scale models. In all, the dome took 37,000 tons of material, including 4 million bricks. This was in 1469. In 1600 the ball was struck by lightening and destroyed (but later replaced by a still bigger one). After this came commissions for the tombs of Giovanni and Piero de' Medici, bronze tombs like jewelry boxes with foliage and garlands. The workshop was literally overwhelmed by orders from the Medici, for their palaces, villas and celebrations.

The workshop became the artistic center of Florence where one exchanged ideas, models, recipes for paint and varnishes, where philosophy was disputed and gossip swapped. Of special interest was the new Flemish technique for mixing paint with oil instead of water, making for brighter and more long-lasting colors and smoother gradations of tints. Songs were sung and music was played, as Verrocchio was an accomplished musician. He was truly a kind of Pericles who created the conditions for geniuses to thrive--much of which was perhaps due to his attempt to compensate for having killed a lad of 14.

Like all boys, Leonardo liked to dress up and nowhere in world history was there a better, more exciting city than Florence under the Medici. The costumes for festivals and carnivals (designed by Verrocchio and company) were magnificent. Boys' trousers so tight they looked painted on, ample shirts that fell from the collar bones to the upper thighs, taken in by a thin

belt at the waist, shirts that scarcely covered the piece of cloth over the genitals, held in place by two ribbons. A headband with perhaps a feather adorned the forehead. This is how I described Juan Borgia in the first chapter: "As virile as his father, slim waisted and certain of his sex appeal, Juan swaggered through the streets of Rome in what can only be described as gorgeous attire, a cloak of gold brocade, jewel-encrusted waistcoats and silk shirts, skin-tight trousers with drop fronts--cloth attached by ribbons that would free a man's loins when he wished to piss or perform other virile activities." As Niccolò Machiavelli said, "The city's youth, being independent, spent excessive sums on clothing, feasting and debauchery. Living in idleness, it consumed its time and money on gaming and women." And boys.

At age twenty-four, as mentioned, Leonardo was arrested for sodomy. Four years later he moved in with the Medici, with Lorenzo *Il Magnifico*, thanks to whom commissions began to rain down on the lad. From there he went on to the career for which he is known the world over. Salaì followed in his footsteps, helping with his paintings, constructing the machines inspired by the master, keeping shop for the man who would reward him with a golden retirement, providing Salaì with a piece of land and the money on which to build a home. Salaì would later die in a duel, some say by sword, others by firearms, still others by a crossbow.

Salaì was the gift of God that those of my sexual persuasion could rightly give thanks for each and every day left to us on earth. A saner man than Leonardo would have thrown him out when the boy stole his first lire, or when caught in bed with another of the master's apprentices. But the genius whom we are all acquainted with, the master of every domain that took his interest, revered the boy as his source of inspiration, as the cherished love of his life. Leonardo could see beyond the daily tribulations and petty treasons. Instead, he held firm to the companion with whom he would walk the rocky path of life, right up to the end. That Salaì was beautiful and beautifully built was important, without doubt, but in a land like Italy, with apprentices he had to turn away in droves, he could have found a dozen replacements. But Leonardo knew that in the end one goes ahead alone or one grants the concessions necessary to share the route with another. The alternative is sterile old age, the shipwreck so well described by de Gaulle in his *Memoirs*.

One of the most impressive realities concerning Leonardo's notebooks is that amidst the thousands of pages there is nearly nothing of a personal nature about the master himself. We have his thoughts, observations, calculations, recipes for mixing oils and ground paint, machines of all nature, fortification, anatomical drawings, male genitalia galore, the texts in reverse left-hand writing, much of which is illegible.

The second love of Leonardo's life was Giovanni Francesco Melzi who became his apprentice around 1508. The boy's father was a senator and a captain in Louis XII's army. Unlike Salaì who only partially succeeded as a painter, Giovanni Melzi did some remarkable works. As handsome as Leonardo had been in his youth, Giovanni followed his master to the end, inheriting half of his oeuvre. The Melzi family property was at Vaprio d'Adda, an enormous mansion, nearly a small Versailles, witness to the Melzi wealth. It was he who informed Leonardo's family of his master's death. Then he returned to Vaprio d'Adda with his master's notebooks and several paintings. He wrote a book drawn from Leonardo's observations about painting, which eventually found its way into the Vatican. The historian Vasari contacted Giovanni for help with the book he himself was writing. About Melzi Vasari wrote, ''Sir Francesco Melzi, a Milanese gentleman, entered da Vinci's service as a young and extremely good-looking adolescent. He was very dear to his master and today is a noble and handsome old man.'' Giovanni left a son, Orazio, who sold off the notebooks bit by bit. His self-portrait, proof of Giovanni Milzi's wondrous beauty, can be found near my own home, at the Musée Bonnat, Bayonne France.

They met when the boy was 15 and Bramly writes that they took to each other immediately. The questions I have on the couple are those expressed by Bramly whom I would much prefer to take over here: ''He addresses his young friend as 'Messer Francesco' on account of his noble rank, but immediately after this polite formula, we read: 'Why in God's name have you not replied to any of the letters I sent you? Just wait till I get back, and by God I will make you write till you are almost sick of it.' By now Salaì must have been twenty-seven or twenty-eight. One wonders how he viewed his master's friendship with this wealthy, presentable, and highborn youth--as different from himself as day from night. It cannot have been easy for him. Harder to understand are the reactions of the Melzi family. Young Francesco soon announced that he wished to follow da Vinci as a pupil, to be initiated into the art of painting. How had his parents taken it? It was quite unprecedented for the son of a good Lombard family to soil his hands with paint. Francesco Melzi was never to leave Leonardo's side, nursing him when he was ill, handling studio affairs, taking all sorts of notes from his dictation.''

Leonardo went to Milan where he was happy to put himself under the patronage of Ludovico Sforze who paid him extremely well and allowed him all the time he wanted in order to do exactly what Leonardo himself wished to do, and this for 18 years. Then Louis XII invaded Italy and Ludovico lost it all, eventually imprisoned by the French king until his death. Leonardo returned to Florence, age 48. The Medici had been expulsed and the Republic reestablished. Savonarola had gone up in smoke

and a new breed of artist had arisen, led by Michelangelo and later by Raphael. His father was still there, age 74, with his forth wife and eleven children still at home, aged 2 to 24. Leonardo had written him often, always beginning with ''Dearly beloved father...'' a tender loving son, even if the reality of their closeness was perhaps other. At age 50 he hooked up with Cesare Borgia who appointed him military engineer, a position Bramly says he deeply desired. Cesare was a bastard as was Leonardo, and Bramly goes on to say: ''these two bastard children, having created their own lives, respected each other for their intelligence, independence of mind, and scorn for convention. Leonardo must also surely have been susceptible to Cesare's boisterous elegance and superb bearing.'' All certainly true as Cesare was virility incarnate. But unlike Leonardo, Cesare, age 27, was the adored son of his father, Alexander VI, who would continue to love him even after Cesare murdered his brother, Juan--the son Alexander cherished even above Cesare. To have the backing and limitless wealth of his father, the pope, was a huge morale booster. Cesare went on a conquering spree and Machiavelli accompanied him. About Machiavelli's *Prince* Jean Giono wrote: ''It is the most objective study of mankind to date, the study of passions treated dispassionately, as if solving a mathematical problem.'' With the death of Cesare Leonardo returned to Florence where the town leaders, reigning from the Palazzo Vecchio, wanted him to paint a huge wall in the Palazzo itself. He covered the wall with an immense sketch of the *Battle of Anghiari* (won by Florence against Milan). On another huge wall in the same room Michelangelo, age 29, was commissioned to do the *Battle of Cascina* (won by Florence over Pisa). Leonardo worked on the sketch and preparations for the painting for three long years. After a first attempt failed due to the preparation of oils (apparently a huge problem before the oils were prepared by stabilized manufacturing), he simply returned to Milan under the auspices of Louis XII who was such an important ally to Florence that the leaders had to bite the bullet over Leonardo's departure. Michelangelo never finished his painting either. Called to the Vatican by the war pope Julius II, he would spend four inhumanly difficult years on the Sistine Chapel. Da Vinci's sketch of the battle was treated as a national monument until the return of the Medici, who had it painted over (by none other than the great art historian--but also painter--Vasari!).

 Both Michelangelo and da Vinci had only their love of men in common. The painted nudes of Michelangelo were peaches-and-cream clean, those of da Vinci homoerotic wet dreams (although Michelangelo's statues were, homoerotically speaking, to die for). The first, da Vinci, had been handsome, the second, Michelangelo, never. The first was now old, the second just starting out on the road to eternal glory. Bramly recounts the story of Leonardo sitting at a café talking about Dante. He was asked a question, but seeing Michelangelo who was walking past said something

like, "Ask Michelangelo." The great artist, always on the offensive, perhaps due to his looks and uncouth appearance, answered, "Explain it yourself, you who made a model of a horse you could never cast in bronze and which you gave up, to your shame." Which was true, but the *clay model* of the biggest horse ever made--with the exception of the Trojan Horse--was destroyed by the French army when they entered Milan in 1499 and, anyway, Ludovico Sforza had used up the bronze to make cannons. But *500 years later* an American pilot, Charles Dent, had the horse built, thanks to Leonardo's sketches, and offered it to Milan where it now stands! Bramly's story shows that things were not always peachy between the two men, but Michelangelo's personal relationships rarely were. For that, he had to fall in love, which we'll see, in detail, later. When in love Michelangelo gave himself body and soul; da Vinci was perhaps too cerebral to do so completely.

Vasari tells us that it was around this time that a boy, 20, living in Urbino, decided to forget everything he had ever learned about art and dedicate himself to copying Leonardo's paintings, paintings that had just come to his attention. The boy had a magnificent name, Raphael.

In Milan the French reserved a wonderful reception for Leonardo who, for Louis XII, was the reincarnation of the Renaissance itself. He started the Mona Lisa but the history of the painting is far to complicated to be approached here. It's the Churchillian riddle wrapped in a mystery inside an enigma. We're not sure even who ordered it, let alone who sat for it, although many think it was Salaì himself. (Michelangelo always had men pose for his statues of woman, as well as some portraits.)

While battles for and against Louis XII whirled around him, Leonardo was creating another work whose importance would span a period of 400 years: it was a study of the human body, dissected with perfection and drawn with a detail that takes one's breath away. In his own words (and 200 illustrations) he tells of accompanying an old man in his last hours, how the man complained of no physical pain, only weakness, and how he gently slipped from life into death. To find out the cause Leonardo did an autopsy, discovering that the artery supply to the heart and lower members had withered, describing, for the first time in the history of medicine, arteriosclerosis. Bramly takes over: "One wonders what it felt like to plunge a knife into the thorax of an old man one had been speaking to not long before." Later in his notes Leonardo describes examining a hanged man, his penis engorged, of which he made detailed drawings. Leonardo went on to say that even if one had a love for dissecting, one's stomach might find it disgusting, and one might "be afraid to stay up at night in the company of corpses cut to pieces and lacerated and horrible to behold."

Politically, there was movement. Ludovico Sforza's son Massimiliano Sforze recovered Milan, expulsing the French back across the Alps. Pope

Julius II died and was replaced by Leo X, the youngest son of Lorenzo *Il Magnifico,* enabling the Medici to reconquer Florence after twenty years of disgrace, and bring an end to the Republic. Leo X was destined to die of gout, as did the majority of the Medici, so rich they could afford the richest food (the cause of gout), but Leo X surpassed them all in girth. He had nonetheless brought a cultural revolution to Rome and was flattered by his followers as he who introduced the reign of Apollo, an esthetic age of gold. Leo X's brother, Giuliano de' Medici, one of many patrons of art supposed to have commissioned the *Mona Lisa,* convinced Leonardo to come to the Eternal City where the artist found himself eclipsed by the new stars of the Renaissance, Michelangelo, Titian and Raphael, Raphael who was paid 12,000 ducats for his works, while da Vinci was offered a measly 33 ducats a month, bringing the quip to Leonardo's mouth, "The Medici created me and destroyed me." He was now old, but his greatest triumphs, his *St. John the Baptist* and his *Mona Lisa* were still to come. He spent three unhappy years in the service of Giuliano, part of which was dedicated to building canals that would drain fever-breeding swamps from around Rome--aided by the intelligent Melzi. The works he initiated were completed 300 years later.

Finally came his encounter with the man with whom he would end his life, François I, age 19, a giant at 6 feet, who loved war, placing himself in the front lines, and was an insatiable womanizer. He recaptured Milan and Ludovico's son Massimiliano Sforze, but instead of throwing him into a dungeon he welcomed the lad to his court and pensioned him off. Leonardo went to the Loire Valley, but only after the death of Giuliano de' Medici. The year was 1516; da Vinci had 3 years left to him. He became François' tutor, and their days and nights were filled with discussion, often in the presence of Salaì and Melzi, all three immeasurable comforts to the old man, old beyond his years as we see in his self-portrait.

The last words will be Melzi's, in a letter he sent to Leonardo's surviving brothers: "He was the best of fathers to me and the grief I feel at his death is impossible to express. As long as I have breath I shall feel an eternal sadness, for every day he gave me proof of a passionate and ardent affection. Each of us will mourn the loss of a man such that nature is powerless to create another."

 Leonardo's Saint Sebastian

MARCO BASAITI
1470 – 1530

A Venetian and rival of the Bellini, he studied at the atelier of Alvise Vivarini and was known for his use of bright colors *à la Titian*.

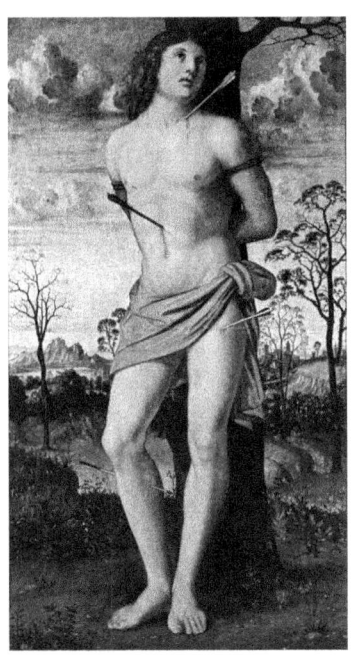

ALVISE VIVARINI
CA. 1442 – CA. 1505

Vivarini was the most important Venetian painter before the Bellini, and like the Bellini he was issued from a long heritage of Venetian artists.

His portraits are truly remarkable, giving one an inside view of how people dressed, wore their hair, and with what pride they presented themselves. Some of his work was lost in Venice during the fire of 1577.

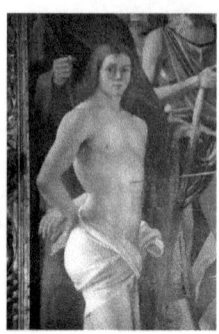

ALONSO BERRUGUETTE
1488 – 1561

Although born in Spain and having studied under his painter father, he continued his studies, after his father's death, in Florence and Rome under Michelangelo, both in sculpture and painting. He later returned to Spain where under Charles V his contribution to art was mostly sculptures.

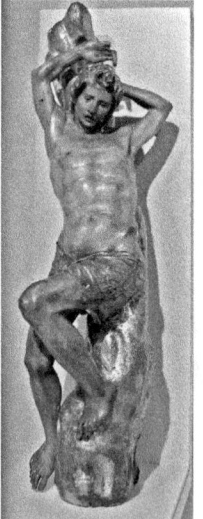

MICHELANGELO
1475 - 1564

Few men have lived a longer, fuller life than Michelangelo, perhaps none had bequeathed as much artistic wealth to humanity as this tortured genius, dead at age 89, with a chisel still in his hand, at work right up to the end. The body was destined for burial in the Basilica of St. Peter's still under construction, but was stolen by Florentines in the midst of the night, destination a city Michelangelo had not visited for 30 years, his nonetheless beloved Florence. Paraded through the streets to his last resting place, word of mouth spread as to who it was, and soon the streets were jammed with crowds. At the Basilica of Santa Croce the coffin was opened for the benefit of the crowd. The body within was intact, clean and totally lifelike a month after his passing, proof to the assembled masses of the artist's sanctity. But he had not had the luck of going to his tomb in company of his lover, as did Caravaggio with Cecco and da Vinci with Salaì and Melzi. The love of Michelangelo's dreams, Tommasso, was absent, and the love of his life, Urbino, had preceded him in death.

Michelangelo was born a Florentine and he died a Florentine, even if his birth had taken place outside of Florence in Caprese, and he had been destined for burial in Rome. The Florence of that epoch was the most beautiful city in the world, 30,000 Florentines massed together between walls that surrounded the town, a space so narrow it could be walked across in an hour. Divided in half by the Arno where ruddy-cheeked boys swam naked in its refreshing waters, Florence was the birthplace of the Renaissance and home to the hallowed sextet, da Vinci, Michelangelo, Raphael, Botticelli, Cosimo and his grandson Lorenzo *Il Magnifico*.

His full name was Michelangelo di Lodovico Buonarroti Simoni, his father was Lodovico who was forced to place him in the bustling workshop of the immense painter Ghirlandaio, at age 10. Forced because the lad was headstrong despite, says Ascanio Condivi, a painter and Michelangelo's biographer, Lodovico's ''outrageously beating him.'' Lodovico had destined the boy for more literary quests, beginning with the obligatory study of Latin, a language Michelangelo would always regret not having learned as it separated him from the ranks of the nobility he admired, a regret that burned like a coal until the day he died. But he did make it to Ghirlandaio's, as if directed by the hand of God, as Leonardo had been fortunate in finding Verrocchio. Michelangelo's older brother, Lionardo, didn't fare as well. Destined for commerce, his father placed him with an abacus teacher, obligatory for the times, Raffaello Canacci, who sodomized the boy, age 10, ''often and often from behind,'' he admitted to the court. He was fined 20 florins and a year in prison which was dropped because he confessed his sin. Lionardo entered the orders, became a Dominican friar, and disappeared from history. Lodovico had five sons about whom he said, ''None of them would give me the slightest help or even a glass of water.''

In the workshop apprentices learned to look after the tools and keep them clean and in working condition, as well as keeping the shop clean and doing the shopping. They became familiar with the materials used in fresco and tempera, and in the preparation of paints, and how to prepare the surfaces over which the assistants and the master would paint. In exchange for their labor they discovered the secrets of their trade. Michelangelo soon became better than Ghirlandaio, which was bad enough, but he bragged about his superiority in Frescoes and tempera to the other boys, earning Ghirlandaio's disdain for the boy's arrogance.

Michelangelo learned about Ghirlandaio's workshop thanks to a boy two years older, Francesco Granacci, who would remain his friend until his death. Together they were sent to work for Lorenzo *Il Magnifico* who owed a part of his prestige to his position as patron of the arts. At the moment Lorenzo lacked sculptors and Ghirlandaio sent him the two promising boys. Here Condivi recounts the charming story of Lorenzo coming on Michelangelo as he was sculpting a faun. He pointed out to the boy, then 15, that a faun as old as the one his was creating wouldn't have had a mouth of such perfect teeth. Michelangelo is said to have not been able to hold still until Lorenzo had left so he could knock out a tooth, and then he couldn't wait until Lorenzo returned and admired what he had done. Alas for boy and man, Lorenzo, although still young, had but four years left to live. About Lorenzo the great historian Guicciardini wrote, "No one, not even his enemies, denies that he was a very great and extraordinary genius." Lorenzo provided him and Granacci a room and a place at his excellent and refined table. Yet despite the refinement, Lorenzo's household was run on an extremely informal basis. One was free to come and go as one wished, and to say what one wished, and Lorenzo himself was always available to boys like Michelangelo, whereas visitors of high rank often had to cool their heels for days before being admitted into his presence. A grown man was present, Poliziano, a professor and Latin poet, a founder of humanism. He translated works from the Greek, especially Plutarch and Plato. He was also a rampant lover of boys, and one can only wonder what effect his intelligence and enticing talk had on seducing the young artist, if any. He took an interest in Michelangelo and was said "to have loved him greatly." Francesco Granacci, on the other hand, would have made a perfect first friend for Michelangelo (he is painted in the nude in the painting *The Raising of the Son of Theophilus* by Filippino Lippi). Another boy was also present, Pietro Torrigiano. He too was a sculptor under Lorenzo's patronage, and later he brought the artistic segment of the Renaissance to England where he finished his life. He was also an insufferable bully and when Michelangelo made some disparaging remark concerning his work, he broke the artist's nose, an infliction that greatly diminished Michelangelo's faith in himself, as he felt he was no longer handsome.

(Some say he was Michelangelo's boyfriend and the dispute was in reality a quarrel between lovers, as Torrigiano was known for his startling beauty.) Afraid of Lorenzo's reaction, Torrigiano fled to Cesare Borgia who was offering money to enroll new army conscripts, and as Torrigiano needed money and was physically fearless, he joined his troops. Afterwards, as I've said, he went to England where his destiny was fulfilled.

Having his nose broken was the beginning of a series of ordeals for the young Michelangelo. Lorenzo *Il Magnifico* died at age 43, certainly from problems centered around the family plague, gout. How this singular light in the history of humanity, ruler of Florence since the age of 20, so strong, courageous and vibrant could just cease to exist was incomprehensible. An event of far less importance, but one that was nonetheless destabilizing, was a charge by a youth called Mancino that Poliziano had repeatedly sodomized him. There followed a roundup in the taverns of anyone in the company of boys. Michael Rocke, in his wonderful *Forbidden Friendships*, points out that by age 30 one out of every two youths in Florence had been arrested for sodomy; by age 40 two out of every three men had been incriminated. As these acts took place in private, and were therefore rarely discovered, it meant that literally every boy, youth and man was doing it. When the dust following Poliziano's arrest settled, those found guilty were fined and they all went right back to satisfying their loins. Priests ardently preached against sodomy, their eyes bulging with hatred for the vile act, spewing saliva over the faithful in their haste to denounce it, while below the pulpit the choir and altar boys quietly awaited the private behind-doors ceremony to follow, when the priests, aroused by the heat of their sermons, would savagely penetrate one of the less fortunate among them. It took place then as it takes place now, and we continue, like them, to do absolutely nothing.

Lorenzo's son Piero had a footman who ran alongside him as he rode, acting both as groom and bodyguard. Piero described the man as exceptional in his beauty and perfect in body. Michelangelo drew the man, as he did others of great beauty and physical perfection who worked for the Medici. In the closed circle of the Medici, which counted palazzos and villas the size of mansions, immense parks consisting of rivers and lakes, of artists, tutors and in-house philosophers convinced of the singular majesty found in the male body, boys and men were plentiful, available, from laborers to grooms to models and apprentices, most of whom were open to the intimacy that allowed the Medici and their guests, Michelangelo included, a chance to familiarize themselves--during languorous Medici nights--with a male's attributes, his nipples, navel, veins, pubic bush, testicles and foreskin, knowledge of which Michelangelo would need to perfect his future *David*. Michelangelo was said to have been very close to Piero, even though the boy was in no way up to the standards of his father

Lorenzo who had founded universities and had had, like his grandfather Cosimo, books translated from the Greek.

Now comes a strange interlude in Michelangelo's life. Charles VIII invaded Italy and appropriated Florence, to the humiliation of Piero de' Medici who tried to deal with Charles but was turned away like a servant. He fled Florence and entered history as Piero the Unfortunate. In fear of Charles' army, Michelangelo escaped to Bologna where he and two friends who accompanied him were jailed because they didn't have the small sum of money needed to buy permission to stay in the city, an important source of taxes for towns like Bologna, one that permitted them to do things like medical dissections which, in Bologna, had been carried out in public for centuries. Somehow an important Bolognese personage recognized him as a Medici sculptor from Florence and paid for his release, taking the boy to his palazzo. Now, Michelangelo would be remembered throughout history as being tight-fisted in the extreme, rarely inviting friends to share a meal, and he never accepted gifts for fear of being placed in a person's debt. But he was also generous to those he loved, literally giving them the shirt off his back. The paradox is that Michelangelo rarely went through life with the same people, no matter how much he had loved them in the past. Only when he was in the throes of love was he fierce and total. Da Vinci, on the other hand, kept loyal to friends and remained close to his lovers until the end, but in a way that may have been too cerebral in comparison to Michelangelo, who loved his boys fully and violently. Be that as it may, Michelangelo was said to have abandoned his two friends in prison and went off to live in such luxury that when Piero de' Medici happened to come to Bologna, Michelangelo didn't even make an effort to see him.

He and his new friend, Gian Francesco Aldrovandi, spent their nights reading Boccaccio, literature as erotic then as it is to us today. A friendship developed ... and perhaps more. At any rate Michelangelo carved three small statues for Aldrovandi's church, St. Dominic, each around 2 feet high, of extreme beauty and intricacy, especially the angel. After a year Michelangelo returned to Florence where the political situation had stabilized, and then went to Rome where he sculpted the *Pietà*, Christ cradled on the lap of his mother, whose portrait is so young she could have been Christ's sister. Michelangelo inscribed his name on a band across her breasts, the first and only time he ever signed a work. The perfection of the faces and the intricacy of Christ's mother's drapery, incredibly complicated, majestic, is beyond human understanding as to how Michelangelo accomplished it. The finish was achieved with pumice stones, a labor of love he would never repeat. Michelangelo had sought out the marble himself from Carrara, beginning a life-long love of the beautiful wooded site that would only grow until his death. He was 25, the new and never to be toppled King of Rome.

Michelangelo had been called to Rome by Cardinal Raffaele Riario due to a statue Michelangelo had carved and then buried, known as the *Sleeping Cupid*. When experts maintained that it was an example of ancient Greek mastery in sculpture, Michelangelo revealed that it was he the creator. The statue had been bought by Raffaele who had amassed the greatest collection of Greek and Roman art in Rome. Upon arrival, at age 21, Raffaele took Michelangelo under his wing, proudly showing him through his immense collection, offering the boy the chance to do all the drawings of the statuary he wished. Raffaele had passed through Florence at the time of the attack on the life of Lorenzo and had been arrested because he was a Riario and others bearing his family name had plotted in the killing. Very young at the time--his uncle Sixtus IV had made him cardinal at age 16, the first adolescent to be so named--and described as being handsome in the extreme, Lorenzo took it upon himself to see that the boy was freed. Now, years later and having lost his beauty, he commissioned a statue, a life-size Bacchus. Since the plot in Florence to kill Lorenzo, Raffaele had become wealthy. Lucky at cards, he had won 15,000 ducats during a night of play, a fortune he used to build an immense palace, the Palazzo della Cancelleria, the columns of which, dating back to the times of Augustus, were taken from the church of San Lorenzo that Raffaele didn't hesitate to have destroyed. He would later lose the palazzo to a Medici pope, Leo X, who remembered Raffaele's supposed role in the assassination attempt against *Il Magnifico*, and told Raffaele, in other words, your palace or your life. Raffaele offered Michelangelo 150 florins for the *Bacchus*, a small fortune for a boy of 21. After pocketing the money Michelangelo denounced his collaboration with Raffaele, calling him crass and uncultivated, the reason being that Michelangelo needed the backing of the Medici, Raffaele's enemy, and so had to be disowned.

After the *Pietà* he was rich but the money was put away in banks or under his mattress. His brother Buonarroto found him living in dingy, humid lodgings, dressed like a beggar. But Michelangelo would always live in avarice, collecting and hiding money, and at his death a whole chest of gold was said to have been found under his bed, a fraction of what he had horded away. He never slept enough, ate enough, or dressed warmly enough. He made it known to those around him that he was penniless, perhaps to keep them from asking for alms.

David was next, carved from a block of Carrara marble that had been awaiting the genius, in Florence, for 40 years. Since his early teens Michelangelo had dissected bodies, learning the secrets of tissue, muscles, veins, skin and bone, a grisly, horrifying experience in times without the least refrigeration, a task he's said to have enjoyed, certainly in the sense of a stepping stone to what would become, at age 26, his and the world's foremost masterpiece, *David,* that would reign until the end of time as the

measure of perfect manhood. A distant secondary miracle, but a miracle just the same, was the consent of the population to dissections, which had taken place in Bologna, as I've said, since the early 1300s. Dissections were anathema under the Romans and the Arabs who, even so, had been known for their advances in medicine.

A month after he started *David* he requested that a wall be built, allowing him to continue in private. Nearly two years later, it was removed. The problem arose as to where to put it. So great was its immediate impact that a panel of Italy's finest artists and most prominent citizens, 28 in number, including Botticelli, Filippino Lipp, Piero di Cosimo and da Vince himself--perhaps realizing that the statue would become the symbol of Florence itself--were united to decide where to put it. Months of discussion ended in accepting Michelangelo's own request to place it in the Piazza della Signoria. It was pulled there over greased wooden beams. It was positioned on a plinth and its genitals covered with a garland, and there it would remain until eventually placed in the Accademia di Belle Arti in 1873.

The first miracle was its creation, the second its perfection thanks to the acceptance of dissection, and the third is that it has gone through riots, revolutions and wars and has come out unscathed, although nearly immediately four louts were imprisoned for throwing stones at it and had to pay heavy fines. Antonio Forcellino in his wonderful *Michelangelo*, underscores *David's* "provocative nipples ... a penis full of energy ... testicles full of vigor." *David* is the canon of male beauty, now and for always. This lad who might have just come out from swimming in the Arno, slightly grimacing at a friend's remark that the water must be cold, judging from his diminished manhood.

Vasari wrote that once one had seen *David*, one need never look at another statue. Strangely, at that very time another statue came to light, one sculpted well before the birth of Christ, unearthed in a field outside Rome in the presence of Michelangelo himself who had been summoned to see it. It is now in the Vatican and is proof that other magnificent creations *are* still worth seeing. It is the *Laocoön*, the story of which can be found in my book *TROY*. Later, in 1527, during a revolt in Florence, *David's* left arm had been broken. It lay on the ground three days until Vasari, then a young boy, ventured out during the fighting and recuperated the pieces that he sent to Cosimo I who, in 1543, had the arm restored.

After the *Pietà* Michelangelo did another virgin and child, the *Bruges Madonna*, for a Bruges merchant, and then the *Pitti Tondo,* a virgin and child carved from marble in the form of a sphere, not unlike a bas-relief. Martin Gayford in his wonderful *Michelangelo* claims that the model for this was a man. The chisel strokes are highly visible, supposedly because Michelangelo liked this particular carving in this unpolished fashion.

Julius II became pope, taking Julius Caesar's first name as his own. Julius asked Michelangelo to build his tomb and asked where it should be placed. Michelangelo answered "in St. Peter's that I will build." "At what cost," asked the pope. "100,000 ducats" was the artist's answer. "Make it 200,000" was Julius' rejoinder. Julius had a passion for collecting ancient sculptures, more so even than Cardinal Riario, a friend, the man who had recommended Michelangelo to him. Julius advanced 1,600 ducats, money that Michelangelo immediately invested in land around Rome and property in Florence, especially houses in the Via Ghibellina, as well as depositing a part in the bank. He then went back to the Vatican to beg for more, which infuriated the pope.

He went to Carrara to command the marble. Martin Gayford takes over with this amazing scene: "One day when he was high up in the mountains above the town of Carrara, looking down at the peaks and valleys below and the Mediterranean in the distance beyond, he formed the wish to make a colossus that would be visible to mariners from afar. In other words, Michelangelo wanted to carve a chunk of mountain into a human figure. One guesses, though the subject is not described, that he had in mind a naked male body."

Julius was as impossibly irascible as was Michelangelo. When the artist went to see him and was repeatedly turned away, Michelangelo left for Florence. The pope, furious, sent five horsemen to bring him back, but as Florence was beyond the church's pale, they could do nothing. Political infighting ensued between the pope and Florence, the end result being that Michelangelo was forced to capitulate as no one could conceive of defying the pope. Julius had made the capitulation easier by sending someone to inform the artist that "No one will harm or offend him, and he will be received by us as if nothing amiss had taken place." Then, as would happen again and again, the pope changed his mind, deciding that painting the upper reaches of the Sixteen Chapel should come first. He rode off to war with Bologna and, winning, then decided that a statue of himself should mark the event. Michelangelo was called for and actually did cast a huge figure in honor of Julius, a statue that was melted down the moment Bologna was lost. And Gayford writes: "The tantalizing suspicion is that it must have been a masterpiece."

Michelangelo returned to Rome and started work on the Sistine Chapel, painted daily on fresh plaster, a technique of such huge difficulty that even da Vinci is suspected of having given up work on his *Battle of Anghiari* because of his failure in mixing the right components, and then, later, making mistakes when doing *The Last Supper* which, consequently, is lost to us forever. That Michelangelo succeeded on just the mechanics, mechanics on such an incredible scale, is in itself a miracle, not counting, afterwards, the choice of the right oils and right pigments. A patch of

plaster to be covered during a day's work was called a *giornata*, the seams of which cannot be seen from afar. Errors could be made up for by painting over the dried plaster, *a secco*. Differences in temperature and humidity complicated the making of the plaster, and the mixing of the colors was a daily challenge, especially as the final result could only be verified once the plaster had dried. Mistakes, when not corrected by painting *a secco*, led to the destruction of the day's work, starting again from scratch. Drawings were made on paper and transferred to the fresh plaster in two ways: In the first the paper, called a cartoon, was held against the plaster and holes were pierced along the lines of the drawing with a sharp instrument; the cartoon was taken away and the holes left an outline of the figures to be painted. Or secondly, the cartoon was pierced before being applied against the wet plaster and coal dust applied over the holes with a cloth. The Sistine paintings are an homage to the male body. In the part dedicated to the story of Noah, called *The Drunkenness of Noah*, Gayford points out that not only was Noah painted in the nude, his sons, shown covering the body while averting their eyes, were also painted--for absolutely no biblical reason--stark naked too. Gayford adds an interesting insight into why the church allowed nudity, saying that it was acceptable because God had made Christ as an incarnation of man, and so the body was not a shameful object. ''Here was a theological reason to decorate the chapel with buttocks, penises, biceps and pectorals,'' says Gayford. The surface he had covered was 1,200 square meters, his head looking always upward, compensating with each stroke for the distortions caused by the curved surface. The ceiling was covered with nine biblical scenes, from the division of night and day to the creation of Adam and Eve and the Great Flood. The lunettes, half-moon spaces around the chapel, were covered with biblical ancestors, the pendentives, corner triangles, with prophets and prophetesses. Four years later, at the end of his labors, Michelangelo wrote in a letter to his father, ''I work harder than anyone who has ever lived!'' And it was so. At age 37 the King of Rome had become the King of the World.

While Michelangelo and his men were bent over, painting in excruciating conditions, in humidity and the freezing cold, an integral part of churches, Raphael had come onto the scene and had won over Julius who gave him his Vatican apartments to decorate. Raphael was physically beautiful and exquisite in his manners. As opposed to Michelangelo, he treated his assistants as brothers, getting the best out of them at all times. He was eager to learn and immediately absorbed the techniques of other artists. He sought knowledge, his conversation was intelligent, his way with people impeccable. He was sociable--in every aspect the opposite of Michelangelo.

Known for his avariciousness, Michelangelo would also be known for eventually abandoning everyone around him, from assistants to lovers.

There were no exceptions. In this case, concerning the Sistine Chapel, he had invited friends from Florence to work with him, childhood friends as it were, paying them 10 ducats a months. But once the Chapel was nearly finished he dismissed them all, perhaps because friends were so much more demanding than strangers, and replaced them with Romans. He then spread the news that it was he, Michelangelo, who, after 20 months of intense labor, had painted the Chapel by himself, a piece of propaganda we see in films even today.

It is said that in the more difficult portions of the ceiling, the lunettes and the pendentives, he would place a handsome boy, naked, before the area to be painted and shine lamplight from behind him, leaving a shadow on the portion of plaster that he would then outline, a technique that immeasurably shortened the usual preparation. The males served for both men and women. The only hick, near the end, were the guests of rank that Julius would continually send him to be personally shone around the cramped space between the ceiling and the scaffolding, princes, dukes, even kings. Michelangelo was said to have fulfilled his mission with talent.

As mentioned, Lorenzo *Il Magnifico* had his son Giovanni named a cardinal at the ripe old age of 13. He was now 37 and pope, taking the name Leo X, although his coronation had to be put off until he was consecrated a priest, which had not as yet been the case. He is shown, fat, in a painting by Raphael, *Portrait of Leo X*, alongside his handsome brother, Cardinal Giulio di Guiliano de' Medici, son of *Il Magnifico's* assassinated brother, and future Pope Clement VII. Leo X was notorious for both the selling of indulgences and his homosexuality, of which there is no detailed confirmation. Along the same lines, Leo summoned Raphael to adorn the Vatican sauna with erotic paintings, in a room called the Stufetta del cardinal Bibbiena, one of which shows the randy goat-god Pan leaping from the bushes with a monstrous erection.

On the sexual front Michelangelo could solicit whom he wished, although longer, more intense relations were known to have existed with Piero d'Argenta, an assistant, and an assistant known as Silvio, whose bedside he refused to leave when the boy became ill. Antonio Mini, 17, replaced Gherardo Perini, 19, who wrote that he was ready to offer Michelangelo any service. Niccolò da Pescia, ''who lives with me,'' wrote the master, followed. There was Febo di Poggio and then Federico Ginori that Cellini describes as a young man with a fine spirit, noble, with handsome looks, whom a princess later took for lover.

We need now interrupt our story with an interlude to catch up on the political situation throughout Italy. The first chapter ended with the death of Alexander VI, a saint or scumbag according to whom one reads, and his son Casare, handsome, fearless and virile. These were extraordinary times, and what follows now is no less so, for we are discussing Italy and the

Renaissance, a time as hallowed as Ancient Greece and Ancient Rome. In a word, we're talking about the very center of the world.

After the death of Alexander Julius II decided he would have all the Papal States returned to the church, as a first step in reuniting the whole of Italy under his sagacious direction. Florence was necessary to the pope, but with the passing of Lorenzo Florence was no longer the same. As Vasari said of Botticelli, "Old and useless, ill and decrepit" he hobbled through the streets of Florence on crutches, an incarnation of the city itself. Luca Landucci, an apothecary who kept a diary, thanks to which Luca lives on through history, wrote this: "Three men were caught after murdering a Sienese physician. They were tortured most cruelly with red-hot pincers as they were led to the place of their execution. The people cried out for the executioner to make the pincers red hot, as they wanted them to be tortured without mercy. Young boys stood ready to kill the executioner should he not do his work well. The condemned men shrieked in the most horrible manner until hanged." This was what Florence had been reduced to after the Florentines had gotten rid of the last Medici, Piero, because he had failed in his effort to find peace with Charles VIII.

Now the Florentines elected an honest, industrious man to succeed him, Piero Soderini, who, with the aid of Niccolò Machiavelli (of *The Prince* fame), decided to arm the city by establishing a militia, as well as fortifying the wall that surrounded Florence. The pope, in the meantime, had conquered holdouts in the Papal States, such as Bologna (where Michelangelo was called to craft his statue), Rimini, Faenza and Ravenna. Afterward the pope made an alliance with France and Spain to chase away Venice, and then demanded that Italian cities unite with him to chase away his former allies, the French and Spanish. The pope demanded help from the Florentines who in no way wanted trouble with either France or Spain. They refused their support. Ten thousand of the pope's troops were slaughtered by the French and Spanish, which sent the Florentines into the streets to celebrate with bonfires and singing. Julius descended on Florence with what remained of his army, among whom was Lorenzo *Il Magnifico*'s second son Giovanni, the future Leo X, already fat and thrilled to be surrounded by virile soldiers who sang bawdy songs and bathed naked. (Piero, his first son, had drowned when a boat capsized two years after his father's death.) The troops made it to Prato, on the way to Florence, where the great historian Guicciardini tells what happened next: "The troops sacked the city, full of avarice, lust and cruelty. Two thousand died fleeing or begging for mercy." The town was literally awash with blood. No one was spared, neither children nor women whose naked bodies were left where they lay, in puddles of gore and semen. Despite Florence's preparations for its own safety, the destruction of Prato sent terror through the hearts of all, including Soderini who escaped dressed as a peasant.

Medici supporters took over the town and where, just weeks before fireworks had celebrated Julius' military defeat, now crowds cheered as Giovanni de' Medici entered and reoccupied the Medici palazzo. The reception was wildly happy, but nothing compared to a short time afterwards when Giovanni became Pope Leo X following Julius' passing. Then the crowds went crazy with happiness, there were fireworks and cannons fired from the fortifications. Leo X put the city into the hands of Lorenzo, son of his brother, the drowned Piero. Lorenzo was described as energetic, high-spirited and handsome, perhaps too handsome as he forthwith gave up his soul at age 25 due to syphilis and a wound he had received from an harquebus, an early muzzle-loaded rifle. The number of Medici who died young defies the imagination. Luckily, intercourse during the Renaissance was as easygoing with lasses as with lads, otherwise the Medici would have died out (as a large number of other noble families did).

Florence was then turned over to two louts, bastard sons Ippolito and Alessandro de' Medici, while Leo X died and was replaced by Giulio di Giuliano de' Medici, whose father Giuliano had been assassinated in the Santa Maria del Fiori during the Pazzi Conspiracy. He was a handsome Medici, described as saturnine, cold, morose, disagreeable and a liar. He had nothing going for him except his ability to govern intelligently. As advisor he chose the historian Francesco Guicciardini who thereby had a bird's-eye view of what went on in government (like Hadrian who took the immensely important Suetonius as *his* private secretary). Guicciardini didn't last long, no one could around Clement VII, but this was good news as he retired to his villa and his monumental oeuvre, *Storia d'Italia*.

Around this time there came to pass what is known in history as the Sack of Rome. The sack was carried out by the mutinous troops of the Holy Roman Emperor Charles V. France, Milan, Venice, Florence and Clement VII joined forces to counterman the growing power of Charles. As far as Clement was concerned, he wanted the papacy to be totally free from Charles V's continual intercessions. Charles' troops were persistently victorious but armies cost enormous funds and Charles was late in payment. The troops were a heteroclite mixture of mercenaries, thieves and deserters, even former soldiers leagued against Charles who now thought the wages would be better under the emperor, although there were also a number of followers of Martin Luther who wished to see the anti-Christ, Clement, at the end of a sword, the ultimate problem solver. Before reaching Rome they destroyed other towns, pillaging, raping and massacring. So inured had they become to blood that even the screams of children and babies left them unmoved. In defense of Rome were an estimated 5,000 militiamen and 500 Swiss Guard, mercenaries so valiant and fearless that the popes had taken them as their personal guards and Michelangelo had dressed them, like a Renaissance Yves St. Laurent. Rome

also had artillery that was lacking in the rebellious troops. Cellini was present, and later the artist claimed that it was he himself who fatally shot the leader of the rebels, Charles the Duke of Bourbon, who prided himself on his all-white cloak, a marksman's perfect target. The attack was terrible and the Swiss lived up to their reputation by fighting until all were dispatched, except the forty-two who accompanied the pope to the redoubtable fortification Castel Sant'Angelo.

The city was looted, every church, palace and wealthy home. Even peasants from surrounding villages joined in, so great was their hatred of Clement VII whose armies had pillaged their farms and taken their women to feed their bellies and satisfy their groins. Clement finally gave in and paid a ransom of 400,000 ducati for his life, as well as numerous parts of the Papal States. Venice found the moment propitious to seize surrounding properties. From then on Clement would spend the rest of his life avoiding conflict with Charles V. This also led Clement to refuse to grant a divorce to Henry VIII because his wife, Catherine of Aragon, was Charles' aunt, thus opening the way for the English Reformation and the loss of an entire nation under the Catholic Church. Rome's population was said to have plummeted from 55,000 before the attack to 10,000 after. Ten thousand people were thought to have been murdered. Thousands more died from disease caused by unburied bodies. The sack continued on for *eight months*, until there was literally no more to steal, no more undiseased women to rape and no more food to eat.

It was now that Alessandro de' Medici, age 19, was placed as ruler of Florence by his purported father, none other than Pope Clement VII. He was aided by his cousin Ippolito. Immediately Alessandro ordered the building of a massive fortress whose canons could be swiveled to point to an approaching enemy ... or on Florentines themselves. He impounded weapons in private hands and ordered the bell in the Palazzo della Signoria--the bell that had sounded for centuries, warning the Florentines of danger within or outside of the walls, the bell that had rung when Lorenzo *Il Magnifico* had been attacked and his brother killed, summoning Florentines and farmers alike to protect this great Medici--he ordered it to be melted down. Alessandro was hated and his end was incredible, an end that I shall divulge in a later chapter.

Alessandro was replaced by Cosimo de' Medici, only 17. Tall, handsome (his portrait by Jacopo Pontormo shows an exquisite youth) and knowledgeable. His father was Giovanni, the youngest son of Caterina Riario Sforza de' Medici whom we discussed at great length in Part II. He was secretive, cold, insulting and he trusted no one which probably saved his life on several occasions as old Florentine families like the Strozzi and the Salviati tried to overthrow him, only to be beheaded in public. He called upon Cellini on numerous occasions but he soon lost all heart for both art

and politics when he lost two sons to malaria. The third son, Francesco, ruled in his place while he lived, and became Duke of Florence after his death. Cosimo died at age 55, young in a sense, but old when compared to other Medici who died even younger. This ends our political interlude.

Michelangelo did an enormous number of statues throughout his life. He lived 89 years, and as he said himself, it would have taken four lifetimes to accomplish all he wanted to accomplish. But a lot of time had been wasted, nearly *40 years* on just the tomb of Julius II. Time wasted by popes demanding one thing, only to change their minds in favor of something else. Literally years were spent at Carrara seeking out the best marble. One thing is for certain, after his run-in with Julius no other pope ever treated him like a servant again. He sculpted the Tomb of Giuliano de' Medici: Giuliano himself, as well as a male nude (*Day*) and a woman (*Night*) who is nothing more than a male nude with breasts. Then he sculpted the Tomb of Lorenzo di Piero de' Medici showing Lorenzo, along with a male nude (*Dusk*) and another male nude with breasts (*Dawn*). Michelangelo hadn't tried to make the statue of Giuliano (whom he had known well, Lorenzo too) resemble in any way Giuliano, and the same with Lorenzo. When someone criticized this he answered, Who cares? In a thousand years no one will remember what they looked like. He did another statue, *Victory*, a naked boy with a strangely small head.

Sexually, he had his models and assistants, all of whom happened to be among the most beautiful and desirable boys found wherever he decided to set down roots. Michael Rocke tells us of a letter Machiavelli wrote to a friend, describing, in couched terms, what men did at night in Florence, what Michelangelo certainly did: ''A man of my acquaintance went from one site to another that lads are known to frequent, and then wound up finding 'a little thrush' agreeable to being kissed and having 'his tail-feathers ruffled.' After this successful find, the man sealed his conquest,'' as Machiavelli put it, ''by thrusting his *uccello* (dick) into the *carnaiulo* (ass).'' Benvenuto Cellini writes, in his autobiography, about a youth called Luigi Pulci ''whose singing was so lovely that Michelangelo, that superb sculptor and painter, used to rush along for the pleasure of hearing him whenever he knew where he was performing.'' Cellini goes on to say that Pulci's father had been beheaded for incest and that the boy had ''just left some bishop or other, and was riddled with the French pox.'' Cellini nursed him back to health, Martin Gayford tells us, after which the boy had an affair with the nephew of a cardinal and with Cellini's own mistress, in revenge for which Cellini wounded him with a sword. Pulci was later killed falling from a horse while showing off in front of Cellini's mistress whom the lad was still seducing. All this is proof again that, in Florence, as in ancient Rome, a boy took advantage of literally any orifice that presented itself. Another source tells us that Michelangelo ''spent time without end

helping boys, like Andrea Quaratesi, to learn how to draw." As Cicero had said of Plato who insisted he was platonic with boys, "If his aim was only to teach philosophy, how was it that he chose only handsome boys and never ugly ones?" The same was true with Michelangelo. Quaratesi was gorgeous, as seen in the master's drawing of him, *Portrait of Andrea Quaratesi.*

Cellini tells us that despite the revolts and wars and even the plague, Michelangelo had never seemed more relaxed, and indeed took time to wander around the city, paying special attention to handsome young men.

He was nonetheless getting old, around 50, and one wonders what his approach to boys was. Did he feel that his talent and willingness to instruct them compensated for his age, and for his need, ever more desperate, it seemed, as he grew older, to inhale their beauty? Could his art have gone on without them? Could he have survived as an artist for the exclusive sake of art? We won't know because to the very end he remained faithful to both, his art and to the blinding beauty of the boys that inspired it.

As Hadrian had found the boy of his life in Antinous, so too Michelangelo found his in Tommaso Cavalieri, who was described as being of incomparable beauty, of having graceful manners, and "more to be loved the better he is known." Vasari wrote that he was "infinitely more than any other friend" to Michelangelo. Michelangelo sent him a letter in which he said, "I promise that the love I bear you is equal or perhaps greater to that I ever bore any man, nor have I ever valued a friendship more than I do yours." Thanks to Tommaso Michelangelo would know his own Renaissance, a new life at age 60, and he still had 30 years left to share it with this young gentleman. Michelangelo immediately set himself to drawing, the most rapid way to offer presents. One was *Tityus*. Tityus was Zeus' son who tried to rape Leto, in punishment for which he was eternally attacked by a vulture. Michelangelo showed him, in Gaylord's words, being assaulted with "the great bird's groin pushed against his buttocks." Next came the drawing of *Ganymede*, being carried off to Olympus where he would serve as Zeus' servant and bedmate. Then came *The Risen Christ*, a full-frontal nude, followed by *Phaeton*, the son of Apollo who nagged his father until allowed to drive the chariot of the sun. He lost control and Zeus had to kill him before he hit the earth, destroying it. Another highly unique drawing was *The Dream*, showing a naked young man surrounded by a ring of vices, a woman (a man with breasts) awaiting copulation, the exquisite buttocks of another young man, and a fully engorged dick. The gifts to Tommaso, all accompanied by what would turn out to be dozens of sonnets.

His favorite brother Buonarroto, the only one who married, died, and Michelangelo took over the care of his children, two boys of whom only Leonardo survived, age 9, who came to live with him, and a girl that he put in a nunnery until marriageable age. The story of Leonardo is amusing as

later, when he was 20, Michelangelo would fall ill and the boy would rush to his side. But the master knew the boy by then, and knew that only his money interested him. He therefore chased him away, telling him, literally, to never darken his doorway again. But as the lad was the very last of the Buonarroti--and Michelangelo wanted the name to go on--he was forgiven. As I've written, at one time or another Michelangelo broke off with nearly everyone he had known. Even when his brother Buonarroto was living Michelangelo said he was disgusted with his family: "I feel that I no longer have a father or brothers or anyone else in the world."

Michelangelo served the popes in diplomacy. One of his statues, *Heracles*, was sent to François in France, the same François who held the dying head of da Vinci. The artist was also dispatched to Ferrara where the duke, Alfonso d'Este, was wild with joy to receive him. As I've written elsewhere, "Alfonso was known to have two interests in life, making cannons in his own personal foundry and parading around town at night, his sword in one hand, his erect cock in the other. His former wife had been so fed up with him that she turned to women for satisfaction. He later married Lucrezia Borgia and at her death he married his mistress, apparently very rare during Renaissance Italy." Due to renewed problems in Florence Michelangelo considered going to the court of François I--he would have been there at the same time as da Vinci--but Florence threatened to jail him if he didn't return home, which he did.

In Florence Michelangelo painted *Leda and the Swan* for his new friend Alfonso d'Este. We see a nude woman in the wings of a swan, its long neck stretched across her belly. You may remember that Zeus took this form to impregnate Leda, slipping his head and neck into her … well … you know. The result was that Leda gave birth to twins, Clytaemnestra and Helen, from the same egg, half fertilized by Leda's husband and the other half--the half that produced Helen--by Zeus. (You can find the full story in my book *TROY*.) The painting was later destroyed in France because it was found quasi pornographic.

Clement VII died and Paul III took his place. He had been named a cardinal by Alexander VI because he was the brother of Alexander's mistress. The Romans thereby changed his name from Cardinal Farnese to Cardinal Fregnese, "Cardinal Cunt." Paul III had been waiting years to get his hands of Michelangelo and did so now by ordering him to paint *The Last Judgment* in the Sistine Chapel, an immense work that would require scaffolding seven stories high and take five years to finish, longer than he had taken on the entire ceiling. In other Last Judgments only the damned were featured naked. Here nearly everyone was, the saved and canonized alike. As Gayford says, "nude, curly-haired young men with the bodies of Oympic shot-putters passionately kiss and caress. Some of them hug grey-haired elders." The genitals and asses were later covered with tissue by

Michelangelo's assistant, Danielle da Volterra, after his master's death, his only claim to fame.

Michelangelo received a letter from the playwright and pornographer Pietro Aretino whom we meet in the chapter on Raphael. Aretino gave suggestions as to how to paint *The Last Judgment*. Aretino had had to flee Rome after an attempt to assassinate him due to his malicious comments on the clergy. He went to Mantua where its ruler offered to do the job himself in order to gain favor with Rome. Aretino then fled to Venice from whence he wrote Michelangelo. It was a measure of his importance that the artist responded, saying that while the letter filled him with pleasure, it had come too late as he had finished the painting.

To a certain high-ranking critic who was shocked by the nudity in *The Last Judgment,* and suggested that its place was in a sauna or tavern, Michelangelo painted the critic into a corner, showing a serpent chowing down on the critic's penis (find it on the Net because it's hilarious—and magnificent *à la fois*).

Paul III bestowed a yearly salary on Michelangelo that would literally keep him and his family in opulence until the end of their lives. At the same time Michelangelo was offered total control over the restoration of St. Peter's, construction that had gone on for centuries at the cost of untold thousands, most lost through scandalous waste and theft. The new money did not free Michelangelo's mind, for such was his nature that he could never ever distance himself from worry. At the moment it was his nephew Leonardo who was still a problem, as he wouldn't marry. He did prove himself capable, however, of reproduction, as he fathered a son on the wife of a stonemason. The boy lived his own carefree existence, feuled by Michelangelo's considerable fortune, but such were the fireworks between the two that Michelangelo could quite literally not stand to be in the presence of the lad. Yet the boy's semen was vital to the survival of the Buonarroti name and Michelangelo seemed crazed by the possibility that the family name would be lost forever. Leonardo, for his part, tried to come to Rome as often as possible to learn--felt Michelangelo--were every ducat of the artist's money had been invested or squirreled away, every piece of land, every farm, villa and building, every bank as well as what the master hid under his bed, be it drawings, paintings, cartoons or gold. He wanted to be on hand too, Michelangelo was certain, when the artist's final hour came to make sure that the likes of Urbino, much younger than Michelangelo, wouldn't steal everything not nailed down. Nonetheless, here Leonardo drops from our story and from History, but let it be known that he did have a son, Michelangelo, who died, but was followed by another son. Today Italy is full of Buonarroti, but how many hail from the genius is unknown. Another of Michelangelo's problems was the loss of his master builder, Cesare, who had built the *Last Judgment* scaffolding and was a vital aid

with St. Peter's. The boy was caught between the legs of a young beauty whose husband dispatched them both with a knife, although the girl survived.

Julius III replaced Paul III. He was a lucky pope in that during his reign Queen Mary returned to the English throne and Catholicism was restored, all of which led to his glorification and allowed him to live the lazy, dissolute existence he favored. Added to this was the fact that he possessed great administrative talent and as he had been named governor of Rome twice, he had that center too in his corner. He built an incredibly luxurious palace, the Villa Giolia, adorned by Michelangelo and Vasari and lesser artists who decorated it with Ganymedes and other soft-core pornographic satyrs and naked angels.

Like da Vinci and his Salaì, Julius had fulfilled his erotic fantasies thanks to a youngster, Santino, a streetwise urchin of 14 he saw and lusted for. He had his brother adopt the lad who then became his nephew, on whom he showered benefices and named a cardinal, ennobled under the title of Innocenzo Ciocchi Del Monte. He boasted of the boy's prowess in bed, Julius being the bottom to "his hung boy."

Of Julius the governor of Milan wrote, "They say many bad things about this pope, that he is vicious, arrogant and crazy." Thomas Beard wrote: "He makes a cardinal only of those who bugger him." The Venetian ambassador to the Vatican, Matteo Dandolo, wrote home to say that "the pope shared his bed with a boy cardinal."

After the pope's death Innocenzo killed two men who had insulted him in some unrecorded way. The newly elected Pope Pius IV had him arrested and imprisoned for several years. He was again arraigned for raping two women but was released thanks to Julius' friends. He died in obscurity and was buried, without a funeral, in the Del Monte chapel next to his benefactor who had preceded him in death at age 68, from fever.

Julius III and Michelangelo were about the same age, around 75, and Michelangelo was even closer to him than he had been with Paul III because Julius had more of an aesthetic sense than Paul, and then, both men shared the same erotic interests.

Calamity came when Julius was replaced by Paul IV, father of several children, among whom was a merciless killer and sodomite whose savage rape of a young priest cost the boy his life. The murderous son was Pier Luigi Farnese, who would later nearly totally ruin the life of Cellini. He was primitive, cruel, ruthless, decadent, courageous and daring (the perfect subject for a book that, for the moment, doesn't seem to exist), and at age 17 he was already a mercenary in the pay of Venice, along with his brother Ranuccio. Under his father the pope he was given certain lands that he taxed to death, permitting, among his favorites, theft and murder. The boy was so evil that Pope Clement VI had tried to excommunicate him, only to

be dissuaded by the bastard-boy's father. Pier Luigi was named head of the papal army, and another brother, Alessandro, was made a cardinal. Another of Paul's sons, Ottavio, married the illegitimate daughter of Charles V and his boy Orazio married the illegitimate daughter of Henry II of France. Pier Luigi was finally deprived of his miserable existence by Giovanni Anguissola who stabbed him to death and then threw the body, his neck attached to a rope, from the window of Pier Luigi's palace in Piacenza. After all kinds of ups-and-downs the duchy Pier Luigi ruled over finally went to his son (this one legitimate) Ottavio. Paul IV called in the Inquisition, saying that he would burn his own father should he be a heretic. He imprisoned many of Michelangelo's free-thinking friends and even, just hours of taking power, cut off the funds that had been awarded to Michelangelo by Paul III, so rapidly that the decision could only have been made before Paul IV became pope, proof of a visceral hatred for the artist. He appointed Pierro Ligorio, a bitter enemy of Michelangelo, to keep an eye on the construction of St. Peter's. Michelangelo had to put up with all this the best he could, especially as he was no longer armed with the resilience of youth. Cosimo I learned what was going on and immediately sent word to Michelangelo that he would be welcomed back at home, Florence. But Michelangelo had become too invested in St. Peter's to withdraw, thinking, perhaps, that his eternal salvation--his place beside God--depended on his continuing God's work. And then again he was old, and could allow himself a certain detachment from the earth he would soon be leaving. Since the breaking of his nose and the loss of his adolescence, when all boys, or nearly, are beautiful, he had lost his own beauty, and although boys without number were attracted to the renowned master he was, this was less the case, less because in that domain he now lacked confidence and also, through their beautiful eyes he saw his own decline, unbearable and intolerable and ... ugly.

Then absolute disaster struck. Francesco d'Amadore, whom he called Urbino, died. He had come into Michelangelo's service as a young man when the master was himself but 30. Michelangelo grew to love Urbino, but in a decidedly different way from Tommaso. Urbino was well cared for, fed and clothed, and he did whatever was needed, from shopping to the grounding and mixing the paints. But he never received a drawing as did Tommaso. Nor did he merit a sonnet. Yet he was always there. Michelangelo would never put on a clean shirt to greet him, nor, when the sap rose while painting his nudes and he wanted relief, would he need more than pull the ribbons that released the cloth covering his engorged manhood, waiting for Urbino to do the rest. Urbino was always there. Just there. Until he was there no longer. It was then that Michelangelo died, not the biological end that came later. God may not exist but we need Him to exist, He must exist in something, and that something, for Michelangelo,

was Tommaso de' Cavalieri. He was the love of Michelangelo's life but not *the* love. That was Urbino, the only person permitted to accompany him during the painting of *The Last Judgment*. Just before the end Cellini had pleaded with Michelangelo to return to Florence, leaving Urbino behind to take care of his master's workshop and belongings. As Cellini related in his autobiography, ''Hearing this, Urbino, in an uncouth way, shouted out 'I will never leave Michelangelo, not until either he or I is under the ground'.''

Michelangelo's last major work was a second *Pietà* that, halfway through, he tried to destroy with a hammer, before being held down by his assistants. It has been written that he had struck in anger, anger at the death of Urbino and anger at Paul IV who had cut off his finances and had threatened to destroy his *Last Judgment* because of the filth--the exposed cocks and asses, painted over later on, as I've written, but, alas, they remained covered even after the 1990's restoration because the painting would have been damaged. Some say he was angry at the arrest of his friend Cardinal Giovanni Morone by the Inquisition or that he tried to destroy his oeuvre due to his exasperation at finding a fault in the marble. Just as many sources claim that Urbino was dead at the time while others maintain he was alive, and that it was he who had stilled the artist's hand. Experts say that they have examined every millimeter of the marble and have come up with no flaw in the marble, while others are certain that the ''fault'' was no longer visible because it was part of the pieces Michelangelo destroyed. This is a long way to get to the point I want to make, which concerns the man's sexuality. There are those like myself who afford Michelangelo a full sexual existence because, based on the unmatched eroticism of his paintings and sculptures (even in the last one, the second *Pietà*, Christ's loincloth is lowered right to the pubic bush)--and based on the sensual beauty of many of his sonnets and letters--his intentions at physical love did not stop at the end of a chisel or a brush or a pen. Forcellino in his really wonderful *Michelangelo, A Tormented Life*, maintains that his sexuality was sublimated into his art, meaning, if you take a stand totally opposed to my own, that he might well have died a virgin. After all, writing love letters could as easily be described as an act of sublimation as it could have been a kind of foreplay in preparation for the real thing. No one can know; no one ever will know. Based on my own experiences, I can only hope that he knew the exquisite love of Italian boys, the warm body of a lad warming an open bed, the only veritable felicity since the Greeks, since Alcibiades himself. (2)

An amazing number of historians excuse evident same-sex activity as a ''youthful phase,'' and/or a ''passing bisexuality.'' They are totally immured in their ignorance of a simple fact: Renaissance man was omnisexual, he never ever thought in terms of homo/hetero/bi behavior

(words that didn't even exist). He simply did or didn't or did partially or did fully, according to the clear needs dictated by his loins. In fact, he enacted the advice that Marlon Brando offered a friend: "Don't ask questions. Go in the direction that your erect dick is pointing. It never ever lies."

Surrounded by what the world has to offer in supreme beauty, Michelangelo died alone, having pushed away even Tommaso at the end, thusly sparing himself the cruelest of all destinies, seeing his own ugliness reflected in the eyes of those he had cherished most, the eyes of his lovers, models, assistants, apprentices, boys he met and offered to draw or to teach how to draw, boys in taverns and in allies after dark in a city, Florence, reputed for its warm nights of sublime encounters--with the imperishable boys of imperishable Italy. There would be no Salaì or Melzi at his side. Like Hadrian who lost Antinous, he too would meet his maker alone--the world's supreme artist, not just in his time, but of all time.

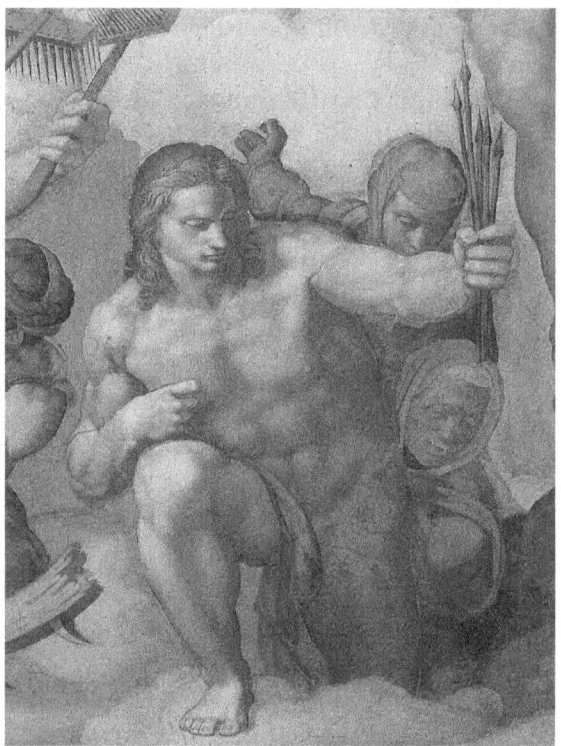

Michelangelo's Sebastian

SODOMA
1477 – 1549

Il Sodoma was his name and he seemed content to have it. He was extremely prolific, said to base the quality of his painting on the sum of money the patron shelled out--the greater the pay, the more time he spent on a canvas. He worked at his own rhythm, when he felt like it, which was nonetheless often. He surrounded himself with a menagerie of animals of every imaginable kind, and boys and young men, boys and young men in profusion, beautiful and all beardless, whom he entertained with jokes and pranks, keeping them in stitches, smiling, always smiling as they horsed around in his bed.

He loved pranks, as I said, and this story has come down to us: A group of monks commissioned a holy scene of virtuous virgins. Sodoma kept the monks out of his studio while he painted a bacchanalia of sluts, the whore friends of his friends. The monks nearly keeled over when confronted by the frolicking nudes. Outraged, they were determined to destroy it. Sodoma, bent over with peals of laughter, painted draperies over the whores, the end product of which was indeed a scene akin to that of joyous virgins, joyous in their virginal love of Christ.

Sodoma was born Giovanni Antonio Bazzi, son of a shoemaker, in Vercelli but spent the bulk of his life in Siena. He's known to have created scores of paintings, the most famous of which are his *Alexander in the Tent of Darius* and *The Marriage of Alexander and Roxanne*, in which Sodoma highlighted Alexander's lover, Hephaestion, making him naked and accompanied by a boy showing him affection. Sodoma married and had a son, but at the time this was par for the course among ingrain boy lovers. He did a St. Sebastian, beautiful and highly erotic, with a horrifying arrow piercing the youth's neck.

His favorite pastime was the races, in which he entered horses, usually borrowed from patrons. He was well known to the stable boys whom he affected, and his generosity went a long way in winning their affection in return. In circles of debauch he was called only Sodoma, the usage of which one and all found amusing. There is this story told of him: At the end of a certain race the horse he had entered won. The presiding officials asked whose name to call out, as it was the custom to honor the owner in this manner. The stable boys, knowing only that he was called Sodoma, gave that name. The officials just repeated it, paying no attention to its meaning. But the crowds of race goers, mostly old and conservative, raised a howl of protest and Sodoma barely escaped with his life, so bent were they on stoning him to death. He nonetheless recuperated his trophy which he proudly showed visitors to his home from then on.

He died at age 75, eclipsed by the giants, da Vinci, Michelangelo and Raphael. Some say he died unknown and in poverty. But maybe, just maybe, there was a Salaì or a Melzi somewhere in the shadows.

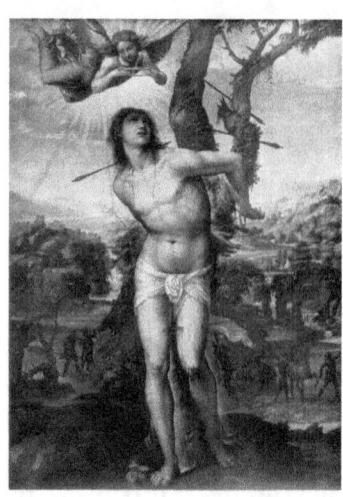

HENRY VII – PERKIN – JAMES IV – MAXIMILIAN
AROUND 1490

In other chapters I recount, as honestly as possible, the intellectual and political settings for the artists who have left so many wondrous stars in our midst. We can never be grateful enough for men such as Cosimo de' Medici for bringing in the Renaissance thanks to the uncovering of texts from the Sun of all these stars, our hollowed ancestors the Greeks. I've tried to bring back the lives of Cosimo and his grandson *Il Magnifico*, leaders like the Sforza, Alexander VI and Julius II, Cesare and Catherina de' Medici. In this chapter we'll discover Edward IV and Henry VII of England, and the role of the scum who took the lives of two innocents, Richard III. We'll discover Margaret of Burgundy. We'll uncover the stories of two lads, so unique, so incredible that their existence is believed only because we have the facts locked away in documents: Simnel and Perkin.

The story of Simnel and Perkin is as true as one can make it after half a millennium. It's a passionate tale that involves five very lonely people: A boy who lost his father and his brother, and was himself purported assassinated at age 9: Richard, son of Edward IV. A tale of another lad, abandoned young to his destiny, whose love of beautiful clothes--a setting for his own beauty--would lead to the loss of his beautiful head, a lad born with the name Perkin. A woman, Margaret of Burgundy, wife of Charles the Bold and sister of King Edward IV and Richard III, whose only request of life was the birth of a baby she would never bear, but who found her consolation in adopting two other lads, two pretenders, Simnel and Perkin. A king, James of Scotland, whose father died in war and who spend his childhood seeking another. And, finally, a king marked by the loss of his father at an early age; a king who fought tooth and nail for a kingdom and won it thanks to the death of the boys in the Tower, King Henry VII.

Richard, Duke of York, second son of Edward III, and his brother Edward were smothered by their uncle, their father's brother, Richard III, in the most vile murder England has known, the murder of two children. Little Richard and his brother Edward V had been locked in the Tower of London. As Edward was the older he guessed at the fate awaiting them both, and despite Richard's trying to entice him into play, he grew each day more saturnine. When the end did come, in the midst of the night, it was Edward who was thankfully asleep, while Richard, seizing immediately the purpose of the men who stole into the boys' chambers, begged them to take him and permit his brother the king to live. The assassins took both. Richard III was later killed in battle, his soul brought to rot each time one opens Shakespeare to read of his dastardly deed, the robbing of two boys of their precious lives.

Perkin, the boy who would be chosen by Yorkists to replace the smothered Richard, was spotted, in Ireland, during a festival on which the usual sumptuary laws did not apply. Decked out in superb doublet and beautiful black gown, news of his beauty and countenance brought his attention to those who wished to undo the King of England in favor of the Yorkists, in battle against the Lancastrians for generations. The boy refused his being taken for royalty, refusal upon refusal until the awe and respect of those who had approached him--he whose parents had set him on his own like a wandering gypsy from childhood--gradually succumbed to their impressments. The task was herculean in its vastness: He would have to learn manners and princely comportment. He would need the Latin learned as a child by the real Richard and the English language the real Richard had spoken since birth. He would need to know the daily lives of his father, King Edward IV, and his mother, as well as those of their advisers and his and his brother's servants. He would need to know his daily routine from the moment he awoke to the moment he retired.

It was the sitting king, Henry VII, who would have to unmask the lad, a lad already accepted by the French king Charles VIII who was about the same age and who received the boy at his court and shared his mistresses with him, no big affair for Charles who prided himself on never having the same woman twice, even if he was the most ugly monarch in living memory. The lad was recognized by the Roman Emperor Maximilian and his son Philip, also about the same age as the pretender, and on friendly terms with him.

Henry VII was the monarch who founded the Tudors, ending--with the death of Richard III at Bosworth--the War of the Roses that had bled England white for generations. He would impose 24 years of relative peace, followed by his son Henry VIII. He married Edward IV's daughter Elizabeth, unifying his red rose to her white rose. An act of genius immediately followed. He declared himself king a day *before* the Battle of

Bosworth, thus allowing him to proclaim that those who had fought against him had been traitors, allowing him to confiscate their lands, castles and their goods. Then, after his coronation, he decreed that any of the traitors who would swear fealty to him could have their possessions back. Edward IV had had two bothers, Richard who became Richard III, now dead, and Clarence. Clarence had been convicted of treason and executed. But Clarence had a son, Edward, a possible threat to Henry VII because of blood more noble than Henry's. He was put away in the tower. Later Edward would share his cell and his bed (a usage of the times) with Perkin, and plot with the boy to overthrow Henry VII. For this Edward would be beheaded.

But the plot thickens: A lad named Simnel appeared to claim that he was Edward, Clarence's son. As the real Edward was being held prisoner in the Tower, no one could dispute his claim.

No one knows Simnel's real name, but around age 10 he was taken under the wing of a priest, Richard Simon, who decided to make the handsome boy a king. At first Simon decided that the boy would be Edward IV's son Richard, especially as their ages matched, but then switched to Edward, Clarence's son. The priest Simon was exceedingly erudite and taught the boy everything he would need to know about courtly behavior. Simon contacted Yorkists who found in Simnel the perfect tool to overthrow Henry VII. They began by spreading the rumor that Edward had escaped from the Tower and made his way to Dublin. It was in Dublin that Simnel was crowned King Edward VI (Edward IV's son, killed in the Tower by Richard III, had been Edward V). An army was mounted and various Yorkists went to Burgundy where Margaret of Burgundy, Edward's aunt, held power. She furnished 2,000 men who returned to England and met Henry's troops at the Battle of Stoke Fiend where they were defeated. Those not killed were executed except for Simons, saved due to his being a priest, although he was imprisoned for life. Incredibly, Henry felt that Simnel himself had been nothing more than a lad manipulated by adults. He made the boy a spit-turner in the royal kitchen, and later a falconer! The boy married and fathered a priest who exercised under Henry VIII.

What happened next was stranger still. A lad by the name of Perkin Warbeck (among other names, but we'll stick with that one, although from the age of about 17 onwards he'll be known to one and all as the boy who pretended to be Richard, the younger of the two lads imprisoned and executed by Richard III, and so I, too, will call him Richard until his capture by Henry VII). His mother supposedly sent him to Antwerp to learn Dutch and from there he was taken on by merchant ships that may have taken him as far as Portugal. But eventually he turned up in Ireland where his love of sumptuous clothing brought him to the attention of

Yorkists who convinced him to play the role of the smothered Richard. From Ireland he went to Margaret of Burgundy, sister of Edward IV and Richard III, who wanted the Yorkists back on the throne with such intensity that she undertook the education of Perkin. He learned the ways and the secrets of the court of England, and his aptitude for languages and personal beauty did the rest. Margaret sent him to James of Scotland.

What followed next can only be described as a love affair between Richard and King James IV. A true love affair, albeit not necessarily in a physical sense. We do know that both Richard and James were ardent lovers of the opposite sex. Richard had wandered through Europe as a child and his early adolescence had taken place in Portugal and the royal court of Portugal, known for its liberality in matters sexual, and the ardor of its boys and girls in the sharing of their bodies. James was insatiable, sexually, as were so many males of position throughout Europe, satisfying himself with the girls--from servants to courtesans to ladies of royalty--who expected and desired his attention. As Henry VIII was to learn, thanks to Anne Boleyn and her sister, whom Henry had "known" long before Anne, girls brought up at French court, as had both girls been, could pass afternoons and nights in endless sexual pleasure, while still maintaining an intact hymen. Fingers, tongues and back passages were of no secret to even the youngest demoiselles in France and Portugal. Boys adored ornamenting themselves in skin-tight trousers, leaving nothing of their muscular buttocks to the imagination, and, in front, held in place by strings or buttons, were cod pieces of immense dimensions, as alluring to maidens as were the boys gestures, their hands stroking the immense bulges, or equally caressing the curvature of their own asses.

As so often with boys at that time, James had lost his father to battle when very young, and literally went from man to man, afterwards, with the heart-breaking question, "Are you my father, sir?" Richard had been set free from his father far too young, as had Henry VII whose father died in battle even before his birth. These men were drawn to their own through an absence that nothing in the world, nothing but one's true only father, can fill. This indelible emptiness was felt even when a father was physically alive but physically absent, called away, perhaps, by war, or simply not present to assuage the needs of his boy. This was the case with Maximilian whose father, the Roman Emperor Frederick III, lived to old age but was away at war, during which his son Maximilian had at times to beg for bread. Rare were those like Cellini to have a dad who desired a son more than life itself, and when presented with the precious gift loved him insatiably, naming him *Benvenuto*, Benvenuto Cellini.

James, at 22, was just a few months older than Richard. From the moment of Richard's arrival James took him in hand, literally in hand in the sense that at every possible occasion, and especially in church, James

entwined his hands in those of Richard, hands joined in the worship and the presence of God. They ate together, perhaps not from the same plate as Richard Coeur de Lion and Philippe II, and they slept in the same bed, without the intimacy of the young and futures kings of England and France--Richard Coeur de Lion and Philippe--but in a tradition even known to President Lincoln, and common in the American Far West.

James was generous to a fault and far from rich, but Richard had nothing. After the mass, it was James who would make a contribution in the name of his friend. James was an athlete, but too trusting, as even his closest advisor, John Ramsay, was a spy in the pay of Henry VII. He was so concerned about his people that he would roam the countryside dressed as they, and seek lodging for the night amidst the most humble, all in an effort to learn what they thought of their king.

And lastly, James provided for his guest's needs by giving him the daughter of the wealthiest man in Scotland, Katherine Gordon, daughter of the Earl of Huntly. She was young, beautiful and virgin, and James saw to it that the marriage could take place rapidly so that Richard and she could enter into union. Later, a captive of Henry VII, Perkin was denied access to Katherine, the reason for his ill-considered actions, while Henry lusted for her but apparently did not take advantage of his limitless powers. James and Katherine would remain loyal to the boy to the end, even if James was forced to make certain concessions to Henry in order to save his country.

James and Richard recognized in each other the brother neither had ever had, the shared resemblance of two boys of the same age, the need of masculine affection that no woman can ever fulfill in a man, the reason men defend each other to the death in war, the indestructible nature of friendship we find in today's Australia where even a homo-hating redneck would die for his mate.

Naturally, everyone thought that with Richard on the English throne they could, one and all, gain something of priceless value with Richard in power. Margaret would have more say in the running of her Burgundy. The Roman Emperor Maximilian would have an English ally he could order around, as he could no longer do even his son Philip. And James would enjoy increased trade and more fluid relations with his neighbor England. But all said and done, James' chief motivation may well have been the beauty of his friendship with the boy-who-would-be-king.

It was James who insisted on invading England, and Ramsay reported to Henry that James, who loved joists and fighting with axes and swords and crossbows, was pushing the boy forward. But Richard was not enthusiastic about an invasion because he *knew* the truth behind his right to the throne of England. And anyway, he had a new wife with lands and nobility and in September he would have a son. What was the chimera of England now to him? He most resembled the Trojan Prince Paris,

ensconced with Helen, behind the impregnable walls of Troy. But like Troy, the Greeks were coming in the form of Henry. (4)

One is nonetheless amazed by the backing Richard benefited from. Maximilian and Burgundy under Maximilian's boy Philip; Margaret capable of offering vast sums of money; and a huge number of Yorkists and other supporters, all furnishing troops, horses and finances. A great number of Yorkists from England sent their seals to Richard as proof of their adherence to his plan of conquest. Alas, the seals were intercepted and forwarded to Henry who had most of the men, the cream of English nobility, beheaded. Only the very young were spared, if imprisonment for life can be so judged. Some did buy their way out, others had been truly loved by Henry and it was they who had no chance of being pardoned. Also, the sums invested by Henry in his defense were absolutely colossal. This was especially painful to a man who was one of history's original misers, amassing the greatest fortune England had ever known, money that would go to his son Henry VIII, making the boy, already lucky in looks and lucky in advisors, the richest lad in the world--until the gods decided to tip the scales, that is, near the end.

On the sidelines of all of this were Ferdinand and Isabella, King and Queen of Spain, a couple who had loved each other the moment their eyes met. Their intelligence, in the sense of brainpower and spies, was such that they knew the truth about the boy, and spent every hour trying to convince the world, and thereby avoid useless wars. They brought order to government, they saved Spain from bankruptcy, they reduced crime for the first time in the country's history, and, icing on the cake, they sent Columbus on an excursion that would double the surface of the known world and enrich it beyond the grasp of the imagination.

At age six Isabella had been promised to Ferdinand but later it was suggested that she marry Edward IV of England or his brother the future Richard III, killer of infants. For unknown reasons she held strong to her desire to wed Ferdinand. An obstacle to their union was their consanguinity, but this was overcome by the Spanish Cardinal Borgia, the future Alexander VI. Her brother the king nevertheless disapproved, forcing her to escape to the wedding site, Valladolid, where she was joined by and married to Ferdinand who had been disguised as a servant to avoid the king's army. When the king died she was crowned but for the first years she had to wage war against those who thought they had a better claim to the throne. Even Portugal invaded in an attempt to seize power. Her place finally became legitimized with the birth of a son.

Slavery was forbidden under Ferdinand and Isabelle but the interdict was little applied. The Inquisition was given full power and Jews were allowed three months to leave with Spain neither gold nor silver nor money

nor arms nor horses. Half are thought to have converted, perhaps cosmetically. Muslims too were ordered to convert or to get out.

Their daughter Joanna was married to the Roman Emperor Maximilian's son Philip, opening the door for Roman rule over Spain. Their youngest daughter Catherine married Henry VIII's brother but he died, supposedly before consuming the marriage. Catherine went to Henry VIII himself, sowing the seeds for the destruction of the Catholic Church in England.

At Isabella's death she was entombed in a sepulcher built by the Roman Emperor Charles V, the new Charles I of Spain, Joanna and Philip's son. Ferdinand followed her, in the same chapel, a few years later.

James' plan seems to have been to cross the boarder into England, grab a few boarder towns, and thanks to the uprising of the English people--especially Yorkists from the north, he would return home and let Richard continue on to glory. Before setting off, both friends had signed an agreement under which certain lands and towns would be given to Scotland, and 100,000 marks forwarded to James' coffers once the lad was on the throne.

The boarder was crossed and James initiated a burned-earth policy that left Richard in tears, claiming that James would leave him no one and nothing over whom he could govern. Richard rode off to the safety of Scotland and as Henry's troops approached, James did likewise.

Following the collapse of James' army, Maximilian kept doggedly at Richard's side. Ferdinand and Isabella tried everything in their power to get the boy to Spain where they could pension him off, thereby neutering him. Maximilian's son Philip had long given up on the lad. Margaret had spent her last cartridges in his favor. Charles of France desperately wanted Richard as a joker to play in his wars with Henry. And Ireland took Henry's bribes and turned its back on the boy.

Henry's troops approached Scotland. Henry offered James his daughter, age 6, in marriage, a peace offering. Although Henry did not hesitate to put traitors to death, he had a very enticing side, one that had forgiven Simnel, had paid for his marriage and had set the boy up as a falconer. And despite the hundreds of deaths occasioned by Perkin, despite the cost in today's money of millions to Henry and a hunt that had gone on for six long years, despite all that Henry took the lad to his side, when finally captured, not as a son, but not far from being one either. And now here Henry VII was, offering his daughter, his own flesh and blood, to his enemy. But James refused to surrender his friend Perkin to what he believed was certain death. Yet as the wolves closed in on all sides, from Spain and especially from England, James had no choice but to ask his friend to leave, at the head of a small army, on an ill-named ship, the *Cuckoo*, destination England where Richard would become king. No one

was present at their *à Dieu*, but I hope it was worthy of the sincere love and wondrous moments they had shared. Then the *Cuckoo* and a few other vessels left to land and reconquer England for Richard.

But Richard was intercepted by Henry and captured. Richard became Perkin.

As I stated, this is a tale of five unhappy people. Henry VII had been an only son, his father dead before his birth and no noble men to show him the route to manhood, let alone kinghood. He had no real pedigree, no real royal blood, and until the rise of Henry VIII such would remain the case. Affable, he was nonetheless a loner and would stay so until the end of his life. Perkin Warwick had stood alone from an early age, and the story of the conditions of his passing from one adult to another, as he passed from one country to another, will remain unknown, but was certainly trying and forlorn. His thirst for betterment was mirrored in his choice of clothes, which in turn brought him to the attention of others who would use him as he had always, in one way or another, been used. He lost to Henry but in so doing he gained a wife and child, was welcomed to Henry's court, one lonely man in the service of another, and there he could have risen to heights less than a kingly Richard IV, but to an unimaginable prosperity, given his lowly birth. It was perhaps Henry's own lowly birth, in comparison with other Yorkists and Lancastrians, that allowed him an intimacy--albeit limited--with humbler lads such as Simnel and Perkin. In his own gauche way he tried to make friends of them both, but it was the Fates, not men, the ultimate arbiters of one's destiny. Henry was 41, the boy, as he called him, 22. Perkin confessed all, totally astonished at the king's leniency. Maximilian and Margaret had known of the conspiracy, Perkin told Henry, no one else knew, and certainly not James. On bended knee the boy confessed, but his manner was unweeping and noble. His wife was brought before Henry who was said to have lusted for her but had kept himself in check by sending Katherine to serve his queen, Elizabeth. Order had returned to the world, the planets again in their rightful place.

Maximilian requested Perkin's freedom. Philip turned his back, provoking his father Maximilian to note the boy's willfulness and lack of cooperation. Katherine, bless her, remained faithful to Perkin, even after Henry had divulged all, but although Henry allowed them to meet at court, in public, he kept them separated physically, his way, perhaps, of unmanning the lad.

The power of fucking has always totally amazed and captivated me. Where along the evolutionary line did something available to nearly every living thing on the planet become an obsession, to such an extent that psychologists say a boy is no longer controllable once he has wet his brush, as the French say (*se tremper le pinceau*). The concept rules the locker room, occupying every thinking moment and expression between young

men: "I made her cum three times last night." Even the word fuck itself is the ultimate in the English language. In the throes of orgasm it's cried out, as it is when a lad hits his finger with a hammer. (5) Here Henry unmanned the boy Perkin by separating cock and cunt. At any rate, it was due to this deprivation that Perkin would attempt escape, and herald in his own death.

Perkin was free to roam the royal premises and the grounds, on foot or horse, accompanied by two unarmed guards that those not in the know took for his servants. Perkin was in fact so free of restraints that Henry had to defend himself by saying that the boy was indeed being punished, this to the obvious disbelief of those who had access to both men. He slept in a small room near the king's and had a tailor paid by Henry. He was at court with Simnel, and one wonders if they were not looked down on, both just lowly fakes, after all, of lesser importance than the fire-eater or sword-swallower who, at least, both earned their keep through amusing the court. Perhaps they were both just tolerated because Henry tolerated them, and the king was the measure of all things. For Perkin, without his Katherine, the humiliation must have been as loathsome as a cesspool, the cloaca in which Diocletian had thrown Sebastian.

All hell broke out when he escaped. The king offered 100 pounds for his capture, a huge sum. The reasons for Perkin's escape are unknown. A need to physically reunite with Katherine. Hatred at being penned up and exhibited. Or perhaps Margaret and Maximilian had offered him exile as a free man. Henry was said to have been indifferent, and even though the boy had tried to usurp his place, had cost him a fortune, and had been the cause of the loss of thousands of lives, this may have become the case.

He was caught four days later, totally undone, turned over by the monks with whom he had begged sanctuary. The end is painful to reveal. When Paris in Troy won a footrace, the crowds went wild in his favor because, said one, "the boy is young and beautiful and when offered the laurels, he wept." (4) Perkin too was young, just 23, and beautiful, but he lost, and as such he was put on exhibit before the people who spat on him. Few were those, like me, who loved this boy for being the entirely unique lad who had kept the known world breathless: Ferdinand and Isabella who with every exchange of letters begged their ambassador to send more news of this Perkin; the Emperor of the Romans who dispatched a ship to his rescue the moment he learned of his flight; Charles VIII, King of France, jumping up and down with glee at Henry's embarrassment, beside himself with joy; and James of Scotland, on his knees before God whom he begged to save the life of his friend, unaware that God's chosen few had denied the boy sanctuary.

Contrary to popular belief, the Tower had more or less furnished rooms--the richness of which depended on the importance of the occupant-- not cells. Perkin's was small, with a small bed, table and chair, and a

window so small a single bar sufficed to make it escape proof. Some occupants had freedom of movement throughout the Tower. Perkin did not and may even have worn shackles and an iron neck collar. The cleanliness of the rooms, their salubriousness, depended too on the nobility of the inhabitant.

A delegation from Burgundy was sent by Margaret and Maximilian's son Philip in order to resolve certain questions between Henry and Burgundy, one of which was the health of Perkin, of upmost importance to Margaret. Ferdinand and Isabella's ambassador was invited to see the boy too, as the lad seems to have become an obsession to the Spanish, a kind of pop star whose every movement was of significance. Henry himself escorted the lot to Perkin's room. In front of them Perkin admitted that he was a fake, news to none present but something Henry insisted on during every visit by outsiders. The Spanish ambassador claims Henry had had the boy disfigured, that he had beaten the last remnant of beauty out of him. In public Henry expressed his disgust of Maximilian and James, and his utter hatred of Margaret, the mastermind behind the entire hoax, according to him. It seems that Margaret wrote to Henry, abjectly demanding his pardon.

The reader may remember that on gaining power Henry had imprisoned Edward, the son of Clarence, brother of Eduard IV and Richard III. He had been imprisoned because he had had a better claim to the throne than Henry himself. Since then, plots unceasingly came to Henry's ears concerning Yorkists who dreamed of having Edward on Henry's throne. Other plotters wanted to place Perkin on the throne, as his right to it, as Edward IV's son, was far stronger than Edward's. It had become obvious, for years, that Henry would never know peace as long a both men continued to breathe.

We know that both Perkin and Edward shared their beds with guards who were there for the purpose of not leaving either man alive. These guards were also conveyers of messages from the outside so that at all times Perkin and Edward were aware of the plans to save them. Whether the guards were motivated by Yorkist loyalty or by gain or both depends of who recounts their stories. It is known too that the guards provided a human, comforting presence. The guards and Perkin and Edward were of the same age, young and virile. Perkin was age 24. Edward was age 24. Words and gestures of love between them were witnessed by others, sighs of lovemaking overhead, comforting solace that at the end neither Perkin or Edward lacked for living presence and understanding.

Henry had his fortune told by a priest, a practice forbidden since Roman times. The priest foretold certain terrible events. Henry swore him to secrecy and then locked up everyone the priest spilled the beans to when in his cups.

The four guardians responsible for Perkin and the four responsible for Edward were accused of treason for conspiring to free the prisoners. They were hanged until nearly dead, disemboweled, quartered (literally cut into four pieces) and beheaded. Edward was found guilty of treason and, thanks to his nobility, only beheaded. After all, he had been the son of a brother to two kings. Perkin was found guilty and hanged with the aid of a ladder that was carefully withdrawn, allowing the noose to tighten and gradually bring death by strangulation, as long as an hour later.

This unique son of man ended his short journey on an earth wondrously bountiful, heartbreakingly beautiful and totally uncaring, having known vicissitudes well beyond those of mere mortals, having given of himself, having known the true devotion of a good woman and that of a loyal friend, having born a son, having brought love to the heart and tears to the eyes of the boy who is writing this, 500 years after the event.

RAPHAEL
1483 - 1520

The first thing to known about Raphael comes from Vasari: "So gentle and charitable was Raphael that even the animals loved him."

The second key is found in those around him, beginning with his student and lover Giulio Romano who became known for 32 drawings called the *I Modi*. Sixteen represented scenes of heterosexual intercourse, 16 others of homosexual couplings. The first 16 were reproduced by the engraver Marcantonio Raimondi and gained such notoriety that they were banned and destroyed under the order of the pope. But they had been more or less well copied by others and can be found today on the Net (you won't be impressed as they're pretty dull--the copies, at least). The 16 homosexual drawings were considered too outrageous to be copied, and so have been entirely lost. The first 16 came to Shakespeare's notice: In *The Winter's Tale* Queen Hermione mentions, "that rare Italian master, Julio Romano." Besides these, Romano did some beautiful paintings, for example his *St. John the Baptist in the Wilderness*, a beautiful young boy *à la da Vinci*. His *Jupiter Seducing Olympias* is an oddity, Jupiter's fully engorged penis just inches away from insertion.

The second personage associated with Raphael is Pietro Aretino who wrote dirty sonnets to go alone with the *I Modi*, but is especially known for his satirical writings, so sharp, witty and revealing that Charles V and François I paid him blackmail under the guise of patronage so he wouldn't include them in his satires. He was, if you will, the talented Renaissance Walter Winchell (known by millions but himself so unpopular that only three people attended his funeral). Aretino too was unpopular with hoards of Italians, barely escaping assassination on several occasions.

The third man is Federico II Gonzaga of Mantua. Mantua, beautiful but dull until the arrival of the Duke, became a center of art, as had Milan under Ludovico Sforza, a vulgar condottiere until he visited Lorenzo *Il Magnifico* in Florence. Seeing the splendor of Lorenzo's court and the magnificence of the city--where, after all, the Renaissance began--Ludovico had an epiphany. Back home, he changed the face of Milan, architecturally first, then artistically, bringing aboard da Vinci himself. Federico was so afraid of Pietro Aretino that he literally became his pimp in procuring boys, as witnessed in this highly-abbreviated exchange of letters that Federico wrote to Aretino, in answer to a request: "I would willingly satisfy your wishes regarding this kept boy who you write could remedy your trouble, if I knew who it was, but I do not know this boy Bianchino." The Duke finds out who the boy is and writes back: "I truly love you more than any other and the fruits of your splendid intellect have so impressed me that I will never forget them. If I could possibly satisfy your desire for Bianchino I would do so gladly. But having understood his reluctance when I spoke to him on your behalf, I did not think it fitting to plead with him or otherwise to exhort him, and I surely can't order him, it not being either just or honest to command him in this case. So pardon me if I have not pleased you. If I can in any other way, you know very well I am only too glad to do it and you will always find me ready…." It was true that boys who sold their favors could gain not only money but a position in the upper hierarchy of government or church. It was true then as today: Clark Cable, wrote William Mann in *Wisecracker*, let himself be fucked by William Haines in order to get a role, and Darwin Porter in *Paul Newman* claims that Newman automatically opened his fly when he saw a certain glint in a director's eye.

Aretino had said of himself: "I was born a sodomist," and it was true. But like all Renaissance men (who normally had a more or less hidden weakness for boys) he too had a weakness, but in his case it was with a woman, a cook. As he wrote Giovanni de' Medici: "My Illustrious Lord, be absolutely assured that I will return to my old ways, and that when I escape from this madness with a woman I will butt-fuck an untold number of men, for me and for my friends." One wonders how he could possibly have had this kind of conversation with Giovanni if Giovanni hadn't shared Aretino's tastes. It's extremely strange to read these letters from civilized highbrows who spent their time screwing boys, boys who were well paid, I hope, for what they had to endure from these fat, powdered miscreants.

Raphael Sanzio (or Sanzi or Santi) was born in Urbino in 1483, the fief of Frederico da Montefeltro whom I've already discussed at length. His father was a court artist and it was at court that Raphael, young, learned proper manners and social skills. He was helping his father at age 4, thanks to which he progressed in talent (as did the equally young Mozart, years

later). Of that time Vasari says that the boy "was a great help to his father." His self-portrait at age 16 shows a boy of unsurpassed beauty. He was apprenticed very early, some say around age 8, to Pietro Perugino, "despite the tears of his mother," states Vasari. Around age 11 he went to Florence for 4 years and then around age 15 he went to Rome where he lived until his death, 12 years later. It was there that Pope Julius II put him to work on several Vatican rooms, in one of which he painted his most famous work, the huge mural *The School of Athens* showing da Vinci, Raphael himself, Sodoma and Michelangelo sitting in front. Here we have the trinity of the times: the Everest of men, da Vinci, followed by the world's Annapurna, Michelangelo, and Raphael. Of da Vinci Raphael said that the moment he saw his works, he gave up all previous knowledge to devote himself to his new master. Raphael was present at the Vatican during the time Michelangelo painted the Sistine Chapel, visiting it during the artist's absences. When Michelangelo found out, he accused Raphael of undisclosed "plots" aimed at him, as well as for copying his works. No one, and especially not Raphael, denied that he copied the works of others, copying being a way of growth. Michelangelo hated da Vinci too, but the challenge was in finding someone the creator of the God-inspired *David didn't* hate. At any rate, Raphael didn't follow Michelangelo into stilted mannerism which, happily, had an early death.

Julius II sent two of Raphael's paintings to François I for reasons of diplomacy and allowed Raphael to do a painting of him, which is sad because the warrior pope comes out looking deathly frail and sick, the antithesis of what he was in earlier life where he lived for war, boys, food and girls, in that order.

Raphael's *Baronci Altarpiece* was seriously damaged by an earthquake but fragments exist, of great beauty, as is the portrait of Giulio de Medici, the future Pope Clement VII, who is seen in the painting *Leo X*. But his *chef d'oeuvre* is *The School of Athens*. Along sexual lines, he was summoned to adorn the Vatican sauna with erotic paintings, in a room called the Stufetta, one of which shows the randy goat-god Pan leaping from the bushes with a valiant erection.

Raphael opened his own workshop with, says Vasari, fifty apprentices and assistants, among whom were his lovers, Giulio Romano and Gianfrancesco Penni. Thanks to these men Raphael was able to produce an amazing number of paintings. They all looked as though they had come from the hand of the master, but in reality many cooks had been involved. Raphael was especially noted as someone who would take over the techniques of others, incorporating any and all external influences. He was also a perfect collaborator, establishing peaceful relations between men of extremely varied characters.

After Raphael's death Giulio Romano and Gianfrancesco Penni continued his workshop, their inheritance from Raphael. One of their assistants was Caravaggio. Unfortunately, they separated and died apart. Raphael died of fever, at age 37, supposedly after a night of excessive lovemaking with a mistress, all of which leaves one dubious, as if claiming that Tchaikovsky was heterosexual because he married--twice. (Although Renaissance men *did* dip their brush, as the French say, into both sexes.)

Pietro Bembo, known, among other things, for his love affairs with Caterina Riario Sforza de' Medici, as well as the notorious Lucrezia Borgia, wrote this on Raphael's tomb: "Here lies the famous Raphael by whom Nature feared to be conquered while he lived, and when he was dying, feared also to die." He was buried in the Roman Pantheon, one of the very rare monuments remaining from ancient Roman times. A hundred painters accompanied the procession, carrying torches. A man deeply loved and revered, his tomb is of incomparable eminence and splendor ... "for an artist," said one contemporary.

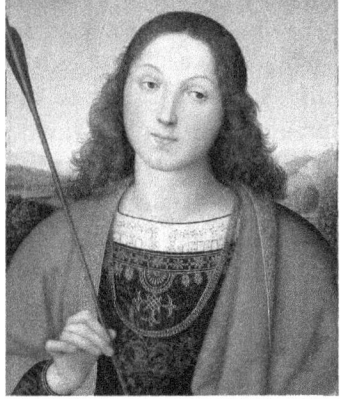

THE WEST: ENGLISH AND SCOTTISH KINGS
1500 – 1600

Elsewhere we have discussed and we will discuss Maximilian and his son Philip, Charles V and *his* son Philip, François I and others. Here we'll concentrate on the political aspects of Henry VIII, his son and daughters, as well as James I/VI.

Henry VIII's life is too well known to be belabored here. He had known and had interworked with all the giants of the times: Julius II who refused his divorce from his first wife Catherine; the Medici Leo X whose wish for peace with France inspired Henry to sign a treaty with Louis XII; Louis's son François I--thanks to the brilliant diplomacy of Cardinal Wolsey--met with Henry near Calais on what was dubbed the Cloth of Gold, two weeks of orgiastic all-out drinking and fucking French girls,

ending in a wrestling match, proof that François had big muscles to go with his big virility (explained elsewhere); he conspired with Charles V against the same François and was furious when the huge-jawed Spanish king freed François from Spanish captivity; and he invaded Scotland in hopes of forcing the Scottish King James to marry James' daughter, the future Mary Queen of Scots, to Henry's boy Edward.

Henry dilapidated the fortune left to him by his father Henry VII. He caused immeasurable suffering to his people, to his loyal servants and to those he had lusted for prior to murdering them, but he too died in excruciating pain.

From all sources his son Edward comes through as a delightful lad, made king at age 9, dead at age 16, two years before his majority. The years of his regency consisted of a series of rivalries without real interest here (or elsewhere for that matter). He was England's first born-and-bred Protestant monarch. He was universally described as kind and generous, and a scholar far beyond the lads of the other nobles. Henry VIII recognized his son for the jewel he was, raising him in hygienic conditions among the best minds in England. He sought to betroth the boy to seven-month-old Mary Queen of Scots, to which the Scots agreed before changing their minds, infuriating Henry to such a degree that he ordered massacres throughout Scotland, a horrible campaign known as The Rough Wooing. Edward worked hard to find a male to succeed him but finding none, and deploring the "lack of issue from my body," he chose Lady Jane Grey. She would prove an unpopular choice and an army in Mary's favor would end her attempt to be crowned. Edward passed away, alas, in great pain, probably from tuberculosis, whispering at the end, "I am glad to die." His loss was terrible because like the youth the world over, he may have had the potential of a second Pericles.

Mary and Elizabeth were left behind. At age 37, the Catholic Mary, whose mother Catherine had been Spanish, decided it was time to marry a Catholic boy and bring forth a Catholic son who would bar the route to the Protestant Elizabeth, her half-sister. She chose Prince Philip, Charles V's boy, which would bring England a good part of Europe, as well as the wealth of the New World. An act of parliament nonetheless made it clear that should Mary die, Philip would no longer be King of England. The marriage was unpopular because for patriotic reasons the people wanted her to marry an English lad, and also England--made Protestant thanks to Henry VIII's wish to rid himself of his wife Catherine--simply didn't appreciate two Catholics on the throne at the same time. Mary became pregnant to the surprise of Philip who found her too repulsive to "honor", as the French put it, and Elizabeth was freed from house arrest to witness the birth that would deprive her of the throne. Queen Mary of England became huge, the time of her delivery came and then passed, finally ending,

as one chronicler put it, "in a gigantic fart." Mary's failure to produce an heir was blamed by her co-religionists on her having tolerated Protestant heresy, thereby incurring God's wrath.

Along with her husband Philip, Mary entered into talks with Pope Julius III to reinstate Catholicism, after which Protestant nobles were put to death under heresy laws--although 800 had by then fled. The Archbishop of Canterbury, imprisoned, was forced to watch his priests burned at the stake. The archbishop renounced his Protestantism but was nonetheless set afire, renouncing his renouncement as the flames enveloped him.

When Charles V abdicated, Philip became King of Spain. Mary lost Calais to the French, reducing her prestige, and due to a prolonged wet season Englishmen began dying of famine. She herself died at age 42, perhaps of ovarian cancer, in pain like her father, and like her father responsible for countless horrible deaths.

Queen Elisabeth was a religious pragmatist, deciding not to decide, an indecisiveness that marked her reign. The heresy laws were repealed and those who sought government employment simply had to swear allegiance to their new queen.

She had been in love and had slept with Robert Dudley since her adolescence, and he is thought to have killed his wife by pushing her down the stairs in order for them to marry. They remained close for 30 years. Her last of many suitors was the Duke d'Anjou, a bisexual cross-dresser 22 years her junior.

Concerning foreign policy, Elizabeth was concerned that Mary Queen of Scots, who had been raised in France, would prove the Trojan Horse by which the French would seize Scotland and then threaten England. Mary, for her part, was having her own problems. A Catholic in a Protestant country, she married the pretty Lord Darnley who killed her Italian secretary David Rizzio, believed to be *both* Darnley *and* Mary's lover. Darnley was blown up in his home (his body was found outside where the explosion supposedly threw it, but as he was still alive he was throttled to death). His murderer was purportedly the Earl of Bothwell whom Mary then married. Due to all of this, and due to her Catholicism, she was forced to abdicated in favor of her and Darnley's son James. She bolted to England where she was imprisoned for 19 years before being tried for attempting to overthrow Elizabeth, earning her decapitation.

Elizabeth was excommunicated but kept her head by decreeing that only priests who came to England with the mission of converting the English to Catholicism would lose theirs. Many did.

She knighted Sir Francis Drake for his circumnavigation of the globe from 1577 to 1580, opening an era of English piracy thanks to English naval superiority. As Spain was the chief target for attacks, King Philip II sent an

enormous and extremely costly armada against Elizabeth, one that was destroyed due to a serious of uncanny events, like a sudden horrific storm.

She sent troops to France to help the Protestant Henry IV to gain the French throne but then Henry, ever pragmatic, converted to Catholicism, stating that "Paris was well worth a mass." He was beloved by his people, one of whom nevertheless stabbed him in the heart.

Elizabeth sent troop to Catholic Ireland to prevent a landing zone for Catholic Spain. The Irish, considered barbarians, were slaughtered, down to women and children, and their lands scorched so they would die of hunger. In Muster alone 30,000 starved to death.

Wars and poor harvests impoverished the English, and the only bright light was the genius of Shakespeare and Marlow, the advent of whom had nothing whatsoever to do with the Virgin Queen.

She favored young men until the end. How many had access to her rich bed and moldy body will never be known.

James, Elizabeth's successor, was a true Renaissance man in that he went from men to women in total abandon, *à la Florentine*, as had Lorenzo *Il Magnifico*, a connoisseur of every form of love/lust. During the restoration of Apethorpe Hall in 2004-2008 a secret passage was found that had linked James' bedroom to that of his then favorite, George Villiers, Duke of Buckingham. His contemporaries remarked that his predecessor, Elizabeth, a known flirt who didn't fear war, was King, while James, who insisted on peace, was Queen (*Rex fuit Elizabeth, nunc est regina Jacobus*). He was nonetheless happily married to Anne of Denmark who gave him *seven* children while suffering through two stillbirths and three miscarriages.

As mentioned but bears repeating: his mother was Mary, Queen of Scots, beheaded by Elizabeth for plotting Elizabeth's death. Mary had been forced to abdicate by Scottish Protestants and had fled to England in hopes of Elizabeth's aid. James was crowned King of Scotland at age 13 months. His father Lord Darley had been blown up in his home, perhaps because he had ordered the death of his wife's suspected lover, David Rizzio, which took place in front of Mary while she was trying to protect Rizzio who was literally seeking shelter in her skirts. Rizzio, young and handsome, was also the purported lover of Darley himself, equally young and handsome.

Thus began a line of regents to stand in for the thirteen-year-old King of Scotland, beginning with Mary's half-brother James Steward, assassinated by James Hamilton. Mathew Stewart became the baby's second regent, killed in battle against Mary's supporters. The thirds regent, the Earl of Mar, was poisoned by James Douglas, 4th Earl of Morton. Morton was executed, not for Mar's poisoning but for his role in James' father Darley's murder.

James was then 15 and placed himself under a series of favorites, beginning with a handsome Frenchman, Esmé Stewart, Sieur d'Aubigny, the future Earl of Lennox, later made the only duke of Scotland. He was forced to leave due to his introducing the boy "to carnal lust," and the boy hadn't as yet enough power to prevent it. But soon he did and Lennox was replaced by Robert Carr, Earl of Somerset, followed by George Villiers, Duke of Buckingham, and many other lovers, handsome pages as well as young nobles. During this period the peoples of Scotland and England congratulated the king on his chastity, as he showed no interest in women. James--like boys the world over are and have always been--took his pleasure when and where and how he wished, seen or unseen, known or unknown.

James became King of England in 1603 upon the death of the last Tudor, Elizabeth. The transition was made smooth thanks to secret negotiations between James and Elizabeth's chief minister, Sir Robert Cecil, and just hours after Elizabeth expired James was declared king. He was welcome with open arms in London by a people thankful that the succession had been peaceful. As prearranged, Cecil and Elizabeth's counselors remained in place, until James had the reins of government securely in hand.

James was interested in witchcraft, which led to the writing of his book *Daemonologie*. He was convinced that witches had sent storms in order to kill him while at sea and personally arranged the torture and burning of several. On the eve of the opening of parliament, which he would preside over accompanied by the queen and his children, Guy Fawkes was discovered in the cellars arranging a pile of wood next to 36 barrels of gunpowder. Fawkes and other conspirators were executed, and the day, known as Guy Fawkes Day (or Night), is celebrated even now with fireworks. He executed Walter Raleigh, one of Elizabeth's lovers, when he came back from an expedition seeking gold in South America, because Raleigh had exchanged fire with the Spanish there, something James had absolutely forbidden due to his policy of keeping the peace with Spain, and his wish to marry his son to the Spanish king's daughter, the Infanta. This greatly disturbed the people because Raleigh was held in great esteem and because no one wanted the English to kowtow to the Spanish. James was in no hurry to marry his son off, because even if the marriage took years to conclude, during that time there would be no war with Spain.

Growing old and afflicted by arthritis and gout, he had a stroke and died.

His son Charles was unpopular in England because of his taxation and his choice of a Catholic wife, and unpopular in Scotland because he tried to impose his Protestant beliefs on the Catholic population. Both peoples rose up against him. He was executed and the monarchy was abolished, only to

be reinstated under Charles' son Charles II in 1660. (How a people--and especially the highly intelligent English--can place themselves under a monarch is, for me, one of the great-unsolved mysteries of my very small life.)

THE CONTINENT: CHARLES V AND PROGENY
"I speak Spanish to God, Italian to women, French to men and German to my horse."
1500 - 1558

As we have seen, the powers preceding the death of *Il Magnifico* were the Medici, popes Alexander VI and Julius II, the French kings Charles VIII, Louis XII and François I, the Sforza for a limited time, Cesare Borgia, the condottiere Montefeltro, the cities of Florence, Milan and Rome, as well as a scattering of city-states such as Ferrara and Venice. The Serenissima had an uncanny way of butting out of other peoples' affairs when there was potential danger, but didn't hesitate to send troops when victory and gain seemed certain.

Then a score of years following the death of *Il Magnifico* Charles V came on the scene, bringing order out of chaos following the massacre of thousands and the destruction of Rome. He brought Pope Clement VII to heel by kissing the pope's ring, and the pope, behind the scenes, kissed Charles' ass, even coronating him emperor, the last pope to ever do so. And what a royal ass! At age 16 he was crowned Charles I, King of a Spanish Empire that included Naples, Sardinia, Sicily, Navarre, parts of Asia and the New World. At 19, as Charles V, he ruled, as emperor, over Europe. And then, age 54, he gave it all up, making his brother Holy Roman Emperor and his son King of Spain. Two years afterwards, in a monastery, at peace with himself or not, he offered up his soul to God, a soul that had seen hundreds of thousands to their deaths in Europe, and millions to an early grave in the New World and Asia, owing to Pizarro, Cortés and Magellan, thanks to Spanish invincibility--courageous, professional and utterly determined men who overcame such odds that the scope of their conquests remains incomprehensible to this very day--and as a consequence of diseases, especially the pox, the conquistadors harbored on their persons. The answer as to why the Spanish sailed to the New World was given by the conquistador Bernal del Castillo: "We went to serve God and his Majesty, to give light to those in darkness and to acquire the wealth men covet."

Charles was an important mover in attempts to reduce friction between Catholics and Protestants. He did this through the Council of Trent, a council that took place in Trento Italy. Protestantism was denounced but it was decided that the way to combat it was through peaceful and intellectual means. A standard bible was commissioned and

abuses, such as the sale of indulgences, were forbidden. There were 25 sessions, held under popes Paul II, Julius III and Pius IV. The next council wasn't held until 300 years afterwards. This and other moves of Charles earned him the reputation as a man "greedy of peace and quiet."

Charles was the son of Philip the Handsome who had Charles at age 22 and died at age 28 from typhoid fever. Physically Charles suffered from an enlarged lower jaw, a grave deformity handed down from generation to generation due to a long history of family inbreeding. He also suffered from debilitating gout, like the Medici, caused by a diet reserved for the rich and consisting of red meat. His mother was Joanna the Crazy. At Philip's death she went mad, probably owing to melancholia. Charles' maternal language was French but he spoke German and Spanish well enough to reign over Spain. He spent a great number of years in Paris, known then as Lutetia, which he said was "not a city but a universe" (*Lutetia non-urbs, sed orbis*), although most of his life unfolded in Spain. He was in continual combat with François I, even though he had been betrothed to two of François' daughters, both of whom died too young to marry.

The problems that arose between Charles, Henry VIII, François I and a number of popes began with the election of Charles as Holy Roman Empire, a prestigious position desired by Henry VIII and François I. Reign over the Holy Roman Empire was an elective monarchy and the electors, around seven in number, came from princes who chose the emperor in Germany before having him crowned by the pope. Besides losing the election to Charles, Henry VIII earned Charles' wrath when he tried to divorce Charles' aunt, Catherine. On the other hand Charles was a natural ally of Pope Leo X because they both wished to put an end to Protestantism and its founder, Martin Luther. As usual, Venice was in the background, seeking a way to gain profit by allying itself with whichever side held promise of being victorious. War broke out between Charles and François I when the French attempted to recuperate disputed Navarre. Henry VIII, Pope Leo X and Charles formed an alliance, the result of which led to François' defeat at Pavia, the decimation of French nobility, and the capture of François himself--all on Charles' 25th birthday.

But war costs money and Charles, lacking funds, decided to renege on his promise to marry into the house of Henry VIII and sought instead Isabella of Portugal who offered a far greater dowry. Back in Paris François' mother, regent while François remained in Charles' hands, decided to align France with Suleiman the Magnificent, the first-ever alliance of such opposing forces. Suleiman sent an ultimatum to Charles demanding the immediate release of François. When Charles hesitated, Suleiman took Hungary and marched on Vienna where his advance was halted during the Battle of Mohács. François had been imprisoned with Henry II of Navarre who had fought at his side, but, dressed as a woman,

Henry managed to escape. In the meantime François became seriously ill, with the result that Charles, for the first time, agreed to meet with him. His sister also rode from Paris to be at François' side in Madrid. When he regained his health François attempted to escape, but failed. In consequence his sister was expelled from Madrid. The situation could have continued for years if Charles were not having problems keeping his troops in line in various parts of France and Italy due to his inability to pay them. This pushed him to seek an arrangement with François, called the Treaty of Madrid, in which François handed over great sections of France to Charles, as well as his two sons. Once home, François immediately rejected the Treaty of Madrid as having been obtained through duress. After three years Henry and his brother were released.

François joined a league aimed at limiting Charles' power, the League of Cognac, made up of Pope Clement VII, Henry VIII, the Venetians, Florence and Milan. Charles answered by sacking Rome, as mentioned above, and forced Clement VII to refuse Henry's divorce, ending Catholicism in England (although it returned for a short time under Mary and with Mary's husband, Charles' son Philip). François sought peace when his armies were defeated, peace that came through what is amusingly known as the "Ladies Peace" because negotiations were done through François' mother, Louise of Savoy and Margaret of Austria, Charles' aunt.

Minor disputes did follow, with Charles even aligning himself with Henry VIII, but it all came to nothing and in general the status quo between the belligerents continued. But Charles was forced into peace with Suleiman because he simply didn't have the funds to continue fighting on so many fronts. In the peace agreement Charles was humiliatingly referred to as the King of Spain and not emperor, as there was only one emperor of the world, and that was Suleiman.

Around the time of Charles' death his son Philip was named the new King of Spain, Naples, Sicily and Sardinia, Duke of Milan and King of Portugal, as well as King of England and Ireland during his marriage to Queen Mary I. He ruled in the New World and the Philippines were named after him. It was during Philip's reign that the expression was coined, "The Empire on which the sun never sets." He was born and raised in Spain and cared little for Germans who cared little for him. An ardent Catholic, he raised havoc in the Netherlands by trying to destroy their deep-seated Protestantism, whereas his father, Charles, had not been overly harsh with Protestants, and had thusly kept the peace throughout his kingdom. He was described as physically attractive--although his chin, too, was immense--tastefully dressed, courteous and gracious. His father had supposedly taught him to be modest, patient and to distrust everyone. He was said to have had "a smile that cut like a sword" and icy self-control.

Philip inherited money problems, for despite Spain's immense world conquests it was a thinly populated country from which few taxes could be raised, leading to repeated governmental bankruptcies, not withstanding the fabulous wealth that flowed in from overseas. Yet Philip continued to spend money in the one way that would eventually ruin any country, he continued to wage war. He decided to avenge his father for his humiliation under Suleiman. The Ottomans had continued to not only attack the Spanish mainland, but they took the Baleares, destroying, murdering and enslaving its small population. The pitiless killing brought instant fear and panic into the hearts of men the moment they heard the word Turk. Philip's response was to join the Holy League, made up of Spain, Venice, Genoa, Savoy, the Papal States and the Knights of Malta. The league amassed a fleet of 200 ships carrying 30,000 men but lost 20,000 of them in just one confrontation off the coast of Djerba. The league made a comeback, however, during the Battle of Lepanto, under the direction of Philip's half-brother Don Juan of Austria (a fascinating person about whom I'm having difficulty finding information), ending Ottoman domination of the western Mediterranean.

Events went Philip's way too in Portugal where the king died without descendants, only to be succeeded by an uncle who died too without heirs. Havoc irrupted when three grandchildren fought for the throne but influential members of the Portuguese government, wanting stability, escaped to Spain where they threw their weight behind Philip who became Philip I of Portugal. He robbed the Portuguese treasury but allowed the country to keep its laws, currency and own government, run in concert with a council on Portugal that Philip set up in Madrid.

One of Charles V's masterstrokes was marrying Philip to the Queen of England, age 37, to Philip's 27. To make sure his boy would have equal rank to the queen, Philip was named King of Naples and Jerusalem. The English government was against the marriage, preferring an English lad to a Spaniard, but once the marriage was consummated and the bloodstrained sheets viewed by all, they did what they could to ensure that power was shared equally between the two monarchs, down to the coins that represented them both holding the same crown. The marriage contract contained but one major codicil, that England would not be obliged to follow Charles in his spendthrift wars. There would be no bankruptcy in England. Documents were translated into Latin or Spanish so they could be read by the foreign king. Mary died too soon to reestablish the Catholic church in England, and with her death Philip lost the totality of his powers and influence. When Elizabeth became queen, Philip proposed marriage but was refused.

Philip nonetheless tried to maintain peace between his maternal country and his adopted country, even throwing his support to Elizabeth

when the pope threatened her with excommunication, but Elizabeth's discriminatory policies against Catholics in England, her support of Protestants outside England, notably in the Netherlands, and her support of English piracy against the Spanish--a source of wealth for England as well as an ardent virility for her bed in the form of Walter Raleigh--obliged Philip, the jilted lover, to turn offensive.

The catalyst was the execution of Mary Queen of Scots, Philip's last hope of seeing a Catholic leader--as Mary Queen of England and he himself had been--at the head of the English Empire. He sent a fleet to invade the country where he had been king, with the hope of bringing an end to Protestantism. The fleet was destroyed by storms and English naval mastery. Undaunted, he sent three more fleets over the following ten years, none of which came to anything. War ended only with Elizabeth and his deaths. He was the first sovereign to personally see to his sailors' medical care, providing pensions to those who survived and compensation to the families of those killed in battle. His own death was atrocious, following a combination of factors that left him so bedridden that a hole had to be cut in his mattress to make way for his body fluids.

Philip was followed by his son Philip III whose older brother died insane. (Hapsburg inbreeding would eventually destroy the lot.) Adjectives describing him are: undistinguished, insignificant, weak, dim-witted, *et j'en passe*. One said his only virtue appeared to reside in a total absence of vice, another that he cared only for hunting and travel. He ruled the Spanish Empire through the Duke of Lerma who filtered those who could see the king; in this way Lerma accumulated immeasurable wealth. Lerma also amassed art treasures, most of which were personal gifts to him or, through him, to Philip III, and are found today in the Prado. He expulsed the Moriscos from Spain, Moors who had nonetheless converted to Catholicism but who remained apart in appearance, customs and some rites inherited from Islam. The expulsions impoverished the country as they deprived Spain of cheap labor. From then on agriculture failed and famines took countless lives, as did the plague. The Moors, around 300,000, were shipped to Tunis and Morocco, under the escort of 30,000 soldiers. Children under age seven were forbidden to leave, however, in order to protect them from being converted to Islam. But Philip saw to it that a law was passed forbidding their being sold as slaves. Philip's father had tried to integrate the Moriscos into the Spanish society, but his efforts had failed. Spain was impoverished by their loss, but not the rich who took over the lands left behind by the Moriscos. The loss was less than that when the Jews were expulsed in 1492. Lerma was eventually deposed by his son. The pope nonetheless named him a cardinal, one who outlived the king who stood passively by while Lerma's son took the reigns of power. His son tried to

despoil the father, but Lerma had so much wealth that the boy was able to dissipate only a smidgen.

TITIAN
1488 – 1576

In many ways Titian's life was charmed, but not so in the essential. He lost his boyhood friend Giorgione at an early age, then his wife, and finally his two daughters. Titian's father was the director of a palazzo, as was Caravaggio's, as well as manager of a number of local mines. His relatives were notaries, all of which meant that the boy and his brother Francesco lacked for nothing. The family had friends in neighboring Venice who placed the two boys in the workshop of the Bellini, established artists. There he met and went through adolescence with the boy who became his best friend and with whom he founded a workshop, Giorgio da Castelfranco, known as Giorgione, an exceedingly handsome lad. Their works were so similar that today, due to the great value of Titian paintings, galleries try to attribute their Giorgione paintings to Titian. Both boys were adept in fresco, both turned to the extensive use of color for which Titian is especially known, and both were competent in landscapes, portraits, religious and mythological subjects.

Giorgione died when Titian was 22, Titian painted in the style of his friend for years, as Giorgione had been slightly older and had set the pace for them both. It's difficult to know exactly what that style was, as Giorgione was influenced by many of his contemporaries, especially da Vince, whom he knew personally. Georgione was nonetheless known for his vibrant colors and landscapes. He probably died of the plague, as would Titian himself, and his son. Today very few of Giorgione's paintings remain, around six, and it is not certain that even these can be confidently attributed to him as Titian finished off those Giorgione had left incomplete.

Titian set up a new workshop, assisted at times by Veronese and perhaps El Greco. His work in color established his reputation, and with the death of the Bellini his atelier became the first in Venice. His glory was cemented by his St. Sebastian, executed for the papacy in Brescia, after which he never lacked for commissions. He married his housekeeper and had two sons, Pomponio and Orazio, and a daughter, Lavinia. His wife Cecilia died giving birth to a second daughter, as would Lavinia later on.

Orazio became his assistant and to house the family Titian moved them to a mansion in Venice with gardens and a sea view. He became friends with Pietro Aretino, already developed in the chapter on Raphael.

Titian was careful with his money but generous to the town of his birth, Cadore. As his reputation grew he rose to the heights of Michelangelo and Raphael. Rome offered him the Freedom of the City in 1546, the last time being in 1537 when it was offered to Michelangelo. The Freedom of the

City was an award dating from medieval times and given to noted citizens or visitors. In America it's called the Key to the City.

Titian executed a portrait of Charles V and his son Philippe II of Spain. Philip's was sent to England and may have helped in his being chosen as Queen Mary's husband. From here on Titian concentrated on commissions from Philip, among which were his *poesie*, mostly from Ovid, a series of pictures based on the mythological Danaë.

With age perfectionism became his byword and at times he spent as long as ten years on a painting, twice as long as da Vinci was known to have done on some of his. Titian never hesitated to give a hand in adding to paintings done by his pupils, greatly increasing the difficulty--along with those he did with Giorgione--of attribution.

One of his paintings, the *Flaying of Marsyas*, was called repellent at the time, but compared to what Caravaggio would accomplish, it would, today, be given the same note for horror as Grimms' *Fairy Tales*.

Titian's sister had cared for the family since the death of his wife, but at her death she was replaced by Titian's daughter Lavinia. Given the sums Titian was now earning, no one lacked for anything.

At nearly 90 Titian died in Venice of the plague, luckily before his son who passed away immediately afterwards of the same affliction. Titian's mansion was plundered by plague-enraged thieves who believed that with the coming of the end of the world, brought on by the plague, they had little to fear.

There is an amusing aftermath concerning the date of Titian's death. At Davos Gordon Brown said that he had much in common with Titian who had done his best work, even up to the age of his death at 90. David Cameron pounced on Brown, saying that he never got his facts straight, and that Titian died at 86. Everyone went to Wikipedia and found that Cameron was right. The only problem was that someone on Cameron's staff had found his way into Wikipedia and changed the dates, down from 90 to 86. Cameron apologized and said that the staffer had been punished. In reality, both dates could be correct as we really don't know for certain when he did die.

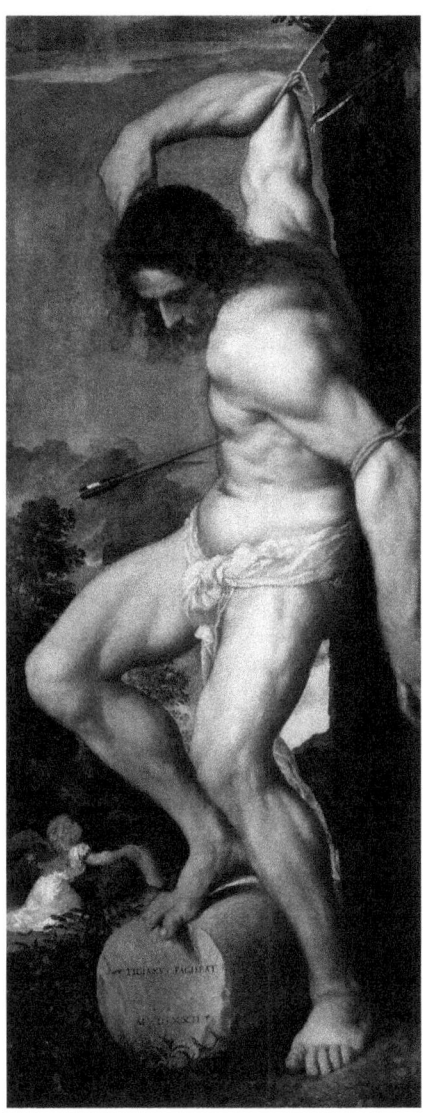

CORREGGIO
1489 – 1534

My approach to Correggio will differ from my other vignettes in that I'll be mostly dealing with his works of art and not his life, for the simple reason that we known so little about him. But the incredible sensuality of his paintings suggests that he fully appreciated the eroticism found in both sexes. His portrait is included in the *trompe l'oeil* mural seen in the ceiling of the Gay and Lesbian Center in San Francisco, an allegorical painting of men and women moving from the darkness of ignorance into the light of knowledge.

In *Ganymede Abducted by the Eagle* we have Zeus' bedmate locked in his arms as he flies back to Olympus, the whole of little eroticism. One observer notes the boy's "radiant buttocks" and draws our attention to the fact that the eagle is licking his wrist. During the Spanish Inquisition a wealthy connoisseur, Antonio Pérez, was charged with sodomy, and one of the proofs was his possession of the Ganymede painting. Luckily, Pérez was able to escape to France.

In the painting usually known as *Jupiter and Io*, but also as *Venus and Cupid with a Satyr*, we find Zeus, a wonderfully beautiful naked boy who has taken the form of a satyr, hovering over Aphrodite and a sleeping Eros, with what is surely his engorged maleness hidden by a tissue, the whole wondrously erotic.

We know that Correggio was born Antonio Allegri da Correggio in Correggio, that his father was a merchant whose brother, Lorenzo, was an artist and Correggio's first tutor. Correggio was influenced by da Vinci and Raphael. He spent much of his career in Padua and is thought to have married and engendered at least one son. He was described as being enigmatic in character, melancholic, introverted and "shadowy."

In his *Danaë* we see Zeus in the form of an angel, ready to impregnate the future mother of Perseus (see Cellini). The angel is prepubescent although handsomely muscular.

Two other highly erotic paintings are *Zeus and Io*, Zeus taking the form of a cloud, and *Leda with the Swan,* the swan getting reading to introduce his head and very long neck into the future mother of Helen of Troy. Madonna and Child with St. Sebastian

Madonna and Child with St. Sebastian

THE EAST: 1500 – 1600

The wonderful adventures that predated the loss of Jerusalem, those of Richard Coeur de Lion of England and his lover Philippe II of France, continued on when the Knights of Saint John withdrew first from Jerusalem and then Acres, and sailed, in 1309, to Rhodes.

Two hundred years later the Shadow of God on Earth, Suleiman, decided, in 1522, that Rhodes, 11 miles of the Ottoman coast, was a thorn that had to be extracted. He knew that the island was the best protected in all of the Mediterranean, with a thick-walled fortification created by the unequaled military engineer Gabrielle Tadini, a fortification that could produce its own gunpowder and was stocked to overflow with grain. Numbering around 500 men from the aristocracy, wearing red cloaks bearing white crosses, the Knights were aided on Rhodes by local Greeks and mercenaries, all placed under the Grand Master Philippe Villiers de L'Isle Adam. Suleiman knew that Rhodes was powered by men limited in number, while his own were limitless clones, dispensable in the thousands.

His attack on Rhodes was greatly feared in Europe where Charles V said that should the Ottomans succeed "all of Christendom would be destroyed." Yet he and the pope and the other powers did nothing aside from dispatching 2,000 mercenaries that made it as far as the Bay of Biscay where storms drowned them all.

Sections of the fortifications on Rhodes were divided up according the nationalities. The Spanish wall was tunneled and blown up and Tadini received a ball in an eye socket that penetrated his skull, but he survived. The Knights built an inner wall and prayed that with the arrival of winter the Ottomans, as was their custom, would return home. But Suleiman continued the siege and even Tadini admitted that there was no way out. Incredibly, Suleiman let them leave with their possessions and arms and their most sacred relic, the arm of John the Baptist. Among those on the parting ships--only 180 out of the original 500--was Jean Parisot de La Valette, a Knight, and watching them go was a soldier called Mustapha. A man not on the ship was Tadini, kept back in service of the sultan. Seeing L'Isle Adam board his ship Suleiman said, "It's indeed sad to be obliged to thrown this old man out of his home."

L'Isle Adam begged the rulers of Europe to give him a base where he could continue the Knight's war against the Ottomans. Henry VIII received him with honors and provided guns and power. Charles V gave him rocky, barren Malta. Charles had come to power at age 17. Suffering from inbreeding, his eyes bulged and his chin was so large his mouth hung open. An idiot in appearance, the inbreeding had not affected his brain. His son Philip would become King of England without speaking a word of English; Charles was King of Spain and knew no Spanish. His personal motto was *Further* and in all he accomplished it fit him well.

The expulsion of the Moors from Spain fueled Suleiman's desire for revenge. He found the perfect arm for his fury in the Barbarossa brothers, first Oruch and then the younger Hizir. Born in Lesbos, their father was an Ottoman cavalry officer, their mother a Greek Christian. Oruch brought terror and barbarism wherever he attacked, but he himself was eventually cornered at Tlemcen by Charles' men. Fleeing on horseback, he sowed the trail with gold coins and jewels destined to slow his pursuers, a stratagem that didn't work on those who knew the immense price on his head. He had already lost an arm in a previous battle, and now the metal replacement was hacked off, along with his head, and his body was skinned and nailed to the walls of Tlemcen.

His brother Hizir took up the torch, even dying his beard red like that of Oruch in order to perpetuate the fear of the Barbarossas. Hizir was given a fleet by Suleiman and proceeded up the coast of Italy to the town of Fondi north of Naples where he tried to capture Julia Gonzaga, countess of Fondi and unmatched beauty that Hizir wanted for Suleiman's harem. He

succeeded only in killing hundreds of men and taking thousands of women and children as slaves back to turkey, the boys to become future janissaries.

When Hizir captured Tunis Charles became frightened. Tunis was only a twenty-hour, 100-mile sail from his possession, the island of Sicily. A stepping-stone to Sicily was Malta, which Charles decided to fortify, at all costs, and who better to guard it than the warriors of God, the Knights of St. John?

But first he decided to recapture Tunis. He arrived with a fleet that took Barbarossa by surprise. Barbarossa ordered the thousands of Christian slaves killed, but their owners refused to turn their wealth into rivers of blood, and when the battle seemed to turn again the Ottomans, the slaves were released in hopes that they would save their owners, now their liberators. The freed slaves took weapons by storming an armory and, aided by Charles' soldiers, massacred every Muslim in sight before taking, for their own use, 10,000 prisoners. On his return to Naples a spectacular bullfight was organized in his honor.

Barbarossa was thought to have perished in Tunis but he escaped and rounded up a fleet that he disguised as Spanish ships, ordering his men to shave. They entered Balearic ports, welcomed with shouts of joy. Those they didn't murder were sent to Africa where they glutted the slave market. Never was a beautiful girl or handsome lad cheaper to buy.

In his attempts to limit Charles' power, François I armed Barbarossa, providing him with guns, powder and cannonballs. He turned over France's natural port of Toulon. The Venetians too paid Suleiman ransom to spare the Serenissima, giving him their Mediterranean trading posts. When Barbarossa became too much of a burden, François was forced to pay him 800,000 gold pieces to sail out of Toulon, leaving the Toulonnais dirt poor but grateful. Barbarossa returned to Istanbul, sowing misery along the way, abducting thousands, especially men as rowers who shat in place and remained shackled and whipped until, weak, they were thrown overboard. Always, always the captured peoples found reasons to justify God's inaction. The island of Lipari is a case in point. The inhabitants agreed to pay for their freedom and in good faith allowed Barbarossa to land, after which he enslaved them anyway, seizing not only what the Lipariots were willing to pay but everything they had. To absolve God's absence it was said that the Lipariots were being made to pay for their proclivity to sodomy.

Barbarossa died of fever at age 80. His mausoleum on the Bosporus was visited by all departing naval expeditions as a sign of respect and to obtain his luck.

Charles V abdicated in 1550 and was replaced by his boy, Philip, King of Spain and the Holy Roman Empire, called the Prudent because, as opposed to his father, he was ever cautious. In fact it was said of him: If we

have to wait for death let's hope it comes from Spain for it will never arrive. Charles entered a monastery to devote himself to god.

Like Charles, Suleiman was also old, 70, and he too was turning more and more to God. And it was herein the problem: Malta's new master, Jean Parisol de La Valette, the young Knight who had embarked at Rhodes, had ordered attacks on Ottoman ships. One ship so boarded--its occupants sold into slavery--had carried pilgrims from Mecca. If Suleiman could not protect God's followers, of what good was he? After the death of Barbarossa Suleiman had left the Mediterranean more or less at peace due to troubles at home: Persia was revolting, he had personally been present at the strangulation of his favorite son, accused of treason, only to learn later of the boy's innocence; another son had been murdered by his children, and the remaining son, Selim, was inept; there was corruption, uprisings among his janissaries, dissention among his viziers, and his favorite wife had just died; and, finally, famine and the Black Death plagued the land. He nonetheless realized that the thorn of Malta had to be extracted. At the same time, Charles' boy Philip came to the conclusion that Malta was the key to the Christians' hold over the western Mediterranean. Suleiman decided to invade the island despite herculean difficulties. Whereas Rhodes had been in sight of Turkey, Malta was in sight of Sicily, just 30 miles away, but 800 miles from Suleiman's throne. Where Rhodes was fertile, on Malta there was nothing, not even a river, and water had to be collected in stove-carved cisterns. There were few places to invade along the cliff coast, with the exception of the magnificent bay in the hands of La Valette. Suleiman would have to bring absolutely everything necessary for an invasion aboard his own ships. The preparations were gigantic.

The Maltese were a mixture of every invading country that had ever passed that way: Greeks, Romans, Carthaginians, Phoenicians, Sicilians, among others. *The Maltese spoke an Arab dialect and their word for God was Alla*, but they had been converted by the shipwrecked Saint Paul himself, and were ardent Catholics. Like the Basques, they were one of nature's true mysteries.

The West had become aware of the coming invasion thanks to spies, but they had no idea of where it would take place. The Venetians feared for Cyprus, the Spanish for Sicily. But La Valette knew the truth. The destination was he himself. Like Charles, like Suleiman, he too was 70. Suleiman's fleet set off in a hurry in order to capture the spring winds, but too much in a hurry to parade before the mausoleum of Barbarossa, thereby assuring their success.

La Valette had led a full life in the service of God since leaving Rhodes. He had fought innumerable battles, had been a galley slave for a year, as well as the governor of Tripoli. Wise, intelligent, versed in many languages, he would befriend Caravaggio and make him a fellow Knight, earning in

return two major portraits of himself, one showing him with one of his many pages, his only supposed weakness.

The secret of Malta's defense was its natural harbor that penetrated the island to a distance of 4 miles, providing a series of inlets and islets, and offering superb anchorage and faultless shelter. The Knights' fortifications consisted of walls that prolonged the height of the cliffs, castles and three major forts, Saint Angelo, Saint Michael and Saint Elmo. As on Rhodes years before, the number of Knights was barely 600. These were aided by the superb Maltese, as well as a limited number of volunteers from other countries, especially Spain and Italy. Women and children were evacuated, although most Maltese chose to remain. La Valette wrote to Philip, his liege, and the pope, asking for help.

The Turks came with 130 galleys, 200 smaller vessels and 30,000 men. (Galleys were like Greek triremes, open rowing boats, not to be confused with ships, far bigger and basically powered by sails.) The Ottoman preparation for war was always faultless thanks to their incredibly efficient centralized bureaucracy, an enormous asset compared to irresolute Europe. The forces facing the Turks totaled 6,000. The Maltese were decided to fight until the last of their children.

The Turks landed and marched towards the fortification, men dressed in bright clothing and carrying hundreds of flags and banners, accompanied by music, armed with swords and muskets. The defenders, armed with lances and arquebus, were so eager to leave the fort and fight, under the red and white standard of St. John, that La Valette couldn't give permission to open the gates fast enough. When the Knights withdrew into the fort at nightfall they left 500 enemy dead behind, having themselves lost 10 men. From then on La Valette, in order to save lives, allowed his men to fight from the top of the walls only.

Hundreds of years of laying siege had made the Ottomans the most accomplished force on earth. They attacked the first Maltese fort, Saint Elmo, and their fire power was such that a Knight could not lift his head above the walls. Thirty who did so the first day, lost their lives. La Valette was hoping for ships and men from Sicily, so close it could be seen from Malta. The only ships that showed up were from North Africa, those of Suleiman. And the man chosen by Suleiman to lead them all was Mustapha, the young Turk present years before at Rhodes.

Roger Crowley, in his wonderful *Empires of the Sea*, describes the hour-by-hour defense of the forts, by Knights, Maltese and others whose courage defies imagination. The defense of Malta truly ranks with the courage and perseverance of those at Salamis, Marathon and the Thermopylae, bulwarks all against the barbarian hordes from the East, courageous barbarians, fanatical even, but mindless cannon fodder ruled by tyrants.

The first fort gave way, massacred to the last man, all 1,500. The heads of the leaders were raised on the top of the fort, at the end of lances. Their disemboweled bodies were dressed in their knightly white and red and nailed to crosses. La Valette had the heads of all the captured Turks fired from cannons into Ottoman lines.

When news of the massacre reached Venice the Venetians danced in the streets, perhaps to gain the goodwill of Suleiman who would permit Venetian trade to resume. In fact, Suleiman used the Doge of Venice to pass on his messages to the pope and European kings, this being the fastest way to communicate. Throughout the entire Renaissance the Serenissima never ever reacted like the rest of Europe.

One "Ottoman," a Greek from the Peloponnesus, captured as a child and now an important janissary, swam to the Knights' position and divulged extremely important information concerning Mustapha's intentions. The man, now nearly 60, reconverted to Christianism. Philip II finally was able to infiltrate 700 reinforcements into Malta, an enormous boon but unbelievably little considering the thousands of eager volunteers waiting on Sicily to help the Knights. European indecision, then as today, was and is the Achilles' heel of these otherwise great peoples. Another Greek slave, this one held by the Knights, tried to warn the Turks of the reinforcements. He was caught and butchered.

Astonishingly, the Turks got 60 galleys into the blockaded harbor by bringing them overland along greased planks, pulled by oxen. These boats, aided by land forces, attacked the remaining forts. But the Knights had positioned a number of cannons in hidden locations and thanks to them the Muslim attack was not only halted, the Muslims eventually were forced to retreat, leaving 4,000 of their own floating in the harbor and spread out in front of the forts. Four Ottomans were captured and interrogated before being turned over to the Maltese to be literally torn apart. Due to the massacre of the first fort, no one would be spared from then on.

In Spain Philip had rebuilt the fleet, but now he hesitated to use it, so great was his fear of the Ottomans and the near certainty, in his mind, of the fleet being destroyed. The gene of decisiveness had simply not been transmitted from Charles V to his boy Philip II. Men of undaunted courage were dying on Malta, with other men and ships, on Sicily, in full view of the Maltese, chomping at the bit to help.

Suleiman sent a message, through the Doge of Venice, to Mustapha, ordering him to accomplish his task. And Mustapha, despite the loss of thousands of his crack troops, the janissaries, moved to do so. Mustapha and La Valette were equally experienced, equally skilled, equally inflexible, but not equally prepared. Muslim thoroughness was so complete that there were daily lists of valorous men and the recompense offered by the sultan to each.

The Ottomans buried their dead, sculpting out mass graves from the sold rock surface. Huge numbers of Muslims lost their lives trying to retrieve the bodies. La Valette, desperately needing every man, forbade the retrieval of their own losses.

With winter on the horizon the rains came, bloating the bodies, bringing death, especially to the Ottomans, in the form of dysentery, the most disgusting form of misery, that emptied the body of its substance while poisoning the atmosphere, already filthy due to the rotting, stinking, unburied bodies.

The enemy was so close that at times they could exchange news. Janissaries captured as small boys could remember enough of their original Italian, Greek or Spanish to give vent to their misery to the Christians facing them, heartbreaking scenes between these men who could have been, for all they knew, brothers separated during infancy.

On Sicily 11,000 men waited word from Philip to cross the 30 miles between the two islands. In turkey Suleiman awaited news of victory from Mustapha, the sultan's life measured now in just a few remaining months.

Then a miracle. A horseman was seen riding with terrible haste towards Mustapha's tent, whipping his horse mercilessly. The animal fell and the rider took his scimitar and struck off its legs in revenge. He ran to Mustapha's carpeted tent to tell him that the long-awaited forces from Sicily were there. Mustapha, whom Suleiman later permitted to keep his head, gave orders to pack up.

The siege of Malta was at an end.

DOSSO DOSSI
1490 - 1542

Dossi was court painter for the Dukes of Ferrara, Alfonso I and Ercole II d'Este, along with his brother Battista Dossi who trained in Rome under Raphael. Born Giovanni di Niccolò de Luteri, his father was a tax collector for the court of Ferrara. Dossi worked in oil, painting mythological scenes as well as the usual church subjects. He is known for his distortions à la Greco. A favored subject was Hercules, especially by Duke Ercole (Hercules) d'Este. He also painted the only confirmed portrait of Lucrezia Borgia.

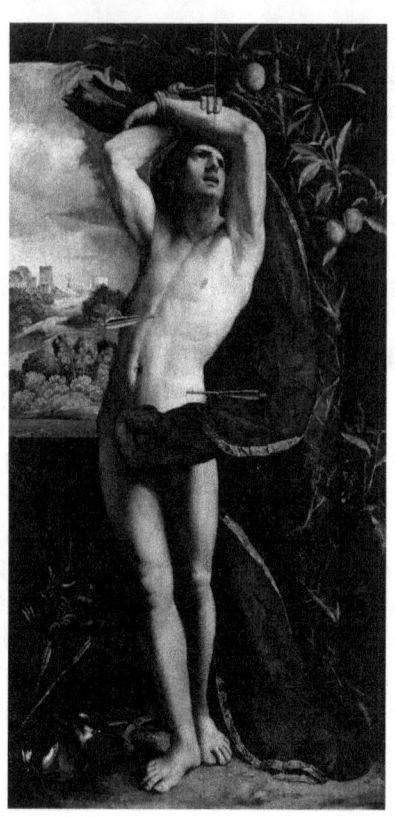

THE RENAISSANCE WARS
1494 – 1559

In the first chapter I carefully exposed the peoples and events that made the Renaissance intellectually and humanistically possible. Some men collected and translated our Greek heritage while others fought over kingdoms as they did table scraps. The nobles led the way into battles, followed by the likes of the Swiss, the Garcons, the landsknechts, who would dash a child's head against a wall and spread a nun's legs until it leaked the colors of the Knights of St. John, red and white, blood and semen, especially if the rapists of nuns were Lutheran. Juan Borgia strutted through the streets of Rome, gorgeous in his velvet black trousers and doublet, his shirt a splendid white, his hand gently caressing the codpieces that accentuated his loins, an invitation to any handsome lass. And so it was and will ever be: the intelligence that sent us to the moon will always be surpassed by the reptilian segment of the brain, and blood and sperm, in ever and ever and ever greater quantities will spill into--and fertilize--the nourishing earth.

The genesis of the Renaissance Wars began well before 1494 but here we'll take them up after the death of Alexander VI and that of Juan Borgia's brother, Cesare. We'll start our story with the League of Cambrai.

The expansion of Venice over the centuries had made enemies, and as Venice, like a spoiled child, always decided what was best for itself, a city-state either won against Venice or lost and gave in: there was no intermediary negotiation. The Venetians didn't hesitate a second in aligning themselves with the Ottomans when they felt their commerce--a lifeline without which they would cease to exist--was threatened. After all, one of their most vital possessions, Cyprus, was in spitting distance from Turkey. At the same time, Venice always found a reason not to come to the aid of the pope or an invading force from France or Spain, unless they could reap easy benefits.

The Venetians had thusly made enemies. Strangely, it was in the surrounding territories they ruled that the rural classes, the farmers, supported them because the Venetians were vultures of a far less aggressive nature than the nobles in places like Padua, Verona and Vicenza whom the farmers' found far more arrogant and who, especially, taxed them to death.

As all the great powers had lost something to the Serenissima, they met to form the League of Cambrai to get everything back: Louis XII, Maximilian, the city-states of Mantua and Ferrara, and Pope Julius II who wanted to recapture the totality of the Papel States.

When the Venetians learned of the League of Cambrai and knew for certain that an invasion was eminent, they closed ranks and raised the money needed for an army.

The French were the first to "enter the dance," as the French themselves put it, with the battle of Agnadello. They came with their own men but they also wanted to complete their forces with the Swiss. While the cantons met to decide whether or not to participate, the French went over their heads, directly to the Swiss mercenaries themselves. They thought that all they needed was adequate bribes, and bribes did secure them several thousand mercenaries who needed the money, but not the expert forces provided by the cantons who, tired of being treated like bumpkins by the French, refused to participate. The Swiss, like the Venetians, would always march to a different drummer, then as today.

The Venetians were drubbed at Agnadello, especially as they refused to commit their entire forces, saving a large number to protect their island kingdom, where they now withdrew. With incredible intelligence, they advised towns like Verona, Padua and Vicenza to surrender to the Holy Roman Emperor Maximilian, knowing that they would be able to win these places back, later, far more easily than if they surrendered to the French.

So the Venetians found themselves back home, but with their military largely intact, while all around them the farmers, who preferred them to

the nobles who had now resumed power over them, began guerilla tactics against the invaders, the French and the troops of Maximilian, who were just beginning to arrive.

The Venetian genius continued when the Serenissima unilaterally gave back every position they had held, including everything Julius wanted. They did the same with their Spanish positions, the Venetian ports surrounding Naples, and they didn't even wait for Ferdinand to contact them, they sent embassies to *him* revealing their decision. They tried to do the same with Maximilian but failed. Both Julius and Ferdinand of Spain decided that a vital, living Venice would serve them better against the unbeatable French, and so they united their forces to reduce the power of Louis XII. That left only Maximilian as a major player in Louis' corner. Deeply religious, Maximilian would not fight against the pope, and when Ferdinand assured Maximilian that Maximilian's own son, Charles, would rule over Spain on the 20th birthday, Maximilian returned to the comforts of Vienna. Venice then took back Padua and Vicenza as they had foreseen, leaving only Verona in the hands of Louis. The pope got the Swiss cantons to provide him with 6,000 men, the best fighting force in Europe, men he paid extremely well, men he put aside as a spearhead should one be needed.

Then a coup de théâtre: Julius, afraid of Louis XII's growing power, proved himself to be the warrior pope History would crown him as being by forming the Holy League, Holy because it was he at its head. Amazingly, incredibly, it would consist of Venice. Julius, who just basically wanted the Venetians to remain neutral, only asked the Serenissima to give the League the soldiers they wished to volunteer. Ferdinand of Spain would provide most of the troops and even Henry VIII was invited, Ferdinand promising him his aid in Aquitaine (a huge chunk of France vital to the English as you may remember from the story of Henry II and Eleanor, so brilliantly played out in *A Lion in Winter*). It was announced that the League was absolutely not aimed at Louis, although it was.

The next year's campaign, that of 1511, in the absence of Louis who remained in France, was marked by Louis' men's attack on Brescia and the horrible sack of the town that was to follow. The attack took place in torrential rain and the French sustained many casualties. French infantry consisted mostly of Gascons and landsknechts, the dregs of humanity, who massacred and raped over a period of five days. 4,000 cartloads of stolen goods left the burning town, the soldiers now so rich that many simply returned home to France. The result was satisfying in the sense that the next town, Bergamo, paid the French 60,000 ducats to escape from the same fate.

The next battle was Spanish and papal forces against the French at Ravenna, said to have been the costliest massacre in troops in centuries. Perhaps 20,000 men and boys lost their lives, with a French win thanks to

French cavalry, but with the loss of the cream of the French nobility. Cardinal Giovanni de' Medici, the future Leo X, was taken prisoner. But the French had been weakened and Julius and his Swiss mercenaries, aided by the Venetians, chased Louis' troops from Milan where they installed Massimiliano Sforza. Louis' troops went back to France. It was 1511. 48 years of wars still remained.

What followed was more Byzantine than the convoluted Byzantines themselves. Take, for example, just the case of Verona. Louis XII died, a great king who was said to have died in supposed bliss while ''honoring'' his new bride, Henry VIII's sister, perhaps a bit young and demanding for the old man. His son François I took the throne (a king covered elsewhere) and retook Milan, showing his acumen by bringing Milan's new ruler, Massimiliano, to France where he was offered a wife and 30,000 ducats. Louis then wanted to take Verona from Maximilian who requested that François--having far stronger forces than those of Maximilian--not humiliate him by allowing him to hand Verona over to the Venetians who had now sided with the French (!). A treaty was drawn up giving Verona to Maximilian's son Charles who immediately gave it to the French who immediately handed it over to their new ally the Venetians. From here on Venice more or less leaves the scene as the Serenissima had suffered more than in its entire history. During the wars the Venetian town of Vicenza, for example, had changed hands 36 times, bringing massacre to the people with each upheaval, death, famine and rape, more than even the worst fate destined for those in Hell itself.

Ferdinand now died, leaving the Spanish throne to Maximilian's son Charles, age 15. Four years later Maximilian himself died and Charles, thanks to his pugnacity and intelligence, became the most important person of his times, King of Spain, Naples and Sicily, and Holy Roman Emperor.

Julius died, replaced by the Medici Leo X who brought Florence back into the Medici lap (fully discussed elsewhere). The Spanish troops who helped bring this about sacked Prato first, a town that had been sold to Florence in 1351 by Naples, a landmark massacre during which 6,000 were killed, a massacre remembered by Pratoans to this very day, summed up in a letter by an Italian to a friend, ''Oh God, oh God, oh God, what cruelty!'' The Florentines paid the Spanish 80,000 ducats to escape the same fate, with an additional 20,000 to the Spanish general.

The year was 1519 and there were still 40 years of inhuman suffering before the end of the Renaissance Wars.

In 1520 François decided to destabilized the very young Charles by backing revolts among the Länder in Germany and dissident followers of Martin Luther. Charles, very religious, united with Pope Leo X to rid Italy of the French by naming Massimiliano's brother, Francesco Sforza, Duke of Milan. Leo felt that Charles would be the best bulwark against Luther,

and confirmed his hold over Naples. As the Swiss cantons were split over aid to François and to Leo, both king and pope received several thousand mercenaries. Venice was obliged by treaty to aid François, and sent troops, but under anonymity.

Because the French had never been welcome rulers of Milan, and because the Venetians took the first opportunity to flee the city, the fall of Milan was immediate. But then Leo X died and papal funding of the war evaporated, bringing havoc as every city-state used the vacuum of power to free itself from any foreign presence.

Order came when Charles proved himself intellectually and militarily invincible. He would be a great king, but in his wake thousands of men and boys, women and children, would have their lives snuffed out. Then François, incapable of leaving well enough alone, invaded Italy. He was captured by Charles at Pavia and shipped to Spain.

The Treaty of Madrid gained François his freedom, but as he never envisaged respecting it, we won't go into its clauses except to say that the king was replaced by his two sons, both traumatized for life by the ordeal of their imprisonment.

Another League was formed, this one the League of Cognac, comprised of the new pope, another Medici, Clement VII, François, Henry VIII, Florence and Francesco of Milan. Charles was invited, but as the intent of the League was to insure Italian independence of all foreign powers, he couldn't very well join. The aim, for Clement, was to place Naples--in the hands of Charles--under papal direction. François had joined the League as a bargaining chip to play in his hand with Henry and his hand with Charles. For Henry, the League was nothing but papal wind, but as he needed Clement to give him a divorce from Catherine of Aragon, Charles' aunt, he went along.

Then, on all sides, things began to go horribly wrong. Charles' troops, a huge percentage of which were mercenaries, were unpaid and reduced to scavenger for food. The papal forces disbanded because neither Henry nor François believed in the viability of the League, and Venice, as usual, withdrew it men in order to save them should Venice itself be attacked. Florentines, again unhappy under Medici rule, held back funds. With disorder everywhere, Charles' troops took things in hand by moving to Rome that they sacked. The doors of the city were closed to Charles' troops but his seasoned warriors had no trouble scaling the walls, slaughtering any man, woman or child that came in reach. As many, if not most, of the landsknechts were Lutheran, churches were especially designated targets in which the usual filth was etched in the frescoes, a landsknecht pope was elected and nuns repeatedly raped on the altars, good sport for these husky lads deprived of warmth, food, pillage and sex during the seemingly never-

ending winter. The Borgo, the rich community of the cardinals, was a prime destination.

Naturally Charles was responsible. His lack of control and failure to pay the troops on time led to his total loss of control over them. The sack went on for *eight months*, until there was literally nothing more to steal and no one undamaged enough to be worth violating. To Charles' wretched troops were added thousands more, any peasant from the surrounding countryside who wanted in on the spoils. 12,000 people were killed and the population of Rome, due to the murders and those who fled the town, fell from 55,000 to 10,000 after the sack. Nearly all of the pope's Swiss guard was slain, an event commemorated to this day by the Michelangelo-clad boys who descended from them.

Charles reestablished control and made a treaty with Clement VII. His troops left Rome and the pope left Castel Sant'Angelo where he had taken cover. He would later crown Charles Holy Roman Emperor in Bologna, at age 30, the last pope to do so. Facing religious unrest at home, Charles made peace with François. The Medici pope Clement VII had Charles promise to restore Medici rule over Florence by marrying his daughter to the Florentine Alessandro de' Medici. Francesco Sforza would remain Duke of Milan. Clement recognized Charles' right to Naples. Venice got back some land and Ferrara lost some. François' sons were freed from Spain. Peace broke out. The treaty, called the Treaty of Barcelona, was signed in 1529. 30 more years of havoc remained.

Charles tried to get Italian states to join him in a league, the purpose of which was their protection in exchange for yearly financial backing. In this Charles was the original mafia boss offering security in exchange for ransom. But there was a secondary purpose: to show to François that Charles had plenty of friends, and so France would do well to watch its step.

Back in France François was building his hunting lodge, Fontainebleau, into a wonderful palace, in part thanks to Cellini. He was keeping busy fucking his mistress Madame d'Étampes and deflowering maidens, his specialty. He transported his own bed on hunting trips to continue his nonstop pleasure, to the utter amazement of Henry VIII who once accompanied him.

Boredom nonetheless seeped through and he decided on still another Italian incursion. As the English nursed the chimera of kingship over France, so François convinced himself of French sovereignty over places like the Savoy, Nice, Genoa and Milan. Like the Venetians, he cast his net wide, opening negotiations with even Suleiman the Magnificent. He gave his son Henry II to Catherine de' Medici, giving him rights, François believed, to Florence. (François had his mistress Madame d'Étampes, his son would

have his mistress Diane de Poitier, and Catherine would eventually evolve into one of the most extraordinary personages in history.)

Francesco died in Milan of natural causes and Charles took over the city-state, the perfect justification for François' renewed intervention.

Paul III became pope (fully discussed elsewhere) and welcomed Charles into Rome with full honors, as Charles was now the most powerful prince in the world and the pope could benefit from his reflected glory. Paul initiated a meeting in Nice between Charles and François, with Paul officiating. The kiss of peace was exchanged and Charles was given the permission to return home by traversing France. François hoped that in exchange for his permission Charles would, in a gesture of brotherly affection, accord him Milan. Charles felt that entrusting himself to François was proof enough of their shared love.

Pope Paul had another brilliant idea. He got his son, Pier Luigi Farnese, to offer Charles 2,000,000 ducats for Milan that Pier Luigi wanted for *his* son, Ottavio Farnese, who was already Charles' son-in-law, having married Charles' daughter Margaret, Alessandro de' Medici's widow. We learn much more about Pier Luigi Farnese in the chapter on Caravaggio, but for the moment I would like to take an instructive detour in order to explain exactly who Alessandro de' Medici was and how he met his death, a detour taken from my book *Cellini*:

Alessandro, age 19, was named to rule Florence by his father Pope Clement VII. Alessandro took advice from no one, living for his own pleasure, his motto being "They made me duke, so I'll enjoy it!" By enjoying it he meant wandering the streets at night fully armed, pushing aside anyone in his way, looking for a fight he was destined to win for the simple reason that he had barred the carrying of a sword or a firearm, both of which never left him, nor did his dagger. And he had reason to fear, as the nobility of Florence wanted him replaced by legitimate blood, noble blood. He had gained power at age 19 and had by now fully tasted every perversion, so that what was left was taking the hymen of those who still had one, notably nuns, and that of those who kept guard over theirs, virtuous women. He liked his boys too, for quick, easy couplings, as heated and virile as possible. His favorite companion was his cousin Lorenzino with whom he shared his bed and more after a night of joint whoring. And when he awoke with a lustful urge, Lorenzino was always conveniently spread out, naked, at his side. This is how Cellini had caught them many times, as the artist was permitted to come and go as he wished, and as Alessandro had no modesty and no need to hide his vices, Cellini was aware of every thing that went on. "Meanwhile I went on making the Duke's portrait and oftentimes I found him napping after dinner with that Lorenzino of his."

Lorenzino, at times, behind his back, was called Lorenzaccio, "bad Lorenzo," for his habit of cutting off the heads of statues and other misdemeanors, clear proof that he shared much of Alessandro's waywardness, at least at the beginning. Lorenzino is extremely famous in France thanks to the *chef-d'oeuvre* by Musset, *Lorenzaccio*:

Lorenzo: *Dormez-vous Seigneur?*
The Duke: *C'est toi, Renzo?*
Lorenzo: *Seigneur, n'en doutez pas.* And he plunges a dagger into the duke's body.
Scoronconcolo: *Est-ce fait?*
Lorenzo: *Regarde, il m'a mordu au doigt. Je garderai jusqu'à la mort cette bague sanglante, inestimable diamant.*

No one knows why Lorenzino turned against Duke Alessandro, aided by a professional assassin, Scoronconcolo. In his play Musset writes that he wanted the duke dead so that Florence could become a Republic again. Others suggest that he was just jealous of the duke's powers and privileges. As Duke Alessandro was so unpopular, he was never without his body armor, weapons and guards. But Lorenzino told him that he had found a Florentine lady of exception beauty and, especially, ironclad virtue. Lorenzino would bring her to the duke, and from then on it was up to the duke to prove that he could triumph over purity. Lorenzino convinced the duke to dismiss the guards for the night, to take off his armor and to slip naked into bed. From then on it was easy for Lorenzino to strike him with a dagger. Afterwards he rode off to Venice, a glove covering a finger Alessandro had nearly bitten off. There, he published his version of what had taken place in his *Apologia*, claiming to be a second Brutus. Lorenzino himself was later stabbed to death by a poisoned dagger on a bridge in Venice.

Now that Alessandro is rightly dead, as they put it at the time, let's get back to our story of the Renaissance Wars.

Charles was tempted to accept the 2,000,000 ducats for Milan, and in truth he should have as it was the destiny of Milan to be an eternal headache. While this was going on François was busy trying to conquer Nice using French and Ottoman troops, to the disbelief of Christian Europe. François had even turned over the French natural port of Toulon to Barbarossa, a bloodthirsty murderer of Christian children and women, only second to the Great Khan. Charles sent Spanish ships to reinforce Nice, thusly thwarting François' plans. To avenge himself, François decided to return to reclaim Milan. Thrilled at the call of battle, infinitely more exciting than the call of the hunt, French boys, mostly still adolescents, begged their king for permission to join his ranks, and François naturally agreed. French met Spanish on Italian soil at Ceresole, the French seconded by Swiss mercenaries, the Spanish by Germans. There was even a crop of

new Florentine lads, Juan-Borgia clones, there in favor of Charles. The weapons of choice were arquebusiers and pistoliers, lances and pikes and arrows. The French and the Swiss were the most redoubtable, and soon the Spanish and the Germans were throwing down their arms and seeking shelter among the horses of the French cavalry, deemed more humane than the Swiss and French troops who were mercilessly ending the lives of all who crossed their path. 15,000 of Charles' men were said to have died, a drop in the bucket in what the Spanish and the Florentines and the Germans and the Swiss had still to offer in the endless generations nurtured on soil drenched in blood.

While awaiting this new generation of cannon fodder, Charles and François signed the Peace of Crépy where all territories taken since their meeting at Nice would be returned. Thousands of sacrificed lives for absolutely nothing. Charles needed money and needed to take care of unrest in Germany; François needed to deal with Henry VIII who had taken Boulogne. A marriage between Charles and François' offspring was set for some unspecified future.

The year was 1547. 12 years remained of the Renaissance Wars.

One had to admire the French troops, nearly annihilated--along with French nobility--under Henry V at Agincourt, in 1415. The rebound had been long in coming and was thorough. Then François died, and Henry VIII too. François' son Henry II was a good boy and king, but no François. Edward VI of England was a good boy too, but dead at age 16, replaced by his sister Mary who would wed Charles V's son Philip. Not until Elizabeth would England be a problem again to the Spanish, or to anyone else.

Through lack of testosterone-charged leaders, Europe would know some peace. But other boys like the Borgia brothers, Juan and Cesare, beautiful and virile, were on the horizon, as will eternally be the case.

Unfortunately, the Spanish missed their unique chance when they had the captured son of François imprisoned. How easy it would have been too spoil the lad, to flatter his ego, to respect his nobility. Instead, he was ill treated, and as such he hated the Spanish with all his heart and soul, enough to continue his relations with the Ottomans, enough to bring death to still untold thousands.

What took place next were tiny disputes in localities with names such as Brà, Bene, Asti and others. Charles took Siena and lost it and took it back. The Sienese were reduced to such misery that Charles ruled over a city of skeletons, a city known then, as it is today, as one of the most civilized and cultured in Italy. Charles resigned power over to Philip who was good at what he did but no Charles. The French did take Corsica, for a while, before taking it permanently in 1769, making Napoleon French, to the apparent joy of French mothers who could witness their sons,

thousands upon thousands of them, sacrifice their brief lives *pour la gloire de la patrie.*

Charles V, François I and Julius II left the stage, and the stage went silent.

Peace came with the treaty of Cateau-Cambrésis. The year was 1559. The Renaissance Wars were over.

TINTORETTO
1518 – 1594

Tintoretto as a person stands out for his uncalculating goodness. He married, had five children, one of whom was Domenico, his apprentice and loyal assistant. When he left home his wife insisted that he be warmly clothed and carry money in a handkerchief. On this return she demanded an accounting which invariably turned out that he had given the money to charity or to prisoners in the local jail. He often painted for nothing or left the amount to the appreciation of the commissioners. He had a workshop, was good to his boys, often joking, never smiling, certainly the prince a young apprentice dreams of working for and learning from. Known for his extreme rapidity, Sebastiano del Piombo said he could paint in two days what Piombo could do in two years. Annibale Carracci said that Tintoretto was at times equal to Titian, at times inferior to Tintoretto. Venetians in general held that he possessed three brushes, one of gold, one of silver and one of iron. In brief: a fine descent man of mixed talent.

His name was Jacapo Comin and during his life he was called *Il Furioso* due to his phenomenal energy and rapidity. He was the oldest of 21 children. His father Giovanni was a dyer (tintore) from which his son received the nickname of little dyer. His men were muscular, his perspectives monumental, and his use of light and coloring in the Venetian tradition.

He was apprenticed to Titian but allegedly was sent away after ten days, certainly not for bad behavior as he was docile and attentive. Some say Titian was jealous of the talents of a 15-year-old boy, others that Titian found him to be, even so young, too set in his ways to be taught. Titian would hold him in disdain from then on, even though Tintoretto remained so loyal to Titian that above the door of his workshop he had inscribed: The designs of Michelangelo, the colors of Titian. After leaving Titian he was said to have learned by himself by copying casts and bas-reliefs of which he eventually had a huge collection. He was also said to have taken dissected cadavers from anatomy schools that he dressed--or left nude--and used as models.

All of his frescoes have been lost. His first paintings, of himself and his brother, have also been lost, as were his paintings for the Doge's palace.

He was friends with Pietro Aretino and painted the ceiling of his house. Pietro Aretino wrote dirty sonnets to go alone with the *I Modi*, drawings of sexual intercourse, but is especially known for his satirical writings (more in the chapter on Raphael).

Alongside Veronese, he did what are called four masterpieces for the Doge, as well as his vast *Paradiso*, aided by his son Domenico, said to be the biggest painting on canvas. One of his daughters, Marietta, was also a painter and musician who had accompanied her father during his work, dressed as a boy.

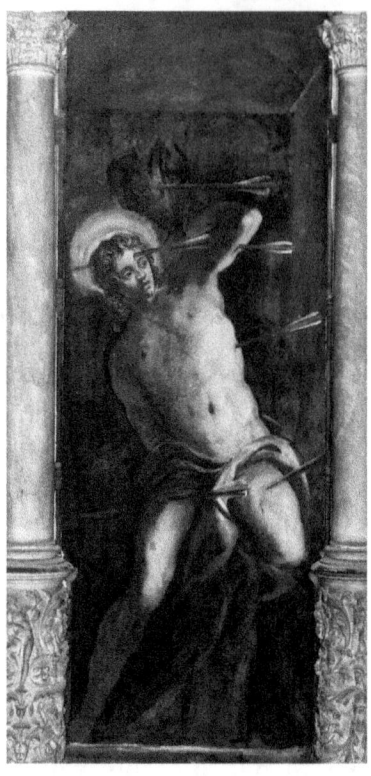

GIROLAMO SICIOLANTE DA SERMONETA
1521 – 1580

He is noted for his mannerist paintings found in the Palazzo Quirinale in Rome. Most of his frescos were destroyed during the War.

CARAVAGGIO
1571 – 1610

Caravaggio was noted for his use of chiaroscuro to such a point as to be thought, by some, to be its inventor. Chiaroscuro is the contrast, often very strong, between light and dark, enforcing the three-dimensionality of objects. 90% of Caravaggio's life resided in the *oscuro*, the bleakness of which made his biography far more difficult than my last work had been, *Cellini, His Life and Times*. Despite the dark side of Cellini, the fact that he had murdered several men (stalking and knifing them from behind) and the even more disconcerting fact that he was a confirmed sadist towards women (confirmed by his own autobiography!), the *chiaro* portions of Cellini's life were by far the more important. Like Caravaggio, Cellini was an artist of genius, but one--and this was the winning point for me concerning Cellini--who worshipped the boys he loved. Throughout Cellini's autobiography we find these panegyrics that leave no doubt as to the erotic nights and equally languorous days spent with his young--at times incredibly young--lovers: "We are never apart, day or night," "We loved each other more than if we had been brothers," "My passionate love for the boy," "The prettiest face of anyone I have ever met in my whole life," "He's amazingly beautiful, and the great love he's shown me made me love him in return--almost more than I could bear," "His beautiful smile would have driven the gods themselves mad," "Extreme personal beauty" and "The most handsome young fellow in Rome."

What was engaging concerning Caravaggio was the *chiaro* of his first paintings, the eroticism found in the close-ups of certain works--here I'm thinking of his *The Musicians*--which show the boys' faces in the very throes of immanent orgasm, the eyes glazed over, the lips sensually parted, the tongue just visible and lasciviously hard. Or the boys' shirts, in this and in other paintings--always boys, as his first painting of a woman came only in 1597 with his *Repentant Magdalene*--shirts at times undone to the waste, open on skin glistening through effort, perhaps sexual, the nipples erect, the

underarms reeking of pheromones, the odor of sex so invasive that one can guess at the traces of sperm smeared somewhere over the lower belly.

But I was enthralled too by the *obscuro*, the blood gushing from the jugular of the virile male in his *Judith and Holophernes*, as the knife is halted forever in mid-distance, as it cuts through the throat. Or the nearly naked soldier in *The Martyrdom of Saint Matthew*, sent to murder the saint so that the king of Ethiopia could have access to Matthew's niece: the horror being that one so young and virile would dare destroy one so old and helpless. Then there's the *Sacrifice of Isaac* in which the withered mind of Abraham pushes him to slit the throat of his screaming son, his hand stayed at the last moment by an angel. And *David and Goliath*, David holding up Goliath's severed head, the self-portrait of Caravaggio himself, one eye clearly dead, the other harboring a lingering thread of life. *The Beheading of John the Baptist* is of disgusting reality: his executioner, muscular and shiny with sweat, the ultimate in homoeroticism, leans over the saint whose head he holds firmly against the floor, while blood spurts from the severed throat. (Caravaggio signed himself--Michelangelo--in the saint's blood, the only time he ever signed one of his works of art.) But the worst is *The Martyrdom of Saint Ursula*: A withered old man, unable to achieve his ends with a young woman, shoots her in the breast with an arrow at pointblank range. Ursula looks down at the wound, as if in wonder that she has been pierced and that blood is flowing. It makes me, too, wonder if the painting inspired the makers of the film *Munich* in which men come upon a female terrorist who, to escape death, offers herself naked. She's shot three times in the breast from close range and, like Ursula, looks down at the blood that begins to treacle from the wounds, as intrigued at the saint, and remains so until a final bullet is lodged in her brain, the most disgusting, oppressive death scene I've seen in my entire life--with the exception of *real* footage taken during wars and revolutions.

There is nothing of the sadist in me, and I would certainly kill no living thing other than flies and mosquitoes, themselves bearers of countless misery, but the obscure part in each of us makes my heart skip a beat and my breath gasp before the bloodletting in Caravaggio's works, taken to an extreme not even surpassed by today's snuff movies, artistry that the likes of Scorsese, a modern-day genius, claims to have formed his own art.

Caravaggio worked alone, had no assistants, no workshop. He strode through the streets of Rome in the company of a wild bunch such as he, looking for action in the form of fights, his sword by his side and his dagger reassuringly in his belt. His eyes were wide-open and seeing, mean and blasé, his lips ridged. His motto was said to have been *nec spe nec metu*, without hope or fear. Someone compared him to a modern-day James Dean, but while Dean was a sissy who liked to take it up the ass, Caravaggio

was a boy of his times, spoiling for a fight and learned in the arts of sword play. He was no sissy.

Historians writing about Caravaggio go off on tangents--interesting and instructive tangents--such as the supposed influence of this or that pope, cardinal or priest on the artist, none of whom had, in reality, the tiniest hold on Caravaggio, because if they had had such a role, how could one explain the painter's violence and the murders attributed to him? Anyway, these men were dwarfs in comparison to the geniuses of the time, da Vinci, Michelangelo, Bernini to name but three. The popes and their servants, the cardinals, were but purveyors of the money that allowed the real heroes, the artists, writers and philosophers, to eat and drink to their fill. The truth of Caravaggio is that once all we know about him is boiled down, it is reduced like a gallon of alcohol and a basketful of roses that pass through a distiller, and what we're left with is the scent emitting from a few residual drops.

He lost nearly every male member of his family to the plague while still very young, the plague that had killed over half of the population of Italy a generation earlier, around the 1350s, but reappeared from time to time to claim the survivors. This might have instilled a sentiment of abandonment, a child's first and greatest fear, a scar on the mind that pushes one incessantly from place to place, person to person, never at ease, never satisfied, always angry, violent, physically and sexually aggressive. Perhaps only a man of such unhinged and brutal appetites could create the works of this totally unique individual, stark, aggressive and sexually explosive segments of human life. This may partially explain the brutality of his nature, as well as the fact that the times in which he lived were in themselves ultraviolent, where even if a man looked at another for a nanosecond too long he might be challenged and put to death by sword. One author even suggested that a catalyst for his brutal character stemmed simply from the chemicals used in his painting, lead white and vermillion, both of which are highly toxic.

Caravaggio was a man of great strength and a first-class swordsman. That he was also an artist whose delicate strokes created works of genius must not mask the fact of his indomitable virility, capable of downing a man with a blow--temporarily if done with the fist, life-threatening at the end of his sword. The proof of this was his slaying of the handsome Ranuccio Tomassoni in a sword duel. Caravaggio ran with a pack of toughs, armed to the hilt in a city where arms were forbidden. He and his goons drank and whored, pushed fellow revelers aside as they made their way through the allies from tavern to tavern. They were constantly picked up by the Roman police, held the night and then freed as they had powerful friends, friends like Cardinal del Monte who was smitten by boys and who appreciated homoerotic art, bringing much of it into the Vatican (one of the

reasons why the Vatican is, today, a must-see museum). Del Monte allowed Caravaggio to bed Cecco, a boy of only ten when he appeared as a prepubescent *St. John the Baptist*, a beautiful, brooding lad when painted a handful of years later in another *St. John*. Caravaggio and his ruffians broke windows, sang bawdy songs, hurled animal bladders filled with blood or ink at buildings, smeared excrement on door handles and, naturally, drew erect, usually discharging phalluses on walls. An unknown source had this to say at the time: "After a fortnight's painting he swaggers about for a month or two with a sword and like-minded friends at this side--Prospero Orsi, Constantino Spata, Mario Minniti and Onorio Longhi--ever ready to engage in a fight or an argument, so that it is awkward to get along with him." To say the least. Another of his acquaintances, Agostino Tassi, was accused by a father of "repeatedly deflowering" his daughter! (Perhaps, like Aphrodite, her virginity continually rejuvenated by bathing off the shores of Cyprian Paphos.)

He whored, but his preference was men, a choice far from unknown in the Florence of his epoch where men chose freedom over marital bondage, where one could take one's pleasure when and where one desired, with a boy or a man, free of nagging and the expense of a meal. This is what Andrew Graham-Dixon says in his wonderful *Caravaggio*: "Caravaggio was capable of being aroused by the physical presence of other men. He could not have painted such figures in the way that he did if that were not so. Caravaggio's painting suggests an ambiguous sexual personality. On the evidence of his paintings he was neither heterosexual nor homosexual, terms that are in any case anachronistic when applied to his world. He was omnisexual." Most authors, other than Graham-Dixon, go out of their way to presume a man innocent of homoerotic yearnings and--even more--of committing homosexual acts, unless provided with the proof of their guilt by someone having spent the night under the perpetrator's bed.

Boys at that time loved to dress to kill. Churches abounded in Renaissance Italy, and especially in Florence and Milan, perfect stages for a young sire to show off his splendid forms, silk-adorned chest, form-fitting trousers, elegance out to swoon the fair sex, a dagger at the belt and a sword ever handy, a youth's tools. For the daily, reliable and rapid purging of one's lust, there were bordellos, taverns with frisky and economically cheap servers, as well as back alleys where, indeed, all cats were grey in the absence of light, and a lad had but to pull the strings attached to the cloth that covered his private parts to take his pleasure with whomever engorged his manhood, or when he simply wished to relieve himself against a wall.

Michelangelo Merisi da Caravaggio was born around 1571. Famous while he lived, he was immediately forgotten after his death, to be rediscovered in the twentieth century. He was blessed with two beautiful

names, *Michelangelo* which evoked the famous Florentine genius, although Caravaggio's first name had been chosen after the feast day on which he had been born, Archangel Michael, and *Caravaggio*, the site of his birth. His father was the chief architect of the Colonna family household, a family known for its military glory, and directed its staff. (I shamefully will not evoke the Colonna during this chapter, but there importance in Italian politics and military affairs was absolutely essential.) Some say he was a mason, which may have been the case before the Colonna opened wider horizons. He was responsible for the servants, cooks, valets, coachmen, among others. One person especially stands out during Caravaggio's youth, Constanza Colonna, who took an interest in the son of her servant. We'll meet her later when she comes to the rescue of Caravaggio, but for the moment she weds, at age 12, Francesco Sforza, 17, a marriage that starts off so poorly that she threatens to kill herself if her father doesn't free her: ''If you don't get me out of his house I'll kill myself and my lost soul be damned!'' As the Colonna carried weight, the pope allowed her to enter a nunnery where she gave birth to a son (I haven't found the key to this enigma, unless it was, quite simply, a miracle). Five other sons followed, perhaps signifying that she had somehow found her husband less boorish than at first. Two of her boys would turn out to be as uncontrollable as Caravaggio, but without his artistic gifts.

A two-hour ride from the stiflingly dead town of Caravaggio brought one to the big city, Milan, under Spanish rule at the time, the bustling center of commerce and manufacturing, 100,000 souls--as many as London and Paris--and the epicenter of the silk industry as well as the finest workmanship in swords and daggers in Italy. Gold from the New World caused a rise in prices in Milan that impoverished the majority of the Milanese, and what had been considered a miracle of riches would soon lead to the bankruptcy of Spain. Milan was inhabited by the young Caravaggio until he went to Florence, later in our story, at the age of 21. Florence was the capital of art, and da Vinci and Michelangelo, soon followed by Raphael, were its kings. What a change Caravaggio would bring to all this. Already Michelangelo was known for his nudes, the genitals of which would be later painted over. But how different were his nudes from Caravaggio's. Michelangelo's muscular lads looked as fresh and scrubbed as if they'd just stepped out of an hour-long shower. Caravaggio's boys were so realistic that one could nearly whiff the pheromones from the lads' beautiful but slightly rank bodies, and in his *Jupiter, Neptune and Pluto* we have a full under view of Neptune's pubic bush, scrotum and penis with its full prepuce. I insist on this point: the boys in Caravaggio's pictures are totally alive, and even when just sitting, surrounded by fruit or flowers, their shirts open over their naked chests, one has the impression that they've just left a bed after making sweet love,

and, as I've said, that unwashed sperm still coats their bellies. In the book *Who's Who in Gay and Lesbian History* the writer says that Caravaggio's *Amore vincitore* makes him think of a "completely naked pin-up teenager," which underlines the sexiness of his paintings, even though, in the case of the *Amore vincitore,* it's not the naked pin-up of a teenager I'd have in *my* bedroom. As far as realism goes, nothing is more ghastly than the blood spurting from the jugular vein of a tyrant, sectioned by a sword in his *Judith and Holofernes*. The realism in his paintings was such that he even showed the dirt under the toenails! But all this is in the future. For the moment he's 13 and apprenticed to Simone Peterzano, a painter of mediocre repute who taught the boy little except for a smidgen of drawing, stretching canvases and the art of grounding colors. Caravaggio's thought to have been rowdy even at that age, controlled with difficulty. He ran around with gangs as he did later in life, and he certainly had his first sexual experiences with boys and whores. And as Milan was noted for its violence he may have done more, he may have killed someone, as is suggested in several texts, but at any rate he left the city, never to return, and headed south to his destiny in Rome.

It is said that Caravaggio, Reni and Ribera were highly influenced by the Council of Trent and its attempt at a counter reformation that would end the sale of indulgences, impose religious subjects in art, outlaw nudity and reduce church music to Gregorian chants. Even before the council Pope Adrian VI envisioned painting over the scandalous nakedness of Michelangelo's works in the Sistine Chapel, a plan happily ending with the pope's demise. Caravaggio himself was supposed to have been influenced by the Milanese cardinal Borromeo, a sincere ascetic who slept on straw, sold his furniture to provide money for the poor and organized succor for the sick and needy during the terrible Milanese plague of 1576-1578 which claimed 25,000 lives in Milan and its surroundings. When dead, Borromeo was embalmed and put on display for the weeping and howling multitudes that passed before his body, touching his feet with crosses and rosaries. A bare 26 years later the desiccated blackened remains, smothered in gifts of diamonds, emeralds, rubies and sapphires, were canonized.

The church held forth against the superfluous, the elegant, the pagan and the naked, yet what followed was the ridiculous bling-bling of the baroque and the eroticism of nude Sebastians, infinitely more sexually stirring than anything envisioned by Michelangelo, other than his *David*, and the realism of John the Baptist's head severed in painting after painting, blood gushing, throat slit open, eyes gaping, teeth bared, tongue engorged, and mouth frozen in silent screams. And on the sexual front, no artist, with the possible exception of Reni, refused himself access to an apprentice's or a model's muscular buttocks.

Certain traits concerning Caravaggio are certain: He was eternally dissatisfied. We don't know why, although having lost most of his family to the plague so young may have been a factor. Cellini was eternally hot-headed, another of Caravaggio's characteristics, even though no boy had been more desired by his father than Cellini, and no boy more worshipped after his birth than Cellini by his dad. Cellini was nonetheless touchy and turned to vengeful murder on more than one occasion, as did Caravaggio. Both Cellini and Caravaggio were alike too in being intrepid workers. In Caravaggio's case he turned out painting after painting, and the more depressed his was, the more the Fates seemed to malign him, the more he churned out masterpieces. Both Cellini and Caravaggio also preferred boys, Caravaggio Minniti and Cecco, Cellini too many to list! Caravaggio was an earthy realist. His paintings show dirty feet, soiled hands and filthy fingernails, rigorous right down to their grooves. Caravaggio makes one think of an animal, with an animal's spontaneity and boldness; there was nothing shy or hesitant about him. If he had to kiss his masters' feet and hands it was with the awareness that he could just as easily bite and, if need be, go for the jugular with the dagger he was never without. Reality in painting, reality in life: this was Caravaggio's creed. He rejected the silly artifice of both mannerism and the baroque. He lived in the post-Reformation world but was untouched by the jeweled, perfumed hands that signed the decrees issued by the Council of Trent. And he would eventually die in the same way, on a deserted beach, in a humble hut among strangers, a man possessed by his art until his dying breath, a man as humble as those who would bury him, as fiercely arrogant as those deprived of the world's greatest treasure: its love.

He was described as being handsome in a wild way; his hair, curly and unruly, his eyes large and wide like a Spaniards, his clothes said to have been of the best quality and cut, but worn until they were nearly rags. The city he entered, Rome, had once been like Caravaggio in a new array of the best clothes, it had been the center of the ancient world and had reigned supreme for half a millennium, but now it was decrepit, the buildings crumpling among fields of mud, rats and stench, with only a few favored islets inhabited by the rich and powerful. During the Cesares there had been 2,000,000 souls, now there were 100,000. Then as today the Romans rose early, slept the sweltering afternoons away and spent the nights in earthly amusement. The city was violent, the streets unsafe, men carried stilettos and swords, and the most vile could poison an enemy through the prick of a death ring. It was there Caravaggio found lodging, in the Palazzo Madama, the palace of Cardinal Francesco Maria del Monte, a man known for his paternal interest in boys in general, and artists in particular, who introduced homoerotic art into the Vatican, and was himself homosexual. The palace housed as many as fifty boys, artists like Caravaggio, actors who

took part in plays dressed as women when the role demanded it, rent-boys when out of work, and castrati. He came with his luggage: a tormented mind, a character as unruly as his hair, violent fists and a sword and dagger at his side, despite their interdiction in the holy city famed for its bordellos. Its clergy lived in palaces and needed architects, sculptures and playwrights to fill their theaters, painters like Caravaggio, and warm bodies to span their nights. One Englishman described Italians as being addicted to "the art of Epicureanism, the art of whoring, of poisoning and of sodomy."

Caravaggio spent much time with his friends roaming the vicinity of the Piazza Navona and, if they wanted sex, the Piazza del Popolo where women and boys plied their trade in ill-lit alleys or behind the parted curtains from their lodgings where they appeared naked, enticing men who often found that what they were buying was far more sordid than what they could get for free among their own sex.

Many of his friends he had met when he first arrived in Rome and slept rough in the vicinity of the Campo Marzio. Not all the religious leaders gorged themselves on the pleasures of life, some religious orders existed that cared for the poor by offering food and medical care. Caravaggio arrived at a time of famine and literally may have escaped death by starvation. Thanks to the Colonna he found a room with a Monsignor Pucci whom he called Monsignor Salad as that was the extent of his nourishment, in exchange for shopping and keeping the dwelling in order. Caravaggio was given additional employment by Lorenzo Siciliano, specialized in the heads of the ancients that he sold cheaply to those who wanted to decorate their homes with the portraits of the Caesars. It was here he met another painter, Mario Minniti, first his lover, then a friend, and finally a benefactor at the end of Caravaggio's life.

With Mario he moved on to the workshop of Cavaliere d'Arpino (his real name was Giuseppe Cesari) where he painted his *Sick Bacchus*, a self-portrait that gives one a queasy feeling as Caravaggio indeed looks deathly ill. D'Arpino was an arrogant tyrant who mistreated him, and if this and his illness were not enough, he was kicked by a horse and forced to spend several weeks in a free hospital, Santa Maria della Consolazione. He had placed some paintings with a French art dealer, Valentin, who sold one, the wonderful *Fortune Teller*, to Cardinal del Monte who took him in, accompanied by Minniti.

One of his early biographers, Giovanni Bellori, describes Caravaggio as being dark, dark in his looks, in his temperament and in his art, an extremely apt insight. Another description of Caravaggio's place in Rome and Roman violence comes from Tommaso Garzoni, relayed to us by Graham-Dixon: "Every day, every hour, every moment, they talk of nothing but killing, cutting off legs, breaking arms, smashing somebody's

spine ... For study, they have nothing other than the thought of killing this or that person; for purpose, nothing more than to avenge the wrongs that they have taken to heart; for favor, nothing more than serving their friends by butchering enemies..." With Caravaggio we will continually go from summit to summit, one in blazing light--that of his art, the other in princely dark--his intimate nature."

He soon came to know his fellow artists against whom he fought for commissions, all of whom lived in the same vicinity, ate in the same restaurants, drank in the same taverns, and bought their supplies from the same street vendor, Antinoro Bertucci. Caravaggio started out, as said, by painting the heads of famous early Greeks and Romans, very popular among those climbing the ladder in society, exchanging their mercantile or militaristic origins for those of the educated nobility. From there Caravaggio went on to still life's, another field just opening up, one he would combine, later on, in his paintings of young shirtless boys, like the *Boy with a Basket,* holding or surrounded by flowers and fruit.

Del Monte was a cardinal in the service of Ferdinando de Medici who lent him the Palazzo Madama. He earned a good salary but had no personal fortune. His brother was a famous mathematician who had taught Galileo. Del Monte lived for art and the collection of art, surrounded by boys who executed his every wish, but he was known for his modesty and modest lifestyle, eating and dressing frugally--even shabbily some said--and was deeply religious.

Caravaggio spent four years in the palazzo. His quarters were extremely small but he was clothed and feed. Del Monte seemed to have been friendly but rigorous, far from the intellectual, easygoing Lorenzo *Il Magnifico.* Contrary to what I've written above about del Monte's modesty, one source states that his servers wore caps when serving him at table in order to be able to raise them every time del Monte took a drink. Again, far from *Il Magnifico* whose dinners were excuses for friends to come together for free-reining conversations. For all this, Caravaggio's four years with del Monte were certainly the most stable and uncomplicated of his existence.

He had boys for his bed, especially Cicco whom he had known as a child and who had grown into an exquisite young man. Sodomy was punished by death, but as it was practiced as often in Rome as in Florence, rare were the persons tried for the crime, rare, at any rate, among the nobility and, even more, among the clergy. But an artist kept his lusts a secret as his commissions could suffer with this kind of taint to his reputation. Of course, none of this stopped Caravaggio who at all times satisfied his sexual lust and his lust to fight. He attacked a young man, a notary, from behind as he walked along the Piazza Navona, in plain daylight, because the boy had somehow insulted him, perhaps over one of Caravaggio's girls. Profusely bleeding, the boy got to the police to tell his

story, before rushing off, unaided, to the hospital. The painter wound up paying a large indemnity. Then came another episode in a restaurant where Caravaggio had ordered some artichokes, half cooked in oil, half in butter. When he asked the server which was which, the lad answered that the man had only to smell them to find out. Caravaggio took this as arrogant disrespect and hit him with the porcelain plate used to serve the artichokes, severely cutting him. He then reached for his sword but the boy had the presence of mind to bolt. Here too he had to pay up. Stopped by a policeman for carrying a sword, he had, exceptionally, a permit to do so on him (permits given to high officials and their bodyguards). The policeman bid him "Goodnight," but as he walked away Caravaggio, perhaps unhappy that an artist like himself, who knew so many great men, had been detained by a redneck officer, called him, to his back, a cocksucker, and invited the gentleman to shove his "Goodnight" up his bloody ass. He was thrown in jail but was released the next day, as he knew he would be.

Caravaggio was far from the only man in Rome with murderous instincts. Even a terrible flood that left 1,500 dead couldn't keep all Rome from being stunned by a murder among the nobility, that of Count Francesco Cenci by his coachman--his daughter's lover--Catalano, who bludgeoned him with a hammer. The count had at first been drugged by his daughter, Beatrice, assisted by her stepmother, the count's wife Lucrezia, whom Count Cenci repeatedly raped in front of Beatrice. Count Cenci had been ruined by a fine of 100,000 scudi for sodomizing his stable boys and his girl servants. His sons, Giacomo and Bernardo, were in on the plot, as the count had tried to sodomize them too, as well as having incest with Beatrice. (She's thought to have had a child, but from her father or the coachman is unknown.) The murder was camouflaged as an accident by shoving the count's body over the broken railing of his palazzo. It was the murder of the century and even Pope Clement wanted to be kept continually up-to-date. If this weren't enough, a Cenci cousin, Paolo di Santa Croce, killed his mother when she refused to bequeath him her estate. The pope demanded death for them all.

After this we discover another chapter in Caravagio's dark existence. Ranuccio Tomassoni had a stable of women he put on the streets. Known for his extreme good looks and for being well-endowed, his women were extremely jealous of whom he chose to bestow his favors, to the point of attacking one another with daggers, hoping to scar a pretty face, or splash it with acid. The Roman police were called in numerous times to bring calm to the domestic situation. Ranuccio was always armed despite its unlawfulness, but invariably defended himself by stating that in his business being armed was necessary due to the girls' rowdy clients. At the same time, it appears that Caravaggio too had his girls who disputed their place of the streets with those of Ranuccio, the basis of an explosive

situation that would lead to Caravaggio's attempt to knife the boy, perhaps aiming at his genitals but striking instead the femoral artery, a place certain to cause nearly instant death. Both Caravaggio and Ranuccio had been accompanied by three men each, Onorio Longhi was there on Caravaggio's side and a captain of the guards was with Ranuccio. He too was run through but whether he died or not is uncertain. Caravaggio was put out of action with an unfatal blow to the head. The surviving six men stated that the incident had been over an unpaid wager on a tennis match although, most probably, it was a duel over prostitution, but as dueling in Rome carried the death sentence.... Caravaggio fled before his trial and was therefore sentenced to death, duel or no duel. A bounty was put on his head, a head that could literally be presented, severed from the body, in order to claim it.

Other sources give a lightly different version of the story. In one version Ranuccio Tomassoni was described as a sweet youth whose innocence was cut short by a fatal sword blow to the boy's private parts, a deliberate attempt by Caravaggio to emaciate the nearly virginal lad. Others have him as a well-hung pimp whose girls vied with each other for his favors, turning tricks with the view of the boy's bedding them as recompense for the girls' putting out.

Concerning Caravaggio, he is painted as a trouble maker--which no one could deny--but one who simply found himself in the wrong place at the wrong time. Others maintain that he was fucking Renuccio's favorite whore, or, in still another version, that Caravaggio was trying to get the whore to work for him as he too, in his free time, was a blasé, world-wise pimp. One thing is nonetheless certain, Caravaggio used whores for his models, the reason for which his Madonnas and Magdalenas were banned from churches and chapels by priests, and why he had to forgo commission after commission when it became known that he used them. (Even so, a painting refused by a church was instantly snapped up by a private buyer, often at far higher prices, and those accepted by priests often found their value quadrupled nearly overnight.) But the models, whores or not, were most often gorgeous, possessing a virginal aura known normally only to nuns. All of Caravaggio's paintings attest to their exceptional beauty.

It was for the bodies of these women that Caravaggio and Tomassoni may have had their dispute, and Caravaggio aiming at the lad's groin may have been in jealousy, as the girls certainly filled him in on the boy's dimensions and sexual prowess. It's not impossible, too, that Caravaggio lusted for the lad who preferred his girls, girls who would literally maim each other, attempting on more than one occasion *sfregio*, the cutting and disfiguring of an opponent's face, instantly ending her sexual appeal.

Carrying a sword in Rome could be punished by death. Dueling was not only punishable by death, the punishment was often truly carried out as a desperate means of stopping this most-favored form of rendering justice.

So to the authorities the witnesses to the feud between the sweet boy/pimp and the acclaimed artist/jealous-avenger claimed that there had certainly not been a duel, that the lads exchanged words when one of them--not specified--refused to honor the wager of 10 scudi at the end of a tennis match (whether a match between themselves or others they had both bet on, is unknown). The words led to the mysterious apparitions of weapons (weapons they had certainly not been carrying) and an accidental blow from which Ranuccio was wounded in the upper thigh. Caravaggio's sword had been seized by a friend of Ranuccio who hit Caravaggio over the head with it, knocking him cold. Ranuccio's brothers were captains in the guards, known for their brawling, their swaggering dominance over every back alley in Rome, their drinking, their swordplay and their predilection for humping their brother's whores. Horny stuff, in an era where power made everything right. Caravaggio, too, had his boys, Onorio Longhi, arrested time and again for very possible misdemeanor, but, following Caravaggio's death, Longhi would straighten himself out enough to become an architect of churches, followed by his son, another architect. Minniti may have been there, Caravaggio's long-time bedmate, who would also turn out straight in the sense that he would eventually marry, twice, father children, and mount a workshop that would flood Sicily with works of art, some of which were of true artistic value.

Now on the run, Caravaggio left Rome with all that was precious to him, his clothes and painting materials, his money and Cecco. He went to the Palazzo Colonna where he begged Constanza Colonna, whom we met at the beginning of our story, for help, help immediately offered as he and Cecco were packed off to the Colonna estate in the Alban Hills. There he painted *David with the Head of Goliath*, David being Cecco and the head, severed from the body, Caravaggio himself, its mouth open in a silent scream. The painting was sent as a gift to Scipione Borghese, who just happened to be head of papal justice, the man who could free Caravaggio from the death penalty. Borghese was powerful, but Caravaggio's enemies more so. He was to remain in exile.

He went to Naples, an immense city of 300,000, a city as decrepit then as it is today, home to criminals, crime and rackets, to the poor and scarcely educated, among whom labored 10,000 slaves. Yet the city thrived thanks to its sleepless citizens, scholars in trade, professors of import and export. As with Milan, Naples too was under Spanish rule, and as in ancient Rome, the nobility--meaning the Spanish and the wealthy--circulated through the streets in covered litters.

He resided with the Colonna but as his reputation had preceded him,

he did not need their help in securing what became a flood of commands. As in Rome, what could the rich do with their wealth, once their stomachs and loins were assuaged, other than tend to their palaces and gardens and interiors? But then word filtered through to Naples, from Rome, that Caravaggio had hired assassins to do away with his enemies, and whatever the truth of the matter, the uproar forced him to flee again, this time to Malta where thanks to the paintings he did of several Knights of Malta he gained near godlike admiration and was even knighted.

Also called the Hospitallers and the Knights of Saint John, the Knights of Malta began around year 1000 as an organization devoted to the poor and sick pilgrims who wished to visit the Holy Land. Attacks from Islamic forces gradually changed it into a military order recognized by the popes of Rome and dedicated to the physical protection of pilgrims. With the fall of Jerusalem in 1187 the Knights fell back on Rhodes. After the seizure of Constantinople the Ottomans turned their attention to Rhodes. In 1522 Suleiman the Magnificent put 100,000 men on the island to combat against 7,000 Knights. At the end of six months, the Knights were permitted to retreat to Sicily. In 1530 the King of Spain, Charles I, gave the Knights Malta. Suleiman sent an army against them. The defense of the fortifications on the island depended on around 8,700 soldiers, against the Muslims' 40,000. Half the Knights lost their lives but even the wounded fought in battle after battle again the attackers. The Turks made a final effort but the Knights and soldiers, working night and day, repaired the breaches in the fortification walls. Dispirited, sick and running out of ammunition, the Ottomans gave up. (Far more about this in the chapter The East.)

Most sources believe that becoming a Knight had been a wish Caravaggio had often expressed, and it played in well with the extremes of his character, from a painter nearly as acclaimed as Michelangelo, to a killer on the run, to a monk in the service of Malta. He would renounce the princely life he had led with del Monte, eating and drinking and fucking the best that life had to offer, pushing his way through the allies of Rome, dagger at easy reach, spending the wild sums his paintings now procured. He would exchange instant justice at the end of his sword in favor of vows of poverty, obedience and chastity. He, Michelangelo da Caravaggio, would trade the good life for the life of a saint. He had convinced himself that this was the right path, just as he and the people about him had convinced themselves throughout all their lives of the existence of good and bad, that a soul left purgatory the instant a coin hit a priest's alms bowl, and that absolution came through confession. Like sex, after the first act of faith one was no longer virgin.

The promise of a painting or two opened all the doors to knighthood for Caravaggio. But the Grand Master needed the consent of the pope

himself, a pope who, for the moment, hesitated to absolve Caravaggio for the killing of Tomassoni, but who planned, too, to squeeze, like a lemon, the last chef d'oeuvre from the rustic artist. The Grand Master was Alof de Wignancourt, from French Artois, intelligent, modest, always ready to accept advice, generous and, when he had the information he needed, decisive. He had rule over 1,800 monks (Knights), half on Malta itself, and was ever ready to protect his subjects from the Moors who would capture and sale them as slaves. He even set up a fund to ransom those captured before he took power. To say the least, he was lionized.

In Wignancourt's request to Pope Paul he didn't mention Caravaggio's name as the recipient of the knighthood, but he did mention that the man in question had been accused of murder, and as all of Italy had had little to gossip about other than Cenci's assassination and Ranuccio's killing, there was no doubt in the pope's mind.

While waiting for word from Paul which, unusual for him, would be sent back on the very next ship to Malta, Caravaggio did several portraits of Wignancourt, one of which showed him in the presence of one of his many pages. Every historian since that time has added two and two, making Wignancourt the king of pederasts, but naturally no one will ever know. The pages were lads chosen from the ranks of poor nobles, and it is said that Wignancourt paid for their education from is own pocket.

Caravaggio was meek in the presence of Wignancourt, whose unassertive manner nonetheless hid a fist of iron, and that even the Tasmanian devil would have watched his step before the Grand Master. Wignancourt was a military leader of extremely long experience, and not for a moment would a mere painter like Caravaggio pose the slightest problem. Whether Caravaggio just played at being meek in order to be accepted as a monk and to mollify the other Knights, aristocrats for whom Caravaggio and his plebeian blood counted for nothing. But Caravaggio had lost his father at age 6, had gone from workshop to workshop, had arrived in Rome with literally not a scudo in his pocket; had allied himself with riff-raff like Longhi (until Longhi turned himself around later); had most probably set himself up as a part-time pimp and had wounded several men, killing one--all this meant that he had the potential of a streetwise hard-core killer, and no matter how much Wignancourt thought himself capable of controlling the situation, he may have let a wolf in among sheep.

Caravaggio had come to Malta on one of the red and gold ships captained by none other than Fabrizio Sforza Colonna, one of Constanza's sons, now Captain-General of the Knights of Malta's fleet! The boats were crowded--up to 500 men--and filthy, rowed by oarsmen in the absence of wind. The heat was intolerable, disease flourished, and the rowers were cadenced by drums and the blows of whips.

Wignancourt loved Malta and had been literally there to see the

capital, Valletta, an immensely fortified town, rise from the island's cliffs. Although he died before the cities' completion, at age 71, he wished to beautify it with churches and Caravaggio's art. Caravaggio came through with his most outstanding creation, the *Beheading of St. John the Baptist*, the only painting he signed with his name, *F Michelangelo*, the F for Fra' as he had succeeded in being made a monk. His signature was in blood--how seemingly typical of this man who had personally known and personally been responsible for so much sufferance--blood from the throat of the saint, his head pressed solidly against the ground by his assassin, while the assassin's other hand hides the offending knife behind his back. He stares down at his victim, set on the sight of the gushing blood, hypnotized even, as if thinking, *"I, the living, have ended this life. I am God. I am misery. And the sight of your suffering has engorged my penis with the blood of the living, and I shall insert it into the living, and my orgasm will make me alive!"* The assassin is a true Derek Jarman male, as found in his film *Sebastian*, virile to the extreme, his hair short--incredibly so for the times--his skin glistening. John the Baptist was the Knights' protector, at that time as today.

And then, when things were going perfectly, he threw a wrench in the works, just like his double Cellini. And yet, everything had turned out so well. He was adored by the Grand Master, adulated by the Knights, even worshipped by the Maltese. True, he couldn't stride the streets armed to the teeth, accompanied by his faithful dogs like Onorio Langhi back in Rome, pushing citizens right out of the way, eating and drinking without paying, and fucking alongside his buddies, when not fucking his buddies. He just had to wait it out, a few weeks longer, perhaps even just a few days, until a red and gold Maltese boat brought word from Paul that his hand was needed in Rome to paint pictures, and that all was pardoned and forgiven. After all, who was Ranuccio Tomassoni, other than a boy who wished to live out his life?

But he screwed up--the least that can be said. Again, not only are details lacking, but we don't even see the big picture. Some said he butt-fucked one of Wignancourt's pages--the Grand Master's own personal reserve (this according to some sources certain of Wignancourt preference for boys--but far from all sources). Others say he killed someone in a duel, this on an island where there were hundreds of testosterone-engorged men and boys, and where men may have had the title of monk but were first and foremost men. Any pretext for a duel is conceivable, from making a pass at a man's whore to looking at a man, as I wrote in the Introduction, a nanosecond too long. One major source believes that what he did so deeply offended Wignancourt that he set out to destroy the artist. Another major source believes he offended an important personage (through an insult? by physically injuring him?) who got him locked in jail and, when he escaped,

set the wheels in motion that finally led to his death at age 38. In this version not only was Wignancourt not against him, Wignancourt did everything necessary to ensure his escape.

Then again, perhaps his problem had had a totally other origin. Perhaps he had been treated disrespectfully by one of the many sons of the Knights. Caravaggio was now a Knight himself, but he knew that he would never be accepted as such by the island's nobles. And yet he was a dear friend of the Grand Master, Wignancourt. He was the pet of popes. His painting was hailed as the best in existence--new, awesomely naturalistic, and the wish of everyone with money and/or power was to possess one, from Wignancourt to Paul, from Scipione Borghese to the Colonna. How dare anyone stand in his way, and especially not these young Maltese pups, aristocracy flotsam compared to the man of talent that was Michelangelo Merisi da Caravaggio. In this case any one of a million slights might have made him reach for his sword and wound some young seigneur, landing him in prison. Caravaggio was the son of a palazzo steward, he was not noble and nobly born. He in no way earned his knighthood, felt many of the Knights and their knightly sons. Caravaggio would never admit the fact but its truth haunted his innermost being. Just a word, just one, in some tavern by a drunken princeling, would have triggered the hatred in his heart that had metastasized through years of ass licking, beginning with those who had taken him in after the death of his father, to the workshops where he had cleaned the toilets and, most probably, been forced to accept what awaited him every night at the hands of the master and the bigger boys. Doffing his cap when del Monte took a drink, bending to the will of Pope Paul and the nobles because he somehow lacked the inner fire and determination of a Michelangelo Buonarroti to resist, nor did he have the immense intelligence of a da Vinci to guide him through the world's shark-filled waters. In blind rage he had struck out, because he in no way had the gifts of a Cyrano de Bergerac to turn insult into rhetorical vengeance.

The prison was Fort Sant'Angelo, and his home for the coming weeks was a cell chiseled from the rock in the form of a beehive, like the Mycenaean tomb of Agamemnon, eleven feet deep and capped with an iron grille. Prisoners were lowered and raised by rope. It was a place that was inescapable, unless accomplices had been given the necessary orders by Wignancourt or the head of the Maltese fleet, Constanza's son Fabrizio Sforza Colonna, he who had brought Caravaggio to Malta may now have decided on his own, or under orders from Wignancourt, to take him to the nearest port outside Malta, Syracuse.

Caravaggio spent a year on Sicily. He came upon his old bar-hoping, whore-frequenting, street-brawling pal and lover, Mario Minniti, who had calmed himself enough to establish his own well-considered workshop, earning the patronage of the island's Who's Who. In résumé, Minniti had

become a gentleman. Caravaggio went from one city to another, some say in near panic, but the exact nature of the threat is unknown. The Knights were all over the island, their ships in every major harbor. Had Wignancourt wished him ill, Caravaggio would have been easily recaptured or killed. But to make certain the Fates were on his side, Caravaggio nonetheless sent Wignancourt a peace offering in the form of a painting. Perhaps it was the Knight he had insulted or physically injured on Malta who was tracking him down. We'll never know.

From Syracuse he went (fled according to one source) to Messina. As the island was too dangerous to be covered on foot, he sailed. Even common farmers, historians claim, would rob, ransom or murder a traveler without hesitation or scruple. Sicilians were vindictive and quarrelsome; the women built like summa wrestlers, the men as skinny as twigs. Caravaggio is thought to have sailed in winter, the time that boats were most likely to be shipwrecked, proof of what he considered an urgency.

Messina was fortified to such an extent that the inhabitants were said to have scoffed at the threat of a Turkish invasion. It was described as wondrously beautiful ... until a succession of earthquakes leveled it.

As usual (and especially in times of troubles), Caravaggio worked. He was known on the island as he was everywhere else, and commissions piled up. From 200 scudi per painting he had gone to 400, a thousand, and now 2,000 was considered a bargain. Caravaggio spent a good part of it on earthy delights, we learn, perhaps making up for Malta where the young aristocrats were too proud and arrogant to give themselves to a mere painter, and where, anyway, such relations were severely punished. He supposedly made up for lost time now in Messina. Besides visiting the taverns and back streets known for their vice, he was denounced for his too assiduous interest in the lads bathing nude in the port, and indeed had hired several to pose and otherwise entertain him. He was forced to leave quickly when right-thinking citizens rose up in force against him.

He went to Palermo where he embarked for Naples by way of glorious Capri and Ischia. Back on familiar ground, he didn't lose time in returning to the Osteria del Ciriglio, a tavern in a back alley of Naples frequented by both the dregs of society and the upper-class slumming for sex, a place known for its orgies, possessing a secret door for men who preferred boys, a door Caravaggio took as he certainly took the lad or lads within. But after one of these visits, on his way out, he was waylaid by a group of men who beat him up and then badly scarred his face, a fate reserved for whores. No one knows who these men were. Had they been sent by the Knight from Malta he would have been murdered. Had Wignancourt been responsible he would have been punished in exactly this way, perhaps, as Wignancourt would have wanted revenge, not his death. Some put blame on the family and friends of Ranuccio Tomassoni, but the Tomassoni family was

stationed in Rome and logistically it would have been difficult for them to organize an attack in Naples.

It was after his attack that Caravaggio started what was one of the darkest paintings of a lifetime of dark masterpieces, his *Martyrdom of St. Ursula* that I described at the beginning of this chapter. He then did his even darker *David and Goliath*, David holding up Goliath's severed head, the self-portrait of Caravaggio himself, one eye clearly dead, the other harboring a lingering thread of life. One observer thinks David was Cecco, which is extremely moving should Cecco have been there at his side, but moving too if Caravaggio had painted the boy from memory. Another observer believes David was Caravaggio himself, and that the painting consisted of two self-portraits. This too is a highly moving possibility. As one grows older one tends to think back on when one was young and beautiful and virile. The David in the portrait is thin and seemingly defenseless, but no less young and beautiful and virile.

Word came from Rome for him to return. Glory would once more be his. Scipione had commissions by the bucketful, as the French say. He would be pardoned. He would be acknowledged and rewarded as the greatest living painter. He would be enriched as only Michelangelo had before him. His knighthood would be reestablished. The young twerps on Malta would be obliged to kowtow despite their nobility--the gift of accidental birth, not merit. And, of course, there would be boys without end, the husky lads of the country, the lithe boys of the towns, the red-blooded glory of glorious Italy.

He sailed from Naples to Rome. Why he landed farther north to Rome, perhaps Palo, is unknown. An ill wind in the form of a gale perhaps blew him there. He landed and was arrested for being a bandit, perhaps do to his clothes, always thread bare, and the cuts that disfigured his face, following the attack at the Osteria del Ciriglio. When he was released he learned his boat had gone to Porto Ercole. He went after it, perhaps on foot, perhaps he had enough money on him after his arrest to hire a mule, although the guards most probably appropriated his valuables. Some sources believe he made it that far. Other that, ill, feverish and in deep sufferance from his Ciriglio wounds, he was taken in at a hut along the way. At any rate at age 38 he died. The paintings he had with him on the boat were recuperated by the wealthy, notably Scipione. The details are unknown and of little real interest. This man, so clearly cut out for a violent death by sword or dagger, came down with a fever, as Virgil had off the coast of Brindisi. The light went out for them both, an eternal loss to the world. Of the lesser players, Caravaggio's sidekick in fighting and whoring, Onorio Longhi, died of syphilis. Cecco took the name Cecco del Michelangelo and vanished from history, having lived a life of infinite rebounds, sharing the air and more with the fabulous, enigmatic artist known as Caravaggio. Constanza

Colonna was faithful to the end, exactly what end I'm unaware of. But she's earned a place in my heart until my own end which I hope--like that requested by Caesar the night before his assassination, while dining with Brutus--will be rapid and unexpected.

But my life is of importance only to me. The life of the choleric genius enriched humanity, affixing his seal until the end of time. He was a man who certainly abused life, but one that allowed life, in its turn, to use him-- for me the paramount accolade.

What was important, however, was the site of his burial, along the coast. His remains were laid to rest in a chapel dedicated to the poor. It's name? St. Sebastian.

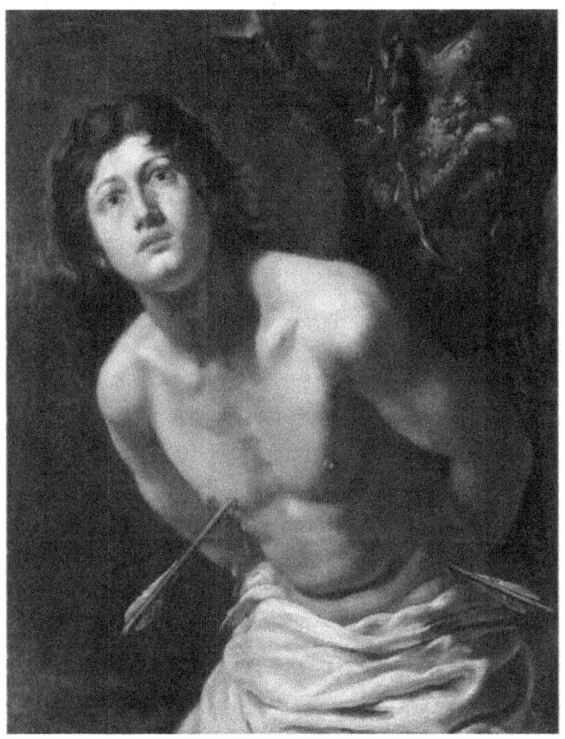

GUIDO RENI
1575 – 1642

Thanks be it to God, one's art can surpass one's human condition. Thusly, a Mahler can live a henpecked existence and nonetheless produce the most beautiful sounds known to human ears. Guido Reni created seven exquisite Sebastians while living with his mother until her death, when he was 55, after which any uxorious influence was banished from home and workshop to the extent that he refused his meals to be prepared or his laundry washed by female hands. But female hands were far from needed.

The shop he founded employed from 80 to a high of 200 boys, assistants, apprentices, models and helpers who dressed the table and ground the colors. All sought to be of service to the master, renowned throughout Europe, a friend of popes, celebrated by the populace and often included in the Holy Trinity: da Vince, Michelangelo and Caravaggio. Handsome as a youth, beautiful even thought Ludovico Carracci, his way with boys was avuncular, polite to a fault, and so sexually disinterested that he may well have died, thought some who knew him well, a virgin.

Or maybe, like the world's two greatest tennis men, Bill Tilden and the gorgeous Gottfried Cramm of the 1920s and 30s, he covered his tracts. These tennis men, saintly in appearance, satisfied themselves with boys without number, especially in pre-war Berlin and its nights of all-male orgies. (Please accept this slight diversion in the life of Reni which offers me the occasion to introduce these two too-long-forgotten tennis men, my way of ceaselessly underlining the marvelous story of men who preferred men, this one brought to us by Marshall Jon Fisher in his wonderful *A Terrible Splendor.*)

So Reni too may have taken advantage of the worshipful boys for whom a little expenditure in the form of sex was, anyway, a daily necessity among growing lads, or he may have sublimated his urges into his art, his seven Sebastians among his other creations, and died as virginal as a nun who surrenders herself to Christ.

Born outside of Bologna, it was in Bologna that he was apprenticed to Denis Calvaert at age nine, along with another future painter, Domenichino, whose fate we'll learn in just a moment. He then spent ten years in the Carracci Academy founded by Ludovico Carracci, who was said to have adored Reni, painting him on numerous occasions, especially as an angel. Reni was accompanied by three other Carracci painters, Annibale Carracci, Agostino Carracci and Antonio Carracci. Another painter was present, around the same age as Reni, Francesco Albani, who was said to have been an ''intimate'' friend of Reni's until early manhood, after which they became rivals. Indeed, several traits seemed to have characterized painters of the period: first, their patrons never paid them their due, or paid them late, or even nothing at all; second, they had fierce temperaments like Michelangelo--whom no one could get along with, even popes--or the murderous Caravaggio, or Cellini who thought it great fun to kick an apprentice in the balls in front of King François I; and, finally, painters hated other painters' guts, as did Reni and Albani, Michelangelo and de Vinci, Michelangelo and Raphael. It got so bad for Reni that three established painters in Naples, where Reni went to paint a chapel--Corenzio, Caracciolo and Ribera to be exact--beat up his assistants when they could get their hands on them, and spread the word that Reni would be poisoned. This was supposedly one reason Reni would later ban women,

especially old women, because for some reason he associated them with poisoning. The three above-mentioned painters, led by Ribera, formed what became known as the Cabal of Naples, the goal of which was to rid Naples of competitors who were not native to the city, although they themselves had fled Rome hounded by creditors. The cabal started out by intimidation, as they did with Reni, and then moved on to destroyed a painter's works in progress. They were often arrested but rapidly released through lack of proof. Domenichino, who had studied with Reni, descended from Rome to Naples to work on the cathedral, assured by the governing bodies of the city that he would be protected, as he had already received threats. But when his frescoes were repeatedly sabotaged, he fled the city leaving, alas, his wife and child, who were arrested and held imprisoned until he returned to finish his commission. Several days later he was dead, poisoned.

Like all painters, Reni was naturally inspired by others, in his case the chiaroscuro of Caravaggio. He liked Veronese and appreciated above all Raphael, Correggio and Parmigianino. As a person he was courteous and diffident, and he's known to have painted himself as a woman in his *St. Benedict Presented with Gifts by Farmers*. He was pious, eccentric and known to blush at the slightest off-colored joke.

After the death of Ludovico Carracci, Reni's workshop became the dominant academy in Bologna, churning out works for churches, chapels, cathedrals, basilicas, private residences and palazzi. Despite the homophobic Baroque, he painted nudes, including the *Judgment of Paris*, and his Sebastians, painted nearly entirely in the 1610s. As the demand for his art increased, so did his prices, rising 400% over the years, even though the quality plummeted. His paintings became repetitive, mannerist and vapidly sentimental, which one critic summarized as trashy, pretentious and cheap. But the paintings sold and he needed the money as even as a young man he had been addicted to gambling, an addiction which, as all addictions, ended in his ruin. He died in debt, from fever, and was charitably buried by the Basilica of San Domenico.

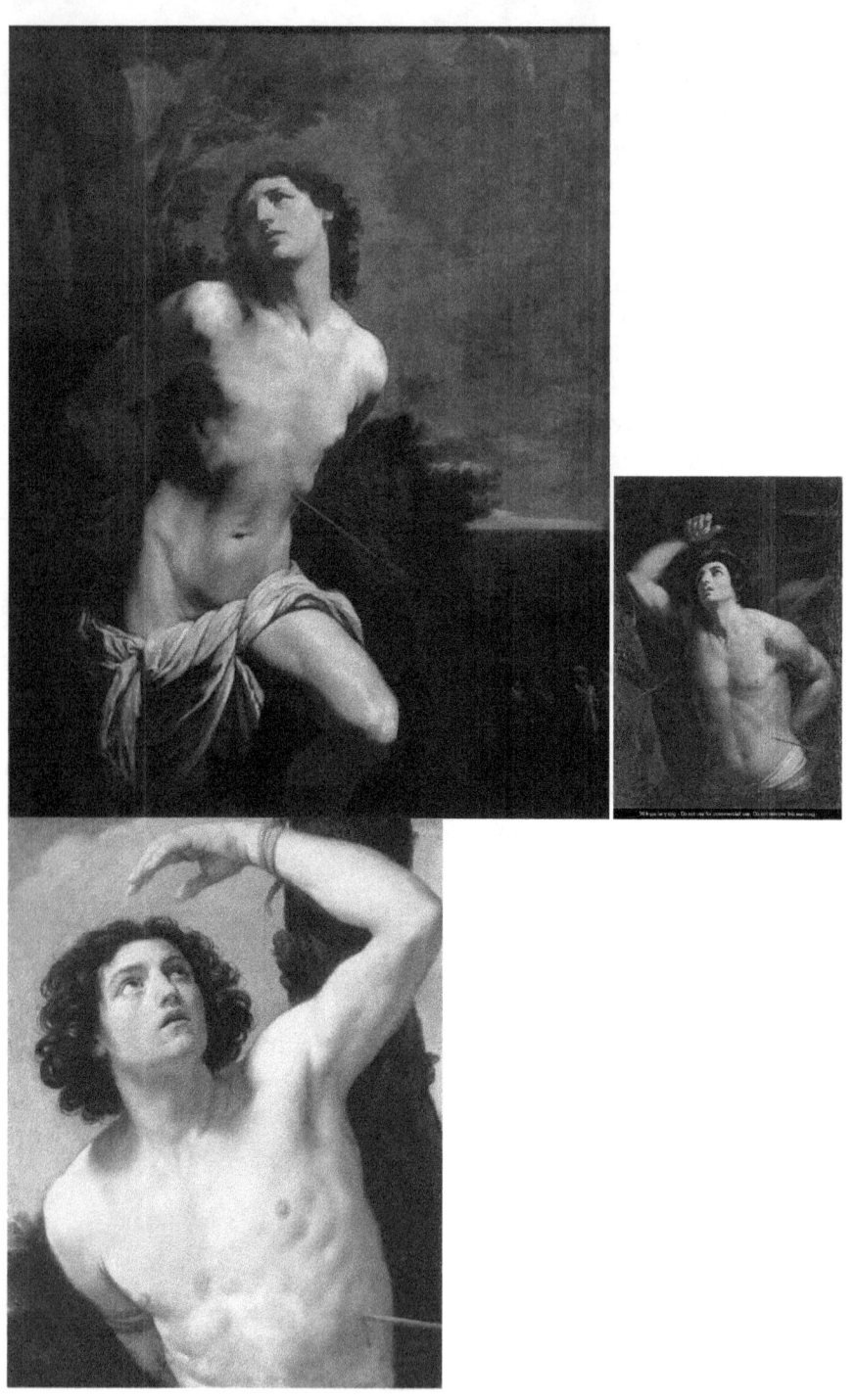

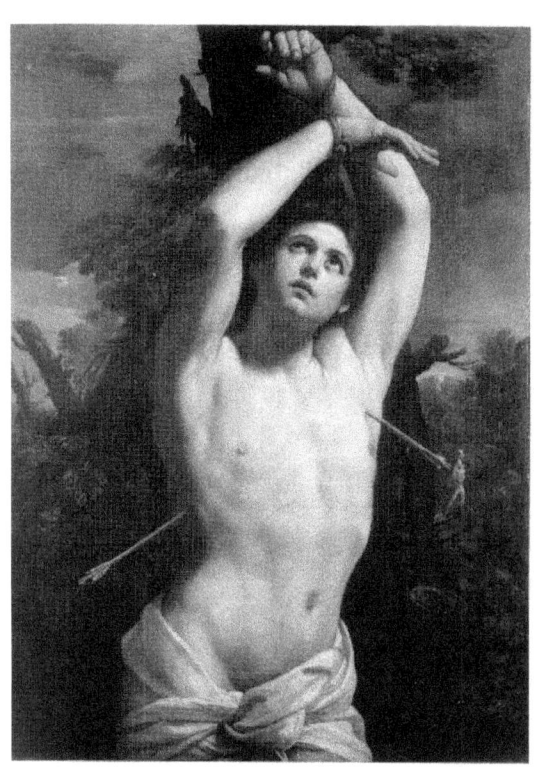

THE CARRACCI: UNCLE LUDOVICO, COUSINS ANNIBALE AND AGOSTINI
ca. 1585 – ca. 1618

Ludovico painted seven Sebastians, his cousins others, and while I've written around 20 pages on Michelangelo, du Vinci, Caravaggio, et al., I hope I'll be able to fill one or two paragraphs about the three Carracci combined, which is extremely disappointing, for me as much as for the reader.

Ludovico formed, with his cousins, a studio in Bologna (some say an Academy) which turned out the likes of Reni and Domenichino. They were all Caravaggists who spent most of their time in Bologna but traveled widely.

Agostino worked with his brother Annibale on the Gallery in the Palazzo Farnese, considered an unrivaled masterpiece of fresco painting. Agostino's son, Antonio, was also a painter and had attended his father and uncles' studio. He was especially influenced by the Venetian Titian.

The three artists often worked together on the same commissions that they simply signed: Carracci. Their best works were in fresco and they were considered masters in an art form so difficult that da Vinci avoided fresco and Caravaggio never even tried his hand at it. Annibale specialized

in landscapes, which greatly influenced Domenichino, his most loyal student. With time his output diminished, supposedly due to severe depression. In a note he left behind he informs one of his students that he hoped to get back on track by eventually putting in two hours a day at the studio. A fervent admirer of Raphael, he requested to be buried beside him in the Pantheon of Rome.

As witnessed by the Saint Sebastians reproduced here, the Carracci painted some wondrous pictures. They were just outclassed by the likes of Veronese, da Vinci, Raphael and Caravaggio.

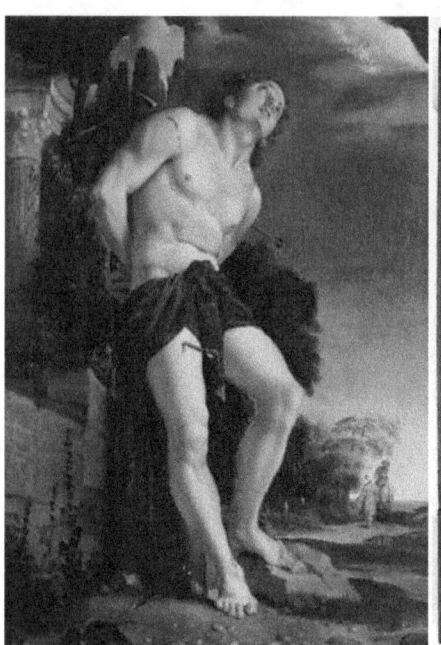
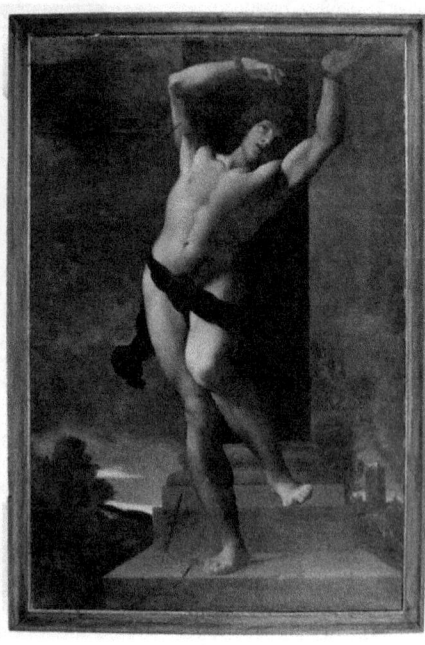

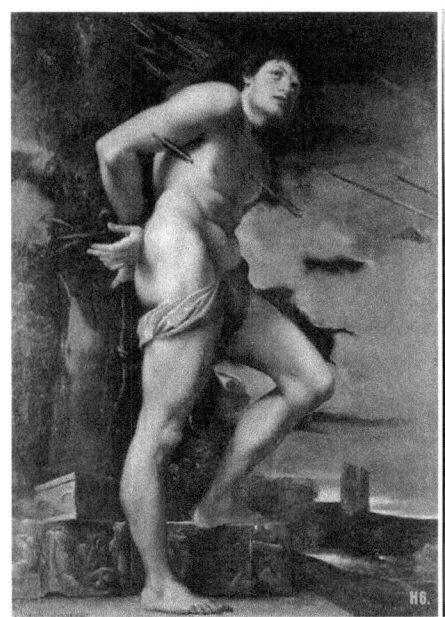 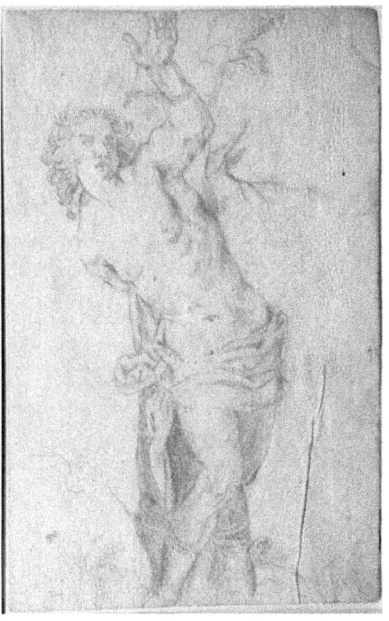

RIBERA
1591 – 1652

Hot Spanish blood is not a myth, as the early Aztecs and Incas found out when hundreds of thousands were massacred by Spanish troops, which were minuscule in number in comparison. Today only a fool would take a Spanish football team lightly. Ribera was born in Valencia but already around age 20 he was in Rome. Called lo Spagnoletto (the little Spaniard) by his contemporaries, the debts he ran up were anything but small and soon he fled his creditor, the taverns that had supplied his food and lodging, and the shop that furnished his art supplies. He ended up in Naples, under Spanish rule where he fit in like a glove tailored for his hand. He grouped with two others, Belisario Corenzio and Biambattista Caracciolo to form an associating of hoodlums known as the Cabal of Naples. The aim was to expulse outside competition, artists usually from Rome, Florence and Venice--Annibale Carracci, Reni, Cavalier d'Arpino, Domenichino and others--invited by successive Spanish Viceroys. The cabal threesome forcibly entered painters' workshops and sabotaged their works. They added ash to paint oil, they threatened the lives of the painters, their assistants and their apprentices, and didn't hesitate to beat them up. All of which ended in the death of Domenichino.

Ribera, son of a shoemaker, albeit a rich one, married well, placing him in the ranks of the most wealthy Neapolitan artists of his times. His mythological subjects, like his martyrdoms, were violent, especially *Apollo*

and Marsyas, but far less so than Caravaggio who supposedly inspired Ribera.

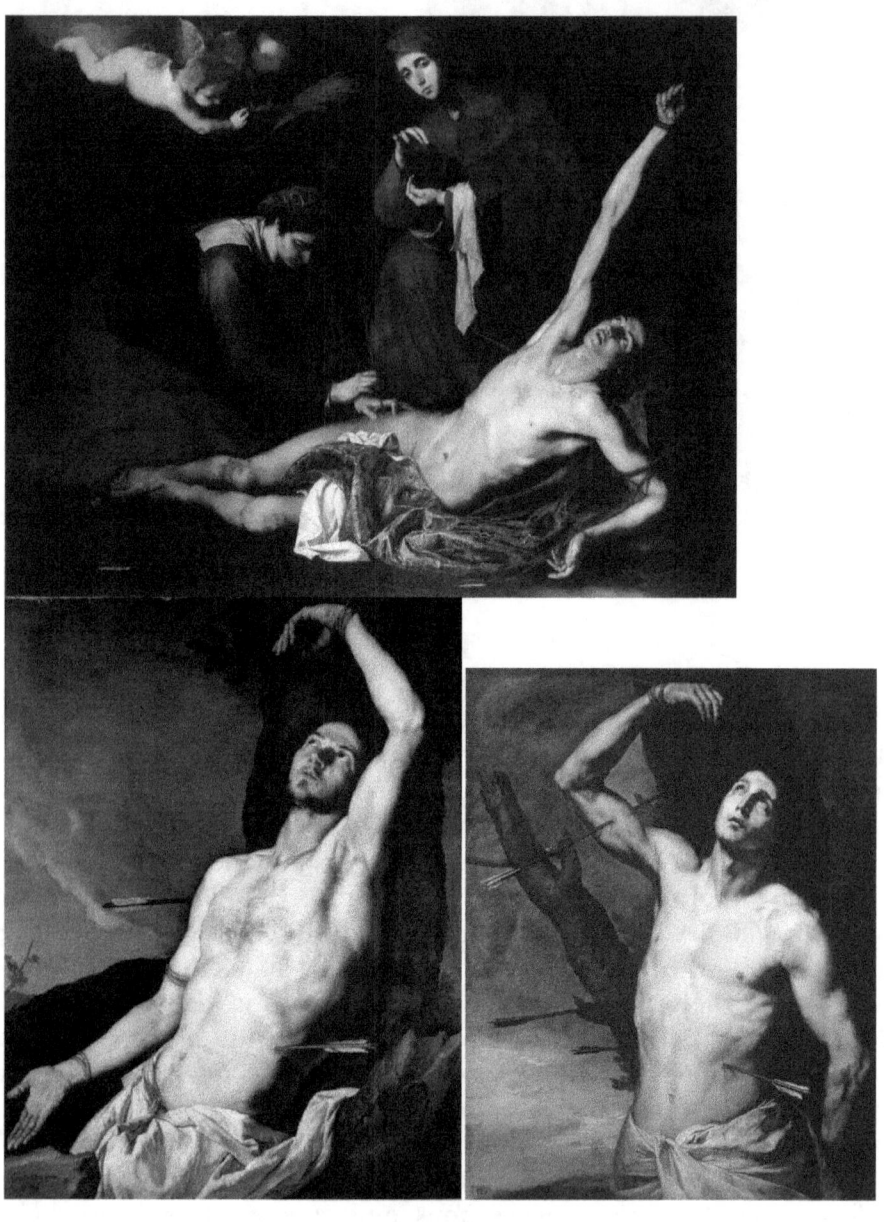

BERNINI
1598 – 1680

The works of Bernini, as those of you who have seen them know, are simply exquisite. The *Blessed Ludovica Albertoni*, the *Ecstacy of Saint*

174

Teresa, and his *Apollo and Daphne* move one to the core. Daphne, caught in the midst of metamorphosing into a tree, was certainly inspired by the same gods that watched over Michelangelo. Apollo grasps at Daphne's body, already encircled in bark, her fingers leaves, her toes roots, and on his face is the beginning awareness that something is going very wrong. Bernini was said to have been influenced by the baroque, Michelangelo by mannerism. Luckily neither of these exaggerated, senseless periods influenced either man sculpturally. Homoerotically, Michelangelo had his *David*, Cellini his *Perseus* and Bernini his *St. Sebastian*. The first two preferred boys, Bernini married late, at age 41, but it must be kept in mind that at the time only half of the men in Florence, as an example, married at all, and those that did married late, after age 30. Sexual freedom had a real meaning for the Italy of the 16th and 17th centuries, whose men may have taken to heart Molière's words: *Tout le plaisir de l'amour est dans le changement.* Bernini was deeply religious, Michelangelo a heathen who may or may not have believed in God, but whose beliefs played no significant role in his art. 96% of Americans say they believe in God, while only 9% say He plays a role in their daily lives: that, too, was perhaps Michelangelo.

No artist in the history of the world has created more sculptures--and more *chef d'oeuvres*--than Bernini. He lived 82 years and humanity can quite simply thank God for each and every one of them. He himself claimed that if one added all the days of his life during which he did not work, they wouldn't total a month. Quick-tempered and indefatigable, he could sculpt for 7 hours at a stretch and then turn to other pursuits like writing the scores of plays he himself directed, using family, friends, apprentices and models as actors.

Born Gian Lorenzo Bernini, Bernini had an advantages boost in life in the form of his sculptor father Pietro who trained his son in his studio. He married late, as I've said, but made up for the lost time by fathering 11 children, one of whom became his biographer. He was taken to Rome at age 8 and helped along by Annibale Carracci, as well as two men of tremendous importance in the history of the period, Scipione Borghese and Pope Paul V. Later Cardinal Barberini, a close friend of Bernini, was elected Pope Urban VIII, an extremely important event as the pope was very fond of art and of Bernini himself. He told Bernini, ''It is your good luck to have me as a pope, but our luck is even greater in having you during our pontificate.'' Urban encouraged Bernini to work in painting and architecture as well as sculpture, in a sense assuming the role that Julius II had played with Michelangelo.

Bernini did two busts of Scipione Borghese, the second after noticing a flaw in the marble that ran across the forehead in the first. He showed the first to Scipione who pretended not to notice the defect and claimed the

work wonderful. When Bernini showed him the second, Scipione sighed with relief and the bond between the two men, close, became closer still.

Besides his sculptures, he made his mark in architecture and painting, fountains and tombs. His life should have been a long tranquil river, so unlike those of Michelangelo, Cellini and Caravaggio, but we know that he was sexually involved with Costanza, the wife of an assistance, whose portrait he painted. He had her face slashed when she gave herself to one of his brothers, and the brother mercilessly beaten. Such slashing was a usual Renaissance punishment, as seen repeatedly in the life of Caravaggio, when even he was attacked and his face cruelly lacerated. Pope Urban VIII got Bernini off the hook for these crimes, as popes before him had saved numerous artists, most notably Cellini and Caravaggio, the truly bad boys in the history of art.

Bernini was named chief architect of St. Peter's and constructed the incredibly unique baldachin with its spiraling columns 30 meters above the marble floor and altar, said to have cost, according to Mormando in his *Bernini: His Life and His Rome*, $8,000,000 in today's money. When several workmen died during the baldachin's construction rumors spread that the project was cursed, and the men refused to work until their wages were doubled. Urban had bronze needed for the baldachin stripped from the Pantheon, one of the few remaining monuments dating from ancient Rome. As Urban had been a Barberini before become pope, he was blamed for looting the Pantheon, and through the streets of Rome it was said, "What the barbarians did not succeed in doing, the Barberini did." So much bronze was said to have been left over that 80 cannons were made for the protection of Urban. Unique or not, the baldachin is a reminder of the excesses of the baroque. Bernini also raised two immense bell towers to complete the façade of St. Peter's, the first of which was partially finished before being razed due to cracks in the construction. He was commissioned to build the Four Rivers Fountain in the Piazza Navona, a needed success after the abandonment of the twin towers. He also built the Fountain of the Triton and the Fountain of the Bees.

Most spectacularly, it was Bernini who created the circular colonnades in front of St. Peter's, creating an enormous open space from which pilgrims could view the pope from his apartments.

For reasons of diplomacy Pope Alexander VII sent Bernini to Paris where he sculpted the world-famous bust of Louis XIV. He also did an equestrian statue of the king that Louis hated so much he had it recarved and dedicated to the Roman Marcus Curtius. Bernini made mostly enemies in France by vaunting Italian art and maintaining that a single work of Reni counted for more than the totality of Paris.

In carving his namesake St. Lorenzo--(Bernini has been known as Gian Lorenzo, Gianlorenzo or Giovanni Lorenzo)--burned at the stake, his

biographer and son maintains that his father put his own leg in the fireplace and studied his facial pain in a mirror. This gave him the idea, continued his son, of sculpting a body twisted in misery, a pose he used in his St. Sebastian pierced with arrows.

Forty years before his death he designed and built his own palace, the Palazzo Bernini.

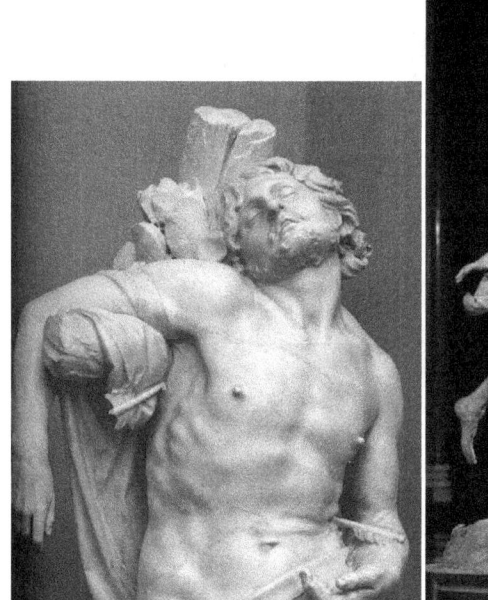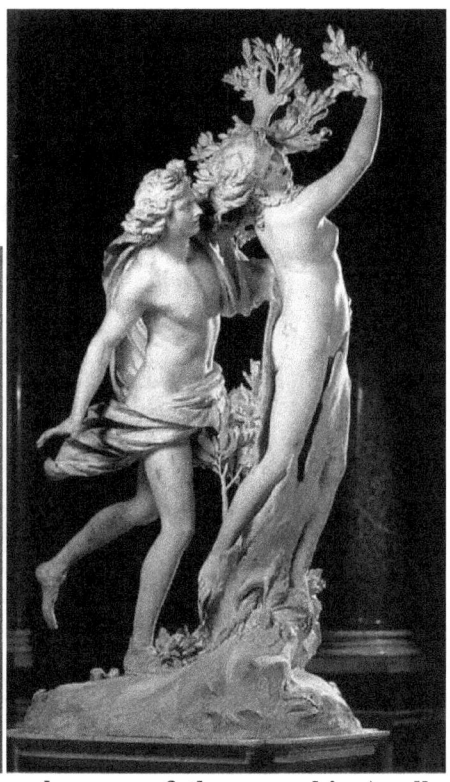

Bernini's Sebastian and, for the pleasure of the eyes, his Apollo and Daphne

BATTISTELLO CARACCIOLO
1578 - 1635

Born in Naples and father of 10 children, his masterpiece is *The Liberation of St. Peter.* He had been greatly influenced by Caravaggio who had sojourned in Naples, and had witnessed the painting of Caravaggio's *Seven Works of Mercy*, next to which Caracciolo's *Liberation* hangs.

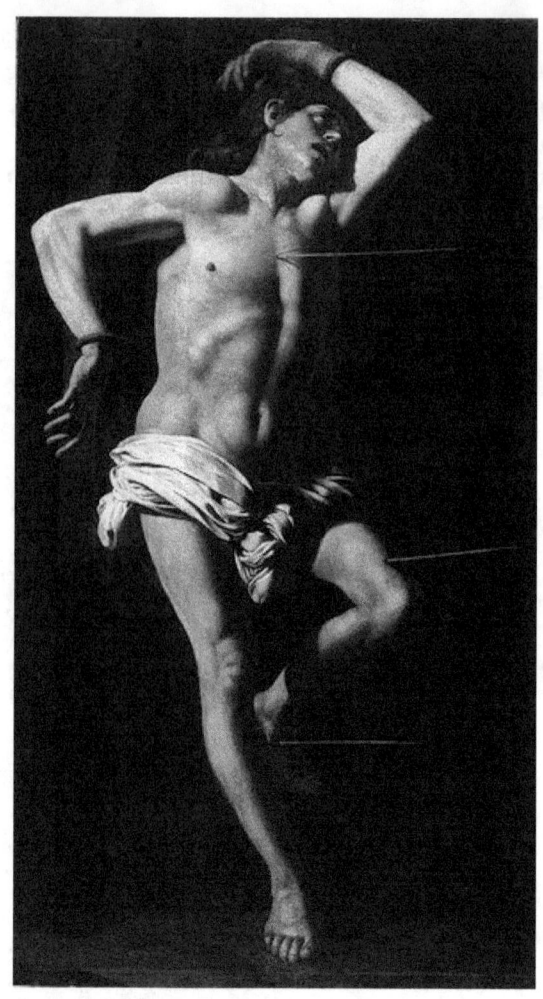

CESARE FRACANZANO
1605 – 1651

An apprentice of Ribera, he was the son of Michelangelo Fracanzano, a painter, and the brother of Francesco. Both sons accompanied their father as he went from town to town plying his art. Cesare then entered Ribera's atelier in Naples. Later he returned to his birthplace, Barletta, founded a family and, like his father, moved from place to place making a living.

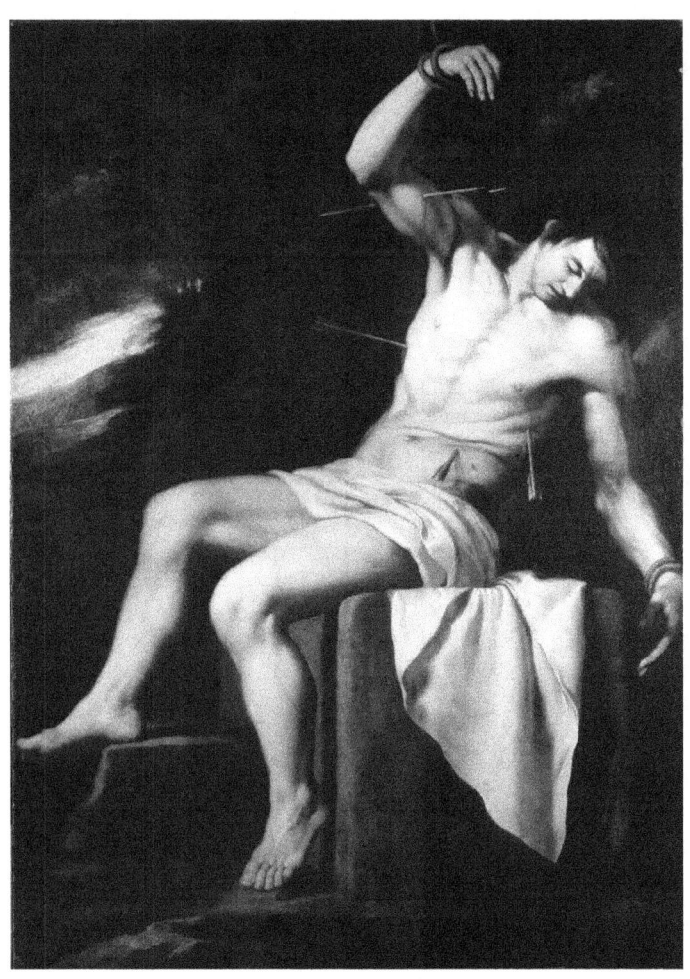

FRANCESCO CAIRO
1607 - 1665

Born in Milan, he was court painter at Turin. He traveled to Rome where he worked under the influence of Crespi, Guido Reni and Caravaggisti. He is especially known for his depictions of ecstasy and the sensuality of his portrayal of flesh.

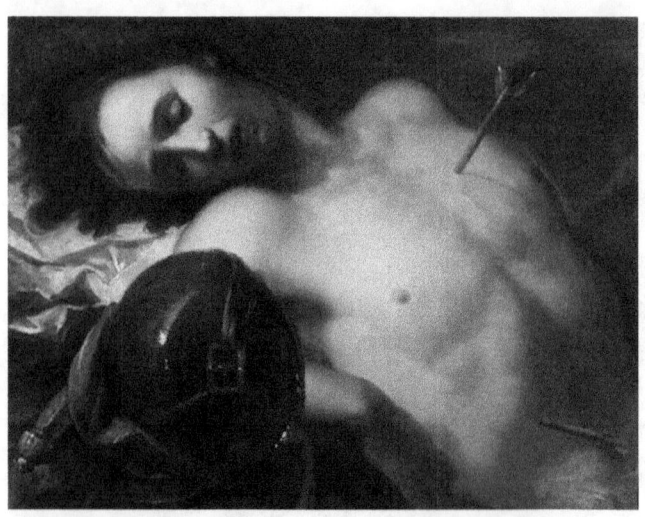

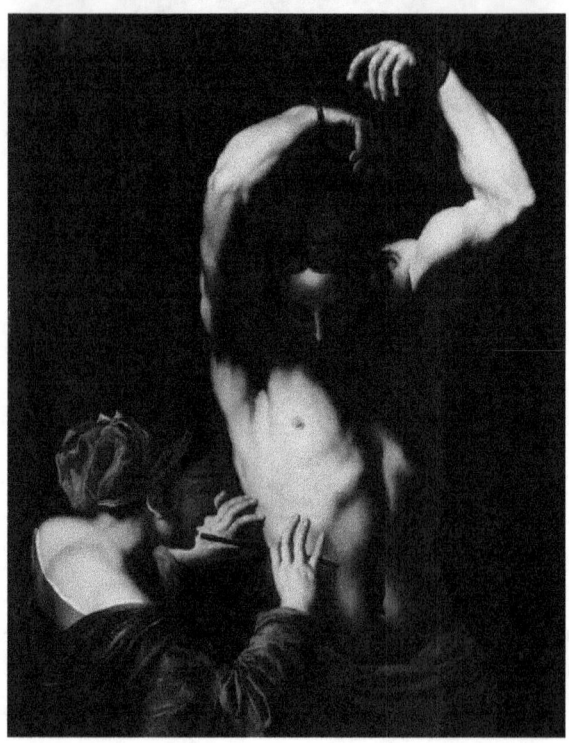

DOMENICO PASSIGNANO (BORN CRESTI OR CRISPI)
1569 – 1638

Widely traveled, a student of Macchietti and assistant to Federico Zuccaro, he at first absorbed the influences of Titian, Tintoretto and Veronese before moving on to the more realistic works of the Carracci and

Caravaggio. He is noted for painting with great speed, thanks to his use of less paint, the result of which are paintings damaged by the passing of time.

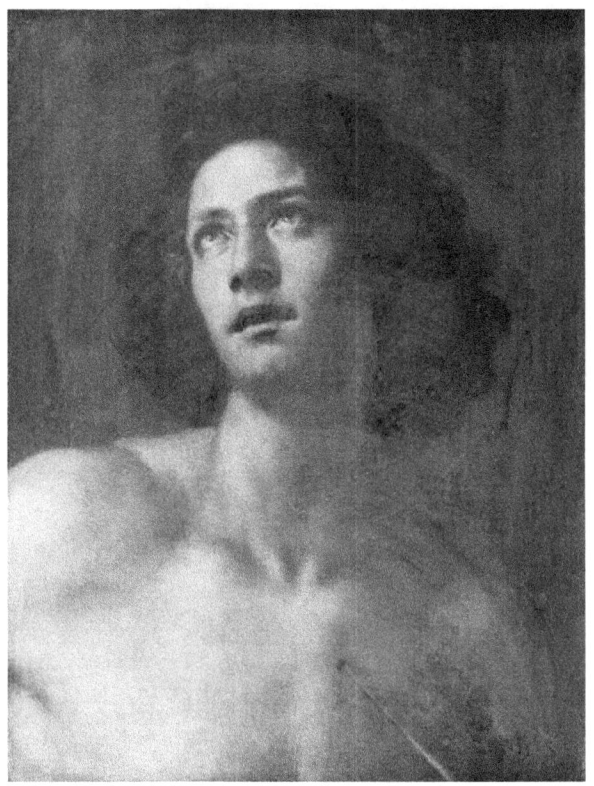

NICOLAS RÉGNIER (RENIERI)
1588 – 1667

Apprenticed in Antwerp, he went to Rome as a young man, studying under Bartolomeo Manfredi, and painted for Vincenzo Giustiniani. Giustiniani was a very important art collector, especially of the works of Caravaggio, whose assembled paintings are found in the Palazzo Giustiniani near the Pantheon in Rome, 300 paintings, 15 by Caravaggio, and 1,200 sculptures. A banker and one of the richest men in Italy, he was aided in his collection by his cardinal brother Benedetto. Later in life Régnier moved to Venice where he dealt in selling paintings and antiques, and where he died. Highly influenced by Caravaggio and Guido Reni, he specialized in crowd scenes, carnivals, concerts and groupings of soldiers. Although Régnier was French he spent nearly all of his life in Italy and his half-brother, the fellow-artist Michele Desubleo, was Italian. His and his brother's style was so similar that paintings by one are often attributed to

the other. Régnier had four daughters, all painters, one of whom married the painter della Vecchia, another van Dyck.

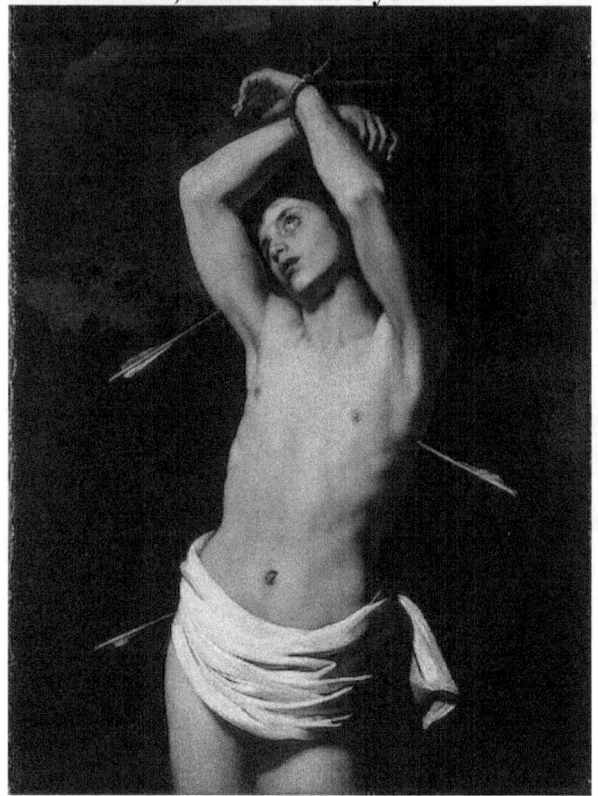

PIETRO RICCHI
1606 – 1675

Born in Lucca, he was a prolific artist, known for at least 300 existent works. In Florence he was apprenticed to Domenico Passignano and studied with Guido Reni. As seen in the following picture, he was especially influenced by Caravaggio, and his rendition of flesh and the male body is the ultimate in homoeroticism.

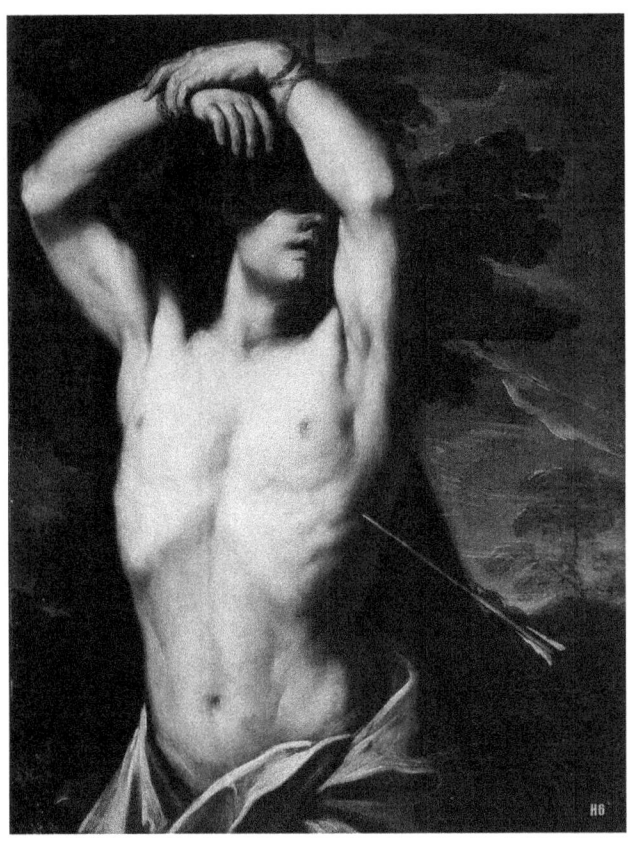

SOURCES

(1) For more: *Homosexuality in Renaissance Italy*, Volume Three.
(2) For more information: my book *Alcibiades, His Role in Athens, Sparta, Persia and Greek Love.*
(3) For more information: my book *Astorre Manfredi, The Most Beautiful Boy of the Italian Renaissance.*
(4) For more information: my book *TROY.*
(5) For more information on this subject: my book *An American in Paris.*
Ady Cecilia, *A History of Milan under the Sforza*, 1907.
Aldrich Robert and Garry Wotherspoon, *Who's Who in Gay and Lesbian History*, 2001.
Baglione, *Caravaggio*, circa 1600.
Bellori, *Caravaggio*, circa 1600.
Bergreen Laurence, *Over the Edge of the World – Magellan's Terrifying*

Circumnavigation of the Globe, 2003.

Bicheno Hugh, *Vendetta, High Art and Low Cunning at the Birth of the Renaissance*, 2007.

Bramly Serge, *Leonardo*, 1988. I hesitated to order the book due to its date of publication, but that would have been a great mistake as it's not only beautifully written, it's marvelously complete. Bramly, no prude, covers in depth da Vinci's homosexuality. An absolute must.

Cawthorne, Nigel, *Sex Lives of the Popes*, 1996.

Chamberlin, E.R. *The Fall of the House of Borgia*, 1974.

Cloulas Ivan, *The Borgia*, 1989.

Crowley Roger, *Empires of the Sea*, 2008. Marvelous.

Defored Frank, *Big Bill Tilden*, 1975.

Forellino Antonio, *Michelangelo*, 2005. The most beautiful reproductions I've ever seen in a book, but nearly nothing about Michelangelo's homosexuality.

Jack Belinda, *Beatrice's Spell*, 2004.

Johnson, Marion, *The Borgias*, 1981.

Gayford Martin, *Michelangelo*, 2013. A beautiful book, wonderfully written. Michelangelo's homosexuality so evenhandedly covered that I had to look up Gayford to see if he was gay--with a wife and children he apparently isn't. A must, must read.

Graham-Dixon Andrew, *Caravaggio, A Life Sacred and Profane*, 2010. The book is fabulous. A genuine I-couldn't-put-it-down.

Grazia Sebastian de, *Machiavelli in Hell*, 1989

Guicciardini, *Storie fiorentine (History of Florence)*, 1509. An absolute must-read.

Hibbert Christopher, *The Borgias and Their Enemies*, 2009. I buy and love everything he writes.

Hibbert Christopher, *The Rise and Fall of the House of Medici*, 1974.

Hibbert Christopher, *Florence, the Biography of a City*, 1993.

Lambert Gilles *Caravaggio*, 2007.

Landucci Luca, *A Florentine Diary*, around 1500, an apothecary who wrote about Florence and is today a vital source concerning his times.

Lev Elizabeth, *The Tigress of Forli*, 2011. Wonderfully written. I love Elizabeth Lev for having giving us this marvelous work about this incredible woman.

Levy Buddy, *River of Darkness*, 2011. Fabulous.

Lubkin Gregory, *A Renaissance Court*, 1994.

Mallett Michael and Christine Shaw, *The Italian Wars 1494-1559*.

Manchester William, *A World Lit Only By Fire*, 1993

Mancini, *Caravaggio*, circa 1600.

Martines Lauro, *April Blood-Florence and the Plot against the Medici*, 2003. A magnificent book, I've reread it three times.

Meyer G.J. *The Borgias, The Hidden History*, 2013.
Noel Gerard, *The Renaissance Popes*, 2006.
Parker Derek, *Cellini*, 2003, the book is beautifully written and full of reproductions. The very, very best on this fabulous artist.
Robb Peter, *Street Fight in Naples*, 2010.
Robb Peter, M – *The Man Who Became Caravaggio*, 1998.
Rocke Michael, *Forbidden Friendships*, 1996, both indispensible and wonderful. Rocke has become *incontournable*.
Sabatini Rafael, *The Life of Cesare Borgia*, 1920.
Saslow James, *Ganymede in the Renaissance*, 1986.
Seward Desmond, *Caravaggio – A Passionate Life*, 1998.
Simonetta Marcello, *The Montefeltro Conspiracy*, 2008. Wonderful, wonderful, wonderful.
Strathern Paul, *The Medici, Godfathers of the Renaissance*, 2003, An absolute must-read.
Unger Miles, *Machiavelli*, 2008.
Unger Miles, *Magnifico, The Brilliant Life and Violent Times Of Lorenzo de' Medici*, 2011. Wonderful. The best.
Vasari: See Part I. We would know next to nothing if it were not for this great, great man (even if he does scratch his boys during sex).
Viroli Maurizio, *Niccolo's Smile, A Biography of Machiavelli*, 1998.
Weir Alison, The Princes in the Tower, 1992. Marvelous.
Wright Ed, *History's Greatest Scandals*, 2006.
Wroe Ann, *Perking, A Story of Deception*, 2003. Fabulous.

Cover painting: Il Sodoma. All paintings are courtesy of Wikipedia. Research today is impossible without the aid of Wikipedia, a monument to the genius of its creator.

I would appreciate any comments you would care to make:
mbhone@gmail.com

INDEX

Alexander VI, 23-58
Alfonso of Aragon, Lucrezia's husband 27, 43-56
Alfonso, 11-27
Amboise George d', 43
Anjou, duke d', 117-126
Aretino, Pietro, 13, 114
Baglione, 13
Banquet of the Chestnuts, 24, 45
Basaiti, Marco, 81
Bellori, 13
Bembo, Pietro, 56, 116
Bentivoglio, Giovanni, 51
Bernini, 174-177
Berruguette, Alonso, 82
Borghese, Scipione, 9-10
Borgia Jofrè, 25
Borgia Rodrigo, see Alexander VI
Borgia, Cesare, 15-58
Borgia, Lucrezia, 15-58
Bothwell, 117-126
Botticelli, 67-69
Burchard Johannes, 24-58
Burchard, Johannes, 57
Cairo, Francesco, 179
Calderon, Pedro, 27
Calixtus III, 24
Caracciolo, Battistello, 177
Caravaggio, 149-167
Carlotta of Navarre, 43
Carr, Robert, 121
Carracci, Ludovico, Annibale and Agostini, 171-172
Catanei, Vannozza de', 24-25
Cecil, Richard, 121
Charlemagne, 17
Charles V, 117-126
Charles VIII 26-58
Clement VII, 122, 124
Colleoni, Bartolommeo, 22-28

Correggio, 129-130
Darley, Lord, 117-126
Diocletian, 10-11
Donatello, 58-59
Dossi, Dosso, 137
Douglas, James, 120
Dracula, 17
Drake, Francis, 117-126
Dudley, Robert, 117-126
Erasmus, 41-42
Est, Ferrante d', 56
Est, Giulio d', 56
Est, Ippolito d', 56
Este, Alfonso d' 45
Este, Ercole de', 37, 45
Fawkes, Guy, 121
Ferrante, King of Naples, 16
Fracanzano Cesare, 178
François I, 117-126
Gonzaga, Federico II, 115
Gonzaga, Francesco, 56
Hamilton, James, 120
Henry IV, 117-126
Henry VIII, 117-126
Innocent VII, 25-32
Innocent VIII, 25, 38
James I/VI, 117-126
Juan King of Navarre, 43, 57
Julius II, 64-67, 116
Lampugnano, 28
Landucci, Luca, 13
Lerma, duke of, 126
Lippi Filippino, 21
Lippi, Filippo, 21
Louis XII, 33-58
Luther Martin, 123
Magellan, Ferdinand, 33-35
Malatesta, Sigimondo, 44
Mancini, 13
Manfedi, Gionevangelista, 52
Manfredi, Astorre, 36-58
Manfredi, Galeotto, 37
Manfredi, Ottaviano, 48

Mantegna, 60-62
Marlow, 120
Mary Queen of England 117-126
Mary Queen of Scots, 117-126
Medici Cosimo de', 15-27
Medici Giovanni de', see Leo X
Medici Giuliano de', 30-32
Medici, Caterina Riario Sforza de', 15-58
Medici, Giovanni de', 115
Medici, Giovanni de', husband of Lucrezia Borgia 48-58
Medici, Giulio de', 116
Medici, Lorenzo de', 15-46, 115
Medici, Piero de', 21-23
Messina, Antonello da, 59-60
Michelangelo, 44, 83-102
Mila Adriana da, 25
Montefeltro, Federico da, 15-58
More, Thomas, 41-42
Nicolas V, 21
Olgiate, Girolamo, 28
Ordelaffi, Antonio, 36-46
Ordelaffi, Lucrezia Mirandola, 36-37
Orsi clan, 38-39
Orsini Clarcie, 22-23
Parentucelli, 20-21
Passignano, Dommenico, 180
Paul V, 9-10
Pazzi, Francesco de', 30-32
Pazzi, Jacopo de', 30-32
Penni, Gianfrancesco, 116
Perugino, Pietro, 69-70
Philip II, 117-126
Philip III, 126
Pignatelli, Stephen, 9-10
Pius II, 21-24
Raimondi, Marcantonio, 114
Raphael, 114-117
Régnier, Nicolas, 181
Reni, Guido, 167-169
Riario, Bianca, 48
Riario, Girolamo, 30-58
Riario, Ottaviano, 36-58
Riario, Scipione, 38

Ribera, 173
Ricchi, Pietro, 182-183
Rizzio, Davis, 117-126
Romano, Giulio, 114
Salviati, Francesco, 30-32
Sancia, 26-44
Savelli Bishop, 38-39
Savonarola, 32-33
Sebastian, passim
Sforza, Francesco, 16-35
Sforza, Galeazzo Maria 22-53
Sforza, Gian Galeazzo, 32
Sforza, Giovanni, Lucrezia's husband, 27
Sforza, Ludovico, 32-48
Shakespeare, 114, 120
Simoneta, 148
Sixtus IV, 24-58
Sodoma, 103
Stewart, Esmé, 121
Stewart, James, 120
Stewart, Mathew, 120
Suleiman the Magnificent, 123
Tintorello, 147-148
Titian, 127-128
Tornabuoni, Lucrezia, 21
Torrigiano, Pietro, 44
Vasari, 12, passim
Villiers, George, 121
Vinci, Leonardo da, 37, 70-80
Visconti, Carlo, 28
Visconti, Gian Maria, 15-16
Vivarini, Alvise, 81-82

www.ingramcontent.com/pod-product-compliance
Lightning Source LLC
Chambersburg PA
CBHW071427170526
45165CB00001B/434